Pacific Visions

MICHAEL L. SMITH

YALE UNIVERSITY PRESS

NEW HAVEN AND LONDON

Pacific Visions

California Scientists and the Environment
1850–1915

For my parents
and my brothers

Designed by Jo Aerne and set in Melior type
by Huron Valley Graphics, Inc. Printed in
the United States Of America by
Vail-Ballou Press, Binghamton, N.Y.

Library of Congress Cataloging-in-
Publication Data
Smith, Michael L.
Pacific visions.
Includes index.
1. Science—California—History. 2. Science—
California—Societies, etc.—History.
3. Scientists—California. 4. Environmental
protection—California. I. Title.
Q127.U6P25 1987 509.794 87–23007
ISBN 0–300–03264–1 (cloth)
 0–300–04907–2 (pbk.)

10 9 8 7 6 5 4 3 2

Contents

Acknowledgments

Writing a book, I was happy to discover, is a surprisingly collective enterprise. Many hands shaped these pages. The Mrs. Giles Whiting Foundation granted financial support at a critical early stage in my research. Award funds from the Theron Rockwell Field Prize and the George Washington Egleston Prize at Yale University greatly facilitated my post-dissertation research. Williams College provided generous funding for additional research and preparation of the manuscript, and defrayed the costs of publishing photographs. Two successive deans of the faculty at Williams, Francis Oakley and John Reichert, extended institutional as well as moral support. Donna Chenail typed the dissertation manuscript with remarkable speed and accuracy. Nora Krevans entered the manuscript onto diskettes, pursued elusive references, and generally sped the project toward completion. Leslie Karen Konrad's considerable research skills brought clarity to the final manuscript's murkiest backwaters. Barbara Roos prepared the index, for which the University of California at Davis supplied funding.

I am grateful to the staffs of a number of libraries and archives, especially the Bancroft Library at the University of California in Berkeley, for providing ideal working conditions during many months of research; Stanford University Archives and libraries; the Beinecke and Sterling libraries at Yale; the California Academy of Sciences; Holt-Atherton Pacific Center for Western Studies at the University of the Pacific; the Henry Huntington Library; the Archives of Scripps Oceanographic Institution; the California Historical Society; the Sempervirens Fund Archives; the Hetch Hetchy Library; the

New York Public Library; the Library of Congress; and at Harvard, the Widener Library, the Geology Library, and the Map Room at Pusey Library. Roxanne Nilan at Stanford's University Archives and Dorothy Day at the Scripps Institution of Oceanography were particularly helpful in guiding me through their respective collections. Elting Morison offered valuable suggestions on the history of surveying techniques.

I owe special thanks to Margaret Campbell, who led me through otherwise inaccessible materials at the California Academy of Sciences Library and provided invaluable insights into the inner workings of the academy, as well as information on Douglas Houghton Campbell; Holway Jones, Sierra Club historian and University of Oregon librarian who made his research files available to me; and John Thomas, professor of biology at Stanford and curator of the Dudley Herbarium, who shared his files and his extensive knowledge of William Dudley and the early years at Stanford. These three each offered the combination of erudition, interest, and friendship that every researcher hopes for but rarely encounters.

Several individuals contributed personal interviews, bringing my subjects to life in ways that documents alone could not convey. John Stillman Duryea provided information concerning John M. Stillman and the first Stanford faculty. Donald H. McLaughlin shared his recollections of Berkeley scientists before World War I. Robert C. Miller, who began his California career as a graduate student at Berkeley in 1920, served as director of the California Academy of Sciences for twenty-nine years and combined the insights of participant and historian in his knowledge of these institutions.

Every author is most indebted to those who read and respond to the work in progress. This project began as a doctoral dissertation, and David Brion Davis was an exemplary advisor, providing suggestions and support when I needed them most. John Blum and Howard Lamar generously exceeded their responsibilities as dissertation readers, guiding my work from its inception. I am grateful to Richard W. Fox, Neil Harris, and Howard Lamar for their thoughtful responses to the seminar papers from which the ideas for this book emerged. Ed Ayers, Gerald T. Burns, John Endean, Elliott Gorn, Ruth Nelson, Daniel J. Silver, and Barbara Smith read early chapters and contributed valuable comments. Christopher P. Wilson, Amy Myers, and James Wood contributed especially insightful observations on the

completed dissertation. Michele Aldrich and Alan Leviton furnished wonderfully detailed commentaries on the final manuscript; their considerable knowledge of the history of science in California rescued me from countless errors and ambiguities.

My understanding of the history of environmentalism and the ecological sciences was greatly enhanced by discussions with William Cronon, Morgan Sherwood, Michael J. Lacey, and James Griesemer. Arthur McEvoy generously permitted me to read a pre-publication manuscript of his excellent book, *The Fisherman's Problem: Ecology and Law in the California Fisheries, 1850–1980* (Cambridge, Mass.: Cambridge University Press, 1987). My treatment of gender and science owes much to conversations with Carolyn Merchant and Evelyn Fox Keller.

Charles Grench of Yale University Press has been called "the ideal editor" by a number of authors, and I am happy to be among them. Stephanie Jones far exceeded her duties as manuscript editor, combining an infallible eye with endless patience.

For support, commentary and guidance throughout this project, I am grateful to Joel Bernard, J. Gregory Conti, Karen Halttunen, Gail Hershatter, Jane Hunter, Jackson Lears, Karen Parker Lears, Angela Miller, Teresa Murphy, Christopher P. Wilson, and especially Christina Spence—superb colleagues, discerning critics, unfailing friends.

Pacific Visions

Introduction:

Santayana's California Dream

On August 25, 1911, George Santayana visited Berkeley, California, and delivered the most celebrated lecture of his career, "The Genteel Tradition in American Philosophy." In their lengthy commentaries on that brief essay, philosophers and social critics have often overlooked the Harvard philosopher's closing remarks to his audience of Californians. Theirs, he said, was "a thriving society," surrounded by "a virgin and prodigious world" of mountains, forests, and sea. Santayana wondered how that society would change, and be changed by, its natural environment. "When you transform nature to your uses, when you experiment with her forces, and reduce them to industrial agents," he told them, "you cannot feel that nature was made by you or for you." Rather, they must recognize "that you are an offshoot of her life; one brave little force among her immense forces." And when Californians escaped "to your forests, and your sierras, I am sure again that you do not feel you made them, or that they were made for you." He hoped that, in their eagerness to convert natural resources into economic and social growth, Californians might also learn from their natural environment "the irresistable suasion of this daily spectacle . . . the daily discipline of contact with things, so different from the verbal discipline of the schools."

Santayana's first concern was not the preservation of natural resources but the social effects of a commodified view of nature. One Californian had recently suggested to him that "if the philosophers had lived among your mountains their systems would have been different from what they are." Santayana agreed. Most systems of thought, he noted, "are anthropocentric, and inspired by the con-

1

ceited notion that man . . . is the center and pivot of the universe. That is what the mountains and the woods should make you at last ashamed to assert." California's terrain taught "no transcendental logic," but rather 'the strength of time, the fertility of matter, the variety, the unspeakable variety, of possible life."[1]

Santayana was not the first to tell Californians that their environment offered alternative ways of seeing nature and society. Since the mid-nineteenth century, a small but diligent group of men and women had worked and lived among those mountains and woods, although they did not call themselves philosophers. They were geologists, surveyors, botanists, and naturalists whose task had been to read the message of the terrain. They began to arrive with the forty-niners, and they provided California with its first semblance of a scientific community. For the rest of the century they studied the natural environment, nurtured public support for science, and became the state's first advocates of environmentally informed land use. This book is about them.

Sigmund Freud once observed that the most influential contributions the various sciences have made to human thought have been those that challenged prevailing anthropocentric myths. In astronomy, the Galilean revolution banished the earth from the physical center of the universe; in biology, the Darwinian revolution dispelled the notion that humans occupied the biological center of creation, apart from other forms of life; and in psychology, the Freudian revolution unravelled the myth that rationality occupied the center of the human mind. Stephen Jay Gould has noted that Freud overlooked a fourth attack on anthropocentrism, the geologists' discovery of what John McPhee has called "deep time."[2] Just as astronomy's vastness of space peripheralized the earth's position in creation, deep time revealed human history to be a recent pause for breath in the ancient song of the earth. The past century of scientific and social thought suggests that a fifth attack on anthropocentrism—an ecological revolution—has been in the making, questioning the scientific, economic, and social assumptions underlying extractive capitalism's definition of nature as a storehouse of commodities to fuel the ever-expanding engines of progress. Scientists in post-gold rush California lived in the midst of two of these revolutions (the geological and the biological), and as Santayana recognized, they stood at the threshold of a third; in their effort to reconcile the patterns of nature and

society in their new home, they unwittingly became the white West's first interpreters of the social implications of ecological thought.

Since most of these people included some degree of mapping or surveying in their work, they would have appreciated Lewis Carroll's map paradox. A simple line on a page is of little use to the traveler without landmarks; in general, the more information a map offers, the more useful it becomes. But as the quantity of detail increases, the map must keep expanding, until eventually it exactly duplicates the terrain it describes—and is therefore useless. Like cartographers, authors must know what to omit as well as what to highlight.

Quantitative studies of the social origins and regional distribution of scientists have been crucial to our understanding of the social history of science.[3] For several reasons, however, I have chosen to focus on relatively few key figures. In my effort to trace the regional formation of a social role for scientists, I found that my questions were best answered by examining the men and women whom Californians identified as key figures in that process. How did they secure patronage for their work? What institutions did they develop? In what ways did their society consider their work useful? What social changes did they advocate or oppose? In each instance, formative rather than representative behavior set the patterns.

Quantitative studies generally require a uniform definition of a scientist (inclusion in the *Dictionary of American Biography*, publication in a major scientific journal, membership in a professional scientific organization). I have tried instead to arrive at a social perspective on science: whom did Californians consider their scientists to be? What social expectations surrounded them? Accordingly, I applied the term *scientist* as nineteenth-century Californians did, to designate those who studied nature rather than marketing it. Thus John Muir could not be designated a scientist by most professional criteria in training or publications; but he is included here because Californians considered him to be one, and because his highly visible public role depended, in part, on his reputation as a scientist.

I concentrate on residents of the San Francisco Bay Area, because it remained the center of activity for the state's scientists and surveyors until the early twentieth century, when the Owens Valley aqueduct brought Los Angeles the water it required to grow beyond its environmental limitations. And I focus on earth and life scientists,

primarily because Californians did. The demand for surveys and data on natural resources followed immediately on the heels of the gold rush; the physical and social sciences, by contrast, did not come of age in California until the twentieth century.

In the 1870s and 1880s, the state's agricultural scientists, horticulturists and viticulturists began to play a public role that increased dramatically in the decades to follow. Their work, however, moved in a very different direction from that of most other scientists in the region; although they make occasional appearances in these pages, their story is better told by historians of agricultural science. Engineers were sometimes described as scientists, but theirs was also a different professional ethos. Some of them appear in this account, but their community has its own history and should be examined in the context of engineering culture.[4]

The major controversies in nineteenth-century biology and geology appear here, as they did for my subjects, as part of a broader backdrop of professional and social concerns. Although scientists in California tried to keep abreast of theoretical disputes, their history reveals more about California, and about the social role of the scientist there, than about the history of scientific thought.

Perhaps the central character in my account is the land itself. The scientists' observation of California's physical environment profoundly affected their thinking—both about science and about their new home. The peculiarities of their social environment influenced the ways in which they sought support for science and eventually prompted their efforts to arbitrate between the land and its occupants. These forces, compounded by geographic separation from other scientists, contributed to a professional role for California earth and life scientists that differed in significant ways from that of their Eastern counterparts. From observing the California backcountry, with its radical variations in topography, climate, and vegetation, they developed an emphasis on environmental interdependence. From witnessing the accelerating commercial devastation of the state's natural resources, they came to view advocacy of environmental reform as an essential aspect of their social role as scientists. Gradually, late nineteenth-century earth and life scientists in California came to share a loose configuration of concerns—an environmental perspective on science, nature, and society.

California's first scientists differed in emphasis among themselves

and seldom represented their work as departing fundamentally from that of their colleagues in the East. But all of them stressed the importance of California, both as a physical setting and as a social context for their work. And in different ways, each of them sought a less rapacious social model for the human use of nature in the Far West. In their effort to interest Californians in science, and other scientists in California, they developed a regional identity that differed noticeably from the professional scientific model being forged along the Atlantic seaboard.

As a social force, American science coalesced between the 1840s and the First World War in response to the changing needs of its chief patrons: the federal government and, increasingly, the emerging industrial corporations. In science as in other professions, a new identity stressed occupational rather than local definitions of community. Scientists looked increasingly to distant colleagues rather than to their neighbors for esteem and guidance. Institutions arose to convey new values and techniques. Universities and graduate schools emulated European scientific schools; professional organizations and journals proliferated. American scientists greatly enhanced their capacity for original research as a result of these changes. Professionalization also brought to their work a problem-solving model more applicable to the needs of business and government. One apparently unavoidable cost of this transformation was a growing distance between scientists and the public.[5]

During these decades, California's first generation of scientists found themselves far more isolated than any of their American or European colleagues. They also discovered among themselves a pronounced similarity of interests. Guided by predilection, reinforced by necessity, they placed emphasis on many of the very practices and values that their Eastern colleagues were rejecting in the name of professionalization. With inadequate laboratory equipment and skeletal institutional support, they turned to the vast natural laboratory all around them, stressing the unique qualities of California's terrain and the importance of first-hand observation. Far from the new professional institutions and conferences of their Atlantic colleagues, and depending on local economic and cultural conditions for support, they fashioned a more direct, public role for science in their region.

In so doing, California scientists struggled to clarify an issue that

colored their career choices, their concept of science, and their collective social identity: the relation of science to capital. Most of them perceived the scientist as a peripheral figure in the marketplace, performing a task unfettered by the profit motive, and often unrewarded by public acclaim. While seeking increased prestige for science, many valued their distance from the imperatives of commerce. Some undertook their training despite family pressure to pursue a more lucrative career. The resulting uncertainties over their social role became greatly magnified in California. Exhilarated by possibilities for the earth and life sciences in the Far West, scientists supported California's economic growth and independence while criticizing its principal means of attaining them. The wealth of natural resources and the social fluidity that attracted them to California also provided an unprecedented frontier for extractive capitalism.

By and large, the scientists were not anticapitalist or antigrowth. Most of them saw prevailing patterns of economic development as essential for the support of science in the West. But they did oppose careless or destructive use of the region's natural resources. To match their emerging social role to their institutional needs, Pacific scientists had to secure financial support from Californians while condemning the practices and tenets of the state's largest industries.

In many ways, California's first scientists were witnessing an exaggerated reenactment of the drama of settlement and land use that had begun on the Atlantic seaboard two centuries before. This time the set was grander in scale, and the actors moved with a chaotic speed worthy of the Keystone Kops, but the script was familiar: overwhelm the previous occupants, then develop a dependent relationship with the more developed East by supplying natural resources and agricultural goods. The differences were primarily singularities of time and place, but they proved to be important.

Far beyond the line of contiguous settlement, California remained "a land apart" long after it had been added to the map of the United States. For its scientific surveyors, the state's environmental diversity—a broad range of natural features nurtured by a unique pattern of climate and topography—required unprecedented attention to detail. For their patrons, that diversity was a mixed blessing: new opportunities in mining, agriculture, and timber

abounded, but they required new land use techniques that were unfamiliar to most Anglo-Americans.

Matters of timing also set California apart. Full-scale settlement and resource development began much later there than in most of the East, and because of the gold rush, it happened much faster. Eventually, many of those who had come to chart California implored its residents to become the great exception—to discard rather than embody the extractive culture that had so far shaped the nation's settlement. By the 1890s, many of the state's most prominent scientists had become environmental activists, hoping to seize the nation's last chance "to create a science equal in majesty to the colossal expanse of its landscape."[6]

Their success was limited and brief. By the end of World War I, California had become integrated into the national scientific community. Many of the questions and projects that had occupied the early geologists, biologists, and surveyors had been completed or eclipsed by new tasks and disciplines. Hampered by minimal professional resources and occupied with vast surveying tasks, Pacific scientists failed to evolve new techniques for ecological sciences; that task fell to a new generation of scientists.[7]

The scientists' social objectives—fostering an environmentally literate public to shape resource development—met with some success. As cofounders and key participants in the Sierra Club and other early environmental organizations, they provided a working base for a new generation of environmental activists. By the time of Santayana's visit, however, few natural scientists defined the social and political implications of their work as part of their professional responsibility.

California's first resident scientists remain important less for what they accomplished than for what they attempted. Although the Pacific slope did not evolve in the manner they advocated, their campaigns and critiques illuminate the forces at work in California's social development. Regional variations on the social role of scientists help to clarify the transformation of science in late nineteenth-century America. Finally, their struggle to achieve environmental and social reform is a crucial early chapter in the emergence of American environmentalism as an agent of political, economic, and cultural change. Little is to be gained from either lionizing or belittling them. But by examining the efforts of these men and women, we may be able to glimpse roads

not taken; to reintroduce into the apparently inexorable sweep of events a sense of the choices that confronted their participants; and to recapture for an "age of diminishing expectations" what Santayana called "the variety, the unspeakable variety of things."[8]

one

Scientists Arrive in California

1

Geopolitics and Gold:
California and the Surveyors' Frontier

Dreams of gold and empire lured the white man to California. He brought with him Bibles and gunpowder, microbes and plows, whiskey, cattle, steam engines, courts, and a relentless vision of conquest—of man over nature and man over other men. With swift vengeance he claimed, renamed, mined, deforested, irrigated, grazed, settled, or leased his strange new home into shapes he could recognize. No region of the country more vividly fit Robert Frost's observation, "the land was ours before we were the land's."

Spanish and English explorers first groped along California's imposing coastline in the sixteenth century—Cabrillo in 1542, Sir Francis Drake in 1579. Both sought the two great elusive legends of the American West: Anián and El Dorado. Known to the English as the Northwest Passage, the Strait of Anián was an imaginary westerly river linking European trade routes with the Orient. El Dorado, the Gilded Man, was the native chieftain in an imagined land just beyond every New World horizon, where each morning his minions dressed him in a layer of pure gold dust, and each night they washed it away.[1]

To the chagrin of England and Spain, three centuries passed before these dreams materialized—just as California passed into American hands. The Gilded Man appeared, in the form of the gold rush miner, before the ink was dry on the Treaty of Guadalupe-Hidalgo in 1848. In four tumultuous years his number exceeded one hundred thousand. In his haste to sift, claw, or blast bits of yellow metal from

the earth, the typical miner left smaller particles—as much as half his find—to wash downstream or to cover his clothes. The forty-niner bore little resemblance to the Spaniards' vision of El Dorado; but saloon-keepers accrued respectable fortunes by sweeping up each night in the wake of this gold-coated, less than noble savage.[2]

As for the Northwest Passage, its California outlet, the San Francisco Bay, eluded European eyes until 1769, when Portolá's tiny band of colonists encountered a harbor grand enough that all the navies "of Europe could take shelter there."[3] But it remained for the Americans to determine that the banks of the Northwest Passage, and the ships traversing it, must be built from iron, bought with gold. One hundred years after the discovery of San Francisco Bay, the driving of a golden spike from the mines of California opened the era of the transcontinental railroad, shackling West to East. It also joined together, in a stroke from the silver hammer, Anián and El Dorado, the twin emblems of empire in the American West.

Scientists and Early California

The conquest of California coincided with the golden age of scientific exploration. Belatedly following the lead of navies and merchants, naturalists in the late eighteenth century stepped out of their gardens and into the jungles and deserts of the New World. In the course of the nineteenth century they were joined by a growing number of pioneers in the geophysical sciences. Together they proposed to complete an inventory—and, they hoped, construct a design—for the entire planet and everything living on it. Their itinerary and their techniques, if not altogether their purpose, overlapped nicely with the needs of expansionist nations to catalogue nature's wealth and chart routes to reach it. El Dorado and Anián had their scientific counterparts. Ships bearing the banners of empire began to carry empiricists as well.[4]

Not until after the 1770s, when Spain's tenuous colonization of Alta California catalyzed global interest in the region's commercial and military possibilities, did California attract sufficient traffic to permit collectors (usually the ships' doctors) to smuggle the field-work of science onto voyages of commerce or state. Gradually, captains and navigators began to produce more sophisticated charts, often adding observations on currents, climate, and topography. In

the late eighteenth and early nineteenth centuries, Russian, English, French, Prussian, and American ships docked at Monterey or San Francisco Bay, quietly assessing Spanish California with an acquisitive eye. With them came the surgeon-naturalists and cartographers, collecting and mapping catch-as-catch-can.[5]

This stowaway science could do little more than cast scattered points of light across a vast terra incognita. Full-fledged geodetic surveys would have to await a more stable political climate. But as collections proliferated and naturalists' interest in California increased, science-oriented associations like the London Horticultural Society and the Zoological Museum of St. Petersburg began to sponsor excursions by trained collectors. Freed from the demands of trade and polity, naturalists undertook more ambitious surveys, venturing farther inland and speculating on patterns of distribution and climate.[6]

For American naturalists this kind of patronage rarely appeared. But in 1834 two Philadelphia botanist-ornithologists, Thomas Nuttall and John Townsend, arrived in California for a two-year venture. They won a measure of fame among life scientists both for the quality of their specimens and for their means of reaching them. By no means wealthy, they had come unsponsored. More dramatically, they had come overland. Accompanying Nathaniel Wyeth's colonizing expedition to Oregon, then forging their way south along the route discovered by pioneer trapper Jedediah Smith a few years earlier, Nuttall and Townsend demonstrated California's growing accessibility to scientists.[7]

By the late 1840s dozens of naturalists and a handful of geographers had visited California, their numbers increasing as overland and seaborne routes became less imposing. But with limited funds and equipment, their efforts remained piecemeal. A more substantial scientific survey of California would require a patron more richly endowed than individual naturalists or scientific societies, yet more dedicated to scientific objectives than captains dispatched by fur traders or competing governments. The United States laid claim to this role just as the cry of manifest destiny reached a fever pitch. The expeditions of Charles Wilkes and John C. Frémont illustrate how radically its efforts varied.

The Wilkes expedition (1838–42) was intended to combine scientific and political objectives, much as Thomas Jefferson had envisioned when he convinced Congress to sponsor the overland expedi-

tion of Meriwether Lewis and William Clark (1804–06). Nominally seeking furs and the perennial Northwest Passage, two army scouts with eleventh-hour training in science set out with instructions to notice everything—to sketch, in Jefferson's words, "the face of the country." Topography, meteorology, observation of Indian life and all things animal, mineral, and vegetable fell within their purview. Thus an expedition commercial by definition, scientific in its method and image, and emphatically political in significance offered something to all concerned. Scientists won the aegis of government; Congress could assure its commercial constituency of the practical value of such exploration; expansionists and the military assuaged nervous foreign powers by stressing the venture's "disinterested" scientific approach.[8] This highly successful formula for mutual legitimation did not find expression again until the United States Exploring Expedition set sail in 1838 under Navy Lieutenant Charles Wilkes.

The Wilkes expedition was a global excursion, ranging from Antarctica to the Canadian Pacific. Once again commercial objectives played a featured role: maritime merchants clamored for better charts and harbors, and the whaling industry sought more information on migratory routes. And again geopolitics wrote much of the script. But just as the geographic scope of the Wilkes expedition far exceeded that of Lewis and Clark's great trek, so did the role of scientific exploration attain new prominence. Following the example of European expeditions, Wilkes carried an unprecedented assemblage of American scientists; their number revealed the growing prestige of the geophysical and natural sciences, as well as the vulnerability of civilian scientists to military patronage.

Concerned that the navy might be expected to "act simply as the 'hewers of wood and drawers of water' " for the scientists, Wilkes reduced the civilian Scientific Corps from a proposed twenty-five to nine. These nine, including the Yale geologist James Dwight Dana and the Philadelphia painter and naturalist Titian Peale, represented "natural history." Since Wilkes considered the geophysical fields— "Astronomy, Surveying, Hydrography, Geography, Geodesy, Magnetism, Meteorology, and Physics"—to be "the great objects of this expedition," he reassigned them to himself and his fellow officers. Naval personnel and civilian "Scientifics" generally worked well together, despite differences in outlook. Some of Wilkes' officers objected to

the extra work and clutter created by the "bug catchers" and "clam diggers," while others praised the dedication with which their civilian shipmates "garner up strange things of strange lands." The Scientifics quickly adjusted to cramped quarters and middling provisions; their greatest concern was that their collecting was being hampered by the expedition's nonscientific tasks and by Wilkes' jealousy of their success. (Dana was more charitable than many of the others when he characterized Wilkes as "overbearing and conceited" but laudably energetic and dedicated). Yet the expedition demonstrated the value of civilian scientists in government-sponsored exploration, and their overland reconnaissance from the Columbia River to San Francisco Bay in 1841 created a new source of scientific interest in the Pacific slope.[9]

The Exploring Expedition returned, however, to find its discoveries hushed in the interests of British-American diplomacy; its collections became entangled in a political melee over the formation of a national museum; and its reports, at the mercy of Congress, remained unpublished or poorly distributed for decades. Wilkes lamented that "we shall become the laughing stock of Europe and all the praise that has been lavished on our Government for its noble undertaking prove but satire in disguise."[10] For its first major scientific expedition, the government had sent an eagle to hatch a mockingbird. And California still remained an unfinished sketch on the explorer-scientists' map of the world.

If the Wilkes expedition revealed the mixed blessings of government as a patron of science, John C. Frémont's Western explorations demonstrated the tactical usefulness of exploratory science to political and military opportunists. A captain in the army's Corps of Topographic Engineers and a veteran of fieldwork with the celebrated cartographer Joseph Nicolet, Frémont divided his allegiance between science and the expansionist vision of his father-in-law, U.S. Senator Thomas Hart Benton. As chairman of the Senate Committee on Territories, Benton arranged for Frémont to lead a series of "scientific" fact-finding expeditions to the Far West—the Rockies in 1842, Oregon and California in 1843–44, and back to California during the critical years 1845–46. Benton saw himself as a latter-day Jefferson with Frémont as his Lewis and Clark, advancing the government's acquisition of the Far West with the Trojan horse of scientific exploration. Frémont spoke with enthusiasm of this chance to learn "at first

hand from nature herself." His 1843–44 reconnaissance resulted in outstanding maps (drawn by German topographer Charles Preuss) of their route, providing as his orders indicated, an inland complement to the Wilkes expedition. And Frémont's expedition reports greatly exceeded Benton's hopes as a major source of inspiration and instruction for potential American emigrants to the Pacific.[11]

But Frémont was prepared to view the West through the sights of his rifle as readily as through a surveyor's telescope. Secretly instructed by Benton to report any opportunities for undermining Mexico's rule in California or England's claim to the Pacific Northwest, he found his role as an explorer-scientist to be a useful disguise for more aggressive forms of "collecting." At the outset of the 1843 reconnaissance, he outraged the commander of the Topographic Corps by slipping a howitzer onto his list of scientific instruments. But it was the California expedition of 1845–46 that revealed Frémont's true colors. Ambitious, quick-tempered, and a creative interpreter of military authority, he did all he could to instigate war with Mexico. In the summer of 1846 he assumed leadership of the abortive Bear Flag Revolt, asserting his authority through the pointless and gratuitously harsh imprisonment of General Mariano Guadalupe Vallejo, the native Californians' most prominent champion of peaceful transfer to American rule. The following year, acting without orders, he declared himself military governor of California.[12]

Frémont went on to win a court-martial for insubordination, the Republican Party's first nomination for the presidency, and a lasting but uncertain place in California's history. His legacy to science, however, was an unambiguous warning: he who pays the piper calls the tune.

The expeditions of Nuttall and Townsend, the Wilkes party, and Frémont brought to California three approaches to scientific exploration that reveal both the immensity of their task and the problems accompanying its sponsorship: a thorough geographic study remained beyond private means, but public support posed dangers. A predominantly science-based effort risked the loss of government interest; yet to serve that interest too zealously often meant enlisting science as a Trojan horse, leading the charge of empire while disguising its intent. As long as California remained under contested dominion and largely unsettled, it lacked the necessary ingredients for a

full scientific reconnaissance: regional support for such an enterprise and an ongoing institutional framework for carrying it out.

Two events early in 1848 assured the fulfillment of these two requirements. On February 2, the signing of the Treaty of Guadalupe-Hidalgo ended the Mexican-American War, ceding Texas, New Mexico (including Arizona), and California to the United States. Now the coastal and geological surveys undertaken by state and federal agencies could be expected to extend gradually westward, at a pace roughly matching that of settlement. In the Southwest, where the Apache Nation successfully resisted Anglo-American domination for another fifty years, the demand for survey scientists was not immediate. But the emergence of California as a state and as a focus for scientific exploration was wildly accelerated by occurrences at Sutter's Fort.

While California's new and former landlords conferred on the terms of peace, pioneer entrepreneur Johann Sutter hired James Marshall, a veteran of the Bear Flag Revolt and of Frémont's California Battalion, to oversee construction of a sawmill. On January 24 Marshall spotted a pea-sized yellow gleam in the millrace that caused him to "think right hard." In the months to follow, California witnessed the most spectacular gold rush the world had seen. Nine days before the formal withdrawal of Spanish-speaking rulers from California, and three centuries after he had first appeared there in the dreams of conquistadors, El Dorado came out of hiding.

The demographic impact was staggering. At the time of Marshall's discovery, California's non-Indian population was probably less than 15,000. In 1852, the new state counted nearly 225,000, of whom about 100,000 were in the mines. Aside from gold country, San Francisco witnessed the greatest change. When the sleepy harbor settlement of Yerba Buena first raised the American flag in July 1846, its 250 inhabitants could easily assemble to discuss the passing of Mexican rule. With a new name and new administrators, San Francisco had grown to a town of nearly 900 before the first wave of the gold rush in May 1848 left its streets deserted. With the realization that miners yielded gold more readily than mines, the city furiously refashioned itself to tap this itinerant unnatural resource. All over the country, men were "rushing head over heels toward the El Dorado of the Pacific," the *New York Herald* observed in January 1849, "that

wonderful California, which sets the public mind almost on the high-way to insanity." By 1850 San Francisco housed over 25,000 people, a hundred-fold increase in four years. Miners and observers, like *New York Tribune* correspondent Bayard Taylor, returned to the city after a few months in the diggings to find entire neighborhoods trans-formed beyond recognition. "San Francisco," Taylor marveled in the summer of 1850, "seemed to have accomplished in a day the growth of half a century."[13]

George Davidson and the Coast Survey

Gold rush California's swift and single-minded growth created an instant practical need for reliable survey work—especially along the coast, where the incessant clamor for passage had converted any-thing vaguely afloat into a ship, some with nothing better than school-book maps to guide them. Luckily, the ablest scientific agency in the federal government was the United States Coast Survey (later the Coast and Geodetic Survey), another brainchild of Jefferson.[14]

Even without the forty-niners, California's twelve hundred miles of coastline would have provided a generation of new work for the Coast Survey. Now that task, like all others in California, had to be compressed into the shortest possible time span. And like all other tasks in California, it had to compete with the mining camps for labor. With no roads or settlements disturbing the horizon, the first coast surveyors had to row ashore countless times, carrying two tons of instruments across nearly impassible terrain, where "wild animals and wilder men" provided their only company.[15] Who would endure such arduous labor for a dollar or two a day, while miners in make-shift inland towns like Rough-and-Ready or Delirium Tremens were digging up tens of millions of dollars in gold with shovels and pans and pocket knives?

That question quickly demanded more than idle speculation. The Coast Survey's first two Pacific field teams "arrived in California early in 1849, but owing to the peculiar condition of things," wrote subassistant James Lawson with considerable understatement, "very little work was obtained." Once the ship came in sight of California, he explained, "it was often necessary to have the boat's crew in irons to prevent their desertion. So great was the inducement to desert,

that the men would submit to any loss, resort to violence, and even attempt murder, to get away."[16]

Coast Survey Superintendent Alexander Dallas Bache had hoped that adventurous patriots would provide crews for his survey vessels. When even his officers were lured inland by the mines, Bache "determined to send another party, to be composed entirely of young men, who had a record to make, and who would not shrink from any necessary labor, or be daunted at any inconveniences or even privations to which they might be subjected." California's "peculiar condition" required men of science who were also men of character. On June 19, 1850, Bache's three young men reached San Francisco. Their leader, twenty-five-year-old geodesist George Davidson, was the oldest member of the party. Three thousand miles from his superiors, dispatched to a region where "everyone is intoxicated with gold," he and his men were expected to abstain from the "freakus" by making "their known character as gentlemen" a hallmark of their professional identity. For George Davidson, their assignment to chart the coast of California marked the beginning of a fifty-year career as a scientist in this "strangest of all countries."[17]

Born in Nottingham, England, in 1825, Davidson moved with his family to Philadelphia in his seventh year. His grandfather had prospered as a sailcloth manufacturer on the eastern coast of Scotland, and his father spent a lifetime failing to duplicate that success. The moves from Scotland to England and then to America were part of Thomas Davidson's grand but elusive scheme to pioneer in the production of machine-made lace. The eldest son in a large family with chronically limited resources, George soon recognized that an alert mind and an inexhaustible capacity for work were his principal assets.[18]

Both parents possessed unusual mechanical aptitude, and Janet Davidson created a lasting impression on her son by preparing demonstrations of the principles of applied physics. Yet, perhaps in an effort to distance himself from the arena of his father's failure, George entered Philadelphia's prestigious new Central High School with the idea of becoming a classics scholar. Instead he quickly attracted the attention of Alexander Dallas Bache, grandson of Benjamin Franklin and administrator of the school. Bache encouraged young Davidson's fascination with astronomy and mathematics. Both at Central High School and as Bache's personal assistant at the University of Pennsylvania, he acquired broad, if informal, training. Soon after Bache took

charge of the Coast Survey in 1843, Davidson again followed his mentor.[19]

Their relocation from Philadelphia to Washington led scientific master and apprentice to diverging notions of a scientific career. Bache immediately took his place in the vanguard of the elite, professionalizing scientists in Washington. A major figure in the American Association for the Advancement of Science, he was the chief advocate of an exclusive, government-sponsored National Academy of Sciences that would determine professional standards and "guide public action in scientific matters."[20] For the next two decades Bache brought the techniques of the entrepreneur to science, shaping the Coast Survey into the most powerful agency in the cartel of federal scientists.

As a promising young protégé of Bache, Davidson had only to fit his ambition and his scientific interests into a desk in the great middle realm of this emerging scientific bureaucracy to retain a secure, if heavily supervised, career. But in Philadelphia he had learned to expect a scientific landscape more contoured to individual interests and reputation. In Washington he felt banished, both from the surveyors' relative freedom and from the upper reaches of the Survey's hierarchy. He vented his growing impatience in terms that vividly expressed the contrast between surveying and administrative authority. The Coast Survey's fieldwork was based on triangulation, a survey method that connects fixed points on the map by a series of triangles (see chapter 3). Before long, Davidson began referring to Bache as "the Great Triangle"; and in his geodesist's imagination, the logical spatial metaphor for the director's position in the Survey hierarchy was a grandiose accumulation of triangles: a pyramid. Soon he was peppering his letters to friends with denunciations of "my Lord & Master—the modern Pharaoh," whose inner sanctum, where decisions were made, was sealed off from enslaved laborers like himself. Finally he decided that his best hope for a successful career lay in playing "a Moses" to Bache, "this Arch-Egyptian Taskmaster," and seeking the Promised Land through fieldwork.[21]

Davidson escaped from his desk in "Washington (D)reary (C)ity" by having himself assigned to the agency's survey of the Gulf Coast under Robert Fauntleroy.[22] For the next few years he divided his time between surveying and preparing the Survey's reports in Fauntleroy's home in New Harmony, Indiana. There he came to know Fauntleroy's

friends and family, one of whom—the younger daughter, Ellinor—he returned to marry in 1858. In the time he spent in this tiny settlement, Davidson also encountered a notion of scientific community very different from what he had experienced in Washington.

Like Davidson, Ellinor Fauntleroy was the grandchild of a wealthy Scots textile manufacturer. But in Indiana, Ellinor's grandfather, Robert Owen, was best known for his experiments in utopian socialism. Convinced that people were products of their environment and that industrial capitalism, private property, and organized religion were inherently destructive social forces, Owen foresaw "an entire new system of society" composed of rural communitarian colonies where shared property and labor, and universal benefit from labor-saving devices, would "remove all causes for contest between individuals."[23] In 1824 he purchased the abandoned Rappite colony of Harmonie, Indiana, and, rechristening it New Harmony, set out to bring his Community of Equality to life.

As an Owenite colony, New Harmony failed within two years. But during that time, thanks primarily to William Maclure, the tiny community gathered a remarkable concentration of like-minded scientists. Similar to Owen, Maclure was a wealthy Scotsman who had come to America with ambitious plans for the radical democratization of knowledge. President of the Philadelphia Academy of Natural Sciences and the first proponent of a geological survey of the United States, Maclure brought to Owen's experiment the celebrated Boatload of Knowledge—a loose confederation of geologists, naturalists, and educational reformers whose influence on New Harmony and on American science far outlived the brief existence of Owen's colony.[24]

Among those inspired by the subcolony of Macluria were Owen's own children. David Dale Owen attributed his interest in geology to the presence of Maclure, and his books and specimens, in New Harmony. He went on to serve as the first State Geologist for Indiana, Kentucky, and Arkansas; as United States Geologist he conducted the first geologically noteworthy federal surveys. From his laboratory headquarters in a New Harmony granary, he trained a generation of state and federal geologists. Richard Owen joined his brother David in fieldwork and strengthened New Harmony's academic connections while teaching geology at the state universities of Indiana and Tennessee. Robert Dale Owen continued in his father's role as a social reformer, fighting organized religion and championing wom-

en's rights and the abolition of slavery. During his terms in Congress (1843–47) he became a principal supporter of federal science, formulating, with Bache and Joseph Henry, the enabling legislation for the Smithsonian Institution. Jane Dale Owen Fauntleroy, barred by her sex from a comparable career, nevertheless mastered "considerable scientific knowledge" and taught alongside the most prominent in New Harmony's progressive schools.[25]

New Harmony exerted a lasting impact on young Davidson. Even before he contemplated marrying into the Owen family, he maintained a lively correspondence with them—especially with Robert Dale Owen and Jane Fauntleroy, who became his closest confidante during his first decade in California. For the rest of his life he diligently collected books, pamphlets, and clippings by and about the Owens, Maclure, and New Harmony's utopian origins. Charmed by "the proverbial idiosyncrasy of New Harmony for making every available occasion an opportunity for festivities," he immediately found himself an accepted member of a community in which some of the nation's most eminent scientists lectured to the townspeople in barns; where Maclure's Workingmen's Institute, the first of its kind in the country, fosterd the kinship between craftsman and scientist; and where, without fanfare, an informal network of geologists had created a unique center for survey science.[26]

But by 1849 New Harmony was a falling star in the scientific firmament. Government patronage for surveying had begun to centralize, shifting to Washington. George Davidson stood poised between two contrasting scientific cultures. Brimming with ambition, he could not afford to leave the Coast Survey for the jerry-built career of a freelance surveyor; institutionalization was rendering obsolete the example of the Owens. Yet his excoriation of Bache only sharpened during his years in the field ("I rarely write that I don't 'give him piss' "); and his distress transcended mere personal animosity. Bache's centralized organization promised a welcome degree of permanence for American scientists. But it brought with it a division of scientific labor, a regimented work culture that obviated both the barn-raising camaraderie and the individual autonomy of New Harmony. David Dale Owen's employment had been sporadic, but he and his assistants conducted surveys as exercises of their own judgment, from the first horseback reconnaissance to the final administrative report. The sheer size of Bache's agency had led to a bureaucracy

of scientific piecework. How, then, could Davidson acquire the professional freedom of an Owen while retaining the legitimation he enjoyed as a member of the Coast Survey?[27]

The acquisition of California by the United States seemed to provide a solution. Far removed from Washington, but retaining official sponsorship, a Pacific assignment might permit Davidson to combine fieldwork with administrative responsibility—to be a Moses in a realm free of pharaohs. But the California that greeted his crew on June 19, 1850, bore only the most tenuous resemblance to a Promised Land. San Francisco, the young surveyors discovered, was not so much a city as a ramshackle dam for the gold rush that had created it—an agitated pool where torrents of human energy collected before spilling across the valley floor toward the mines. In what had instantly become one of the busiest ports in the world, only a makeshift plank connected their pier to the shore. Everywhere the stuttering of hammers punctuated the air; five days before their arrival, a great fire—the third of six in three years' time—had gutted one entire section of town. Rebuilding, they quickly learned, posed little problem in a city accustomed to adding fifteen to thirty new buildings per day. But a stroll along the "streets"—unpaved dust-chutes that were transformed into ankle-deep quagmires with each rain—revealed that the word *building* enjoyed a remarkable range of application: shops made from canvas or ships' hulls, packing-crate shacks nestled alongside presumptuous "luxury hotels" with imported hardwood balconies and "French cuisine." Impromptu emporiums leveled by fire would reappear a day later, nearly indistinguishable from the ruins they replaced.[28]

If Davidson's party entertained any doubts concerning the relative value of survey science at this tollhouse on the "highway to insanity," they had only to consult their wallets. Davidson's salary was seventy-five dollars per month; his assistants earned thirty. Their cook received "more than the three of us together were getting." ("The sum total of his accomplishments in the culinary line," Lawson noted, "was to be able to fry a piece of pork or bacon, and to make a pot of very muddy coffee.") Good mechanics commanded twenty dollars per day, and an ironsmith charged Davidson nine hundred dollars—the equivalent of the young surveyor's entire annual salary—to make four screws and an instrument frame. "This is a 'fast' place & fast men in it," Davidson wrote a few days after their arrival; "many have rooms at

$500 per mo. and pay $150 a month for board! They *don't* belong to the survey!" As for his expedition, "we [all three] now rent a little wretched room for $20 per month, sweep it with a broom which cost $22 (15 cents in the States) wash with water at 25¢ a bucket. . . . If you look at a man you don't know whether [he] is going to charge you or not!" Ungilded men could not afford to tarry here.[29]

Speaking as "an old inhabitant (5 days here)," Davidson expressed mixed reactions to his new workplace. From a hilltop south of town, he scanned the city and marveled: "what cannot our citizens do—15 months since [there were] but 6 'Adobes'. . .now there are almost 25 thousand inhabitants." But back in town, the cost of this "mushroom-y" growth assaulted his senses: "nothing but the most extreme selfishness in every one—all striving, driving, running . . . wild with speculation, tomorrow broken. Everything is at extremes—but the Open Sesame is Gold! Gold! Gold!" Women were outnumbered twelve to one ("as scarce as strawberries in Nova Zembla"); and most of the few there were could be found at one of the city's "cultural establishments": gambling saloons, slapdash theatres, and brothels. None of his survey instruments could help George Davidson "fix" San Francisco in his mind: "everything is feverish, exciting, unusual, unnatural—hurrying, whirling & maddening—we must go with the stream."[30]

Equally perplexing, at first, was the countryside. Davidson had never witnessed the effects of aridity, and he did not yet recognize that the brown, "sterile" hills just beyond the bay were simply in the dormant phase of a broad climatic cycle of summer drought and winter rain. "Combine all the worst features of New England," he wrote at the outset of his reconnaissance, "make every hill barren— no roads, no timber, no houses,—and you will get a country in which no man will work while he can live elsewhere." But after three months in the field, he had visited the pine forests of the Coast Range, gazed across the valley floor to the High Sierra, and observed the central coastline's varied microclimates of cypress-studded cliffs, coastal dunes and grasslands, and steep escarpments notched by lush, fogbound inlets. "Nature only served an apprenticeship when she made the East," he wrote from Point Conception: "a master hand fashioned the charm of the Sierra Nevada." A California career looked much more enticing with "the Broad Pacific washing at our feet, and in the back ground rise peak upon peak—striving to ascend

the heavens themselves!" For the next eight years he charted the Pacific coast from the Mexican border to Puget Sound, fixing longitudes by astronomical readings, recording the topography and climate of isolated capes, bays, and mountains until he knew "almost every mile" by memory. By 1858, when he returned East to compile his findings, it was Philadelphia that seemed "barren"; "the blooming flowers midst of a California 'rainy season' have unfitted me for the bare trees & brown earth of the Atlantic States."[31]

In the meantime, civilization stamped a more lasting impression on San Francisco. Richard Henry Dana, whose *Two Years Before the Mast* had bestowed world fame on his 1835 California voyage, returned in 1859 and "could scarcely keep my hold on reality at all." Where twenty-five years earlier he had encountered barren sandhills and "wild beasts rang[ing] through the oak groves" with only one other ship and three "ruinous" structures to betray any hint of human presence, he now found an orderly and prosperous city of fifty thousand "with its storehouses, towers and steeples; its courthouses, theatres, and hospitals; its daily journals; its well-filled learned professions; its fortresses and lighthouses, its wharves and harbor, with their thousand-ton clipper ships" more numerous than in London harbor. San Francisco, Dana concluded, had instantly become "one of the capitals of the American Republic, and the sole emporium of a new world, the awakened Pacific."[32]

Davidson, like Dana, saw the stunning commercial growth of this "awakened Pacific" as a sign of the region's future greatness, but he also discerned more troubling aspects to "the 'go-ahead' principles that are here at play." "I venture to assert," he wrote to Jane Owen Fauntleroy in 1856, "that there is more vigorous talent—more energy & more ambition in this country than in any part of 'the States.'" But that talent remained discouragingly one-dimensional: "You look in vain for the noble, generous, expanded view of literature, of science, of institutions, and of nature, which at first glance we would expect to find among a people astonishing the world by their herculean growth."[33]

The problem, then, was not simply herculean growth. The Coast Survey's budget was linked to its ability to serve commercial development; more capital growth meant more Survey support. What distressed George Davidson was the corresponding absence of a cultural context for science. In the East, science occupied a more featured

position in the cultural orchard of genteel Victorian society, where it could attract public recognition while filling the baskets of commerce. California offered no such protection: "the Almighty Dollar swallows & consumes every attempt at solid and profound knowledge."[34]

Yet this lack of social definition had its benefits. Davidson welcomed the distance from narrow Eastern avenues of social and professional advancement that he found in "this cosmopolitan country, where you can enjoy the society of a red buttoned Mandarin—a right lineal descendant of the Sun and Moon, hob nob with a governor, play poker with the 'commanding officer of the Pacific Division,' dine with a millionaire who five years since could not pay his washerwoman."[35] The task confronting the scientist in California was to create a social identity in a culture that looked upon him as another "red buttoned Mandarin"—a colorful but expendable curiosity.

Incomparable terrain, a rudimentary social structure, great distance from the rest of the country: after eight years in California, Davidson tried to weigh its promise against its "many drawbacks." Back in Philadelphia in the summer of 1858, he wrote to Jane Fauntleroy to discuss his impending marriage to her daughter and its effect on his career plans. He had nearly completed his *Directory for the Pacific Coast,* a compendium of all his efforts in the West; this was a logical time to bring his California career to a close. The caliber of his work surely guaranteed some freedom to choose his next assignment, and his future mother-in-law dreaded the idea of so much distance between her and her daughter. But fieldwork, Davidson explained to her, was not only "congenial to a brain taxed and ennuied of routine" but vital to his work. And to "take to the field" anywhere but on the West Coast, he feared, would jeopardize his health—a risk that, as a "family man," he felt he could no longer justify. California's greatest attraction, however, remained "the independent position in which it places me on the work; far away from immediate control, my judgment is brought into play upon emergencies and intricacies of detail." Here was the professional independence he had left "Washington (D)reary (C)ity" to find. A few months later, he and Ellinor were at the crest of San Francisco Bay, honeymooning at a coast survey station on Mount Tamalpais.[36]

Davidson returned East in November 1860 and spent the Civil War years conducting naval defense surveys in the Delaware Bay area. In 1867 he led a reconnaissance of Alaska and by the following year he

was back in San Francisco, this time to stay. In addition to his survey duties (he had taken charge of all land-based Coast and Geodetic Survey work on the Pacific coast), Davidson now did his best to serve as the Bache of the West, tirelessly organizing California's nascent scientific community. But where his teacher had sought to codify the social role of scientists under the leadership of a national elite, Davidson dispersed his efforts to each point at which scientists intersected with their society—from the California Academy of Sciences and the University of California to the Mechanics' Institute and the local newspapers.

In 1850 Bayard Taylor had compared San Francisco to "the magic seed of an Indian juggler, which grew, blossomed and bore fruit before the eyes of the spectators."[37] The magic seed of science, Davidson knew, must germinate more slowly in this Western soil. Acting as groundskeeper for science in the West, he borrowed from both Washington and New Harmony in the decades to come, grafting and pruning the tree of science while cross-pollinating it to suit its new surroundings. The task required diligence. Californians, to be sure, had devised a society less beholden to sleight-of-hand since Taylor's visit, but they still expected their scientists to be Indian jugglers.

2

So Fine an Experiment:
After the Gold Rush

On November 6, 1860, Americans cast their ballots and braced themselves against the tremors of a shattering Union. With secession and war only weeks away, scientists, like everyone else, faced extensive disruption of their work and lives. Thousands of miles from the battlefields, Californians experienced the Civil War more as a series of aftershocks than as an immediate event. For West Coast scientists, the war signified an increased reliance on local and state support, as most federal scientists returned East. A succinct but unnoticed signal of this shift occurred when two ships passed each other along the Pacific Coast of Mexico early that November, perhaps on Election Day itself. The southbound vessel carried George Davidson and his family, en route from San Francisco to Philadelphia. On board the northbound steamer were Josiah Dwight Whitney, director of California's new State Geological Survey, and three of his assistants.[1]

J. D. Whitney and the California Geological Survey

Whitney approached California on the crest of a gradual wave of regional interest in scientific exploration. In addition to the meticulous shoreline reconnaissance by Davidson and the Coast Survey, tentative webs of surveyors' triangulation began to lace the state's interior in the 1850s. Military expeditions led the effort—notably,

the Army Corps of Topographic Engineers' surveys of the Mexican-American border and the proposed transcontinental rail routes. In spite of complex political pressures, both the Mexican Boundary Survey (1850–57) and the Pacific Railroad Surveys (1853–54) generated a great deal of scientific interest in California and the Far West.

The railroad surveys attempted, unsuccessfully, to resolve the debate over the best route for a transcontinental rail. Confined to rapid reconnaissance, these surveys provided very little detailed information. But the new state of California was greatly interested in the surveyors' reports on possible transportation routes and in geologist William P. Blake's impressively detailed study of the gold regions. The Mexican Boundary Survey developed a method of rapid cartographic measurement especially suitable to the arid Southwestern terrain: triangulation based on the location of mountaintops. Under Major William H. Emory's direction, boundary surveyors employed careful astronomical readings, barometric readings of elevation, and even nocturnal signal fires to achieve an impressive degree of accuracy from even the briefest reconnaissance. In addition, the railroad and boundary surveys each carried an entourage of civilian naturalists, whose collections and reports provided glimpses of California's natural environment to scientists throughout America and Europe.[2]

A more detailed survey of the state, however, required a sustained commitment from Californians themselves. A major rallying point for such an undertaking appeared in 1853, when seven ambitious amateur scientists in San Francisco founded the California Academy of Natural Sciences. (In 1868, the organization decided to broaden its scope by shortening its name to the California Academy of Sciences.) "It is due to science; it is due to California," the founders stated in their preamble, "that early means be adopted for a thorough survey of every portion of the state and the collection of a cabinet of her rare and rich productions."[3]

Motivated more by gold than by science, California lawmakers came to share the academy's interest in surveying the state. Beginning in 1853 John B. Trask, one of the academy's founders, provided the state senate with a series of reports on the geology of California, with special attention to "the mineral districts." A physician with little geological training and limited resources, Trask nevertheless provided useful preliminary indications of the state's natural re-

sources and geological complexity; his reports contributed to the state legislature's willingness to establish the California Geological Survey in 1860.[4]

Shifts in the state's mining industry also increased the lawmakers' interest in a more elaborate state survey. By the mid-1850s most of the surface wealth of the gold rush had been carried off or washed away; mining now required more sophisticated equipment and greater capital outlay. The first reports of Nevada's spectacular Comstock Lode in 1859 rejuvenated hopes for fresh mineral discoveries, but the trial-and-error methods of the forty-niners no longer sufficed. Mine owners thus became more willing to suspend their traditional cynicism toward "college geologists." Other industries, such as timber, cattle, and agriculture, concurred that the state should inventory its unexplored assets. Largely through the efforts of State Supreme Court Justice Stephen J. Field, the legislature hired Josiah Dwight Whitney, a family friend of the Fields', to oversee the task.[5]

At age forty-one, Whitney was among the best-trained American scientists of his generation. The first child of a prominent Northampton banker and a descendant of Puritans, he had been expected to proceed from Yale to Harvard Law School. Instead, he resolved "the old subject, the bothering subject, the never decided subject of my profession" by following his fascination for geology and chemistry to Europe in 1842. In Paris he attended the Collège de France and the Ecole des Mines and learned geology on field trips with Elie de Beaumont. In Germany he studied in the laboratories of the great chemists Liebig and Rammelsberg.

His field experience looked equally impressive: an apprenticeship with the New Hampshire Survey (1840–41); first assistant for the Lake Superior Survey (1847–50); codirector of the Iowa State Survey with the celebrated Albany paleontologist James Hall. His letters of recommendation added up to a virtual who's who in American science: O. C. Marsh, Joseph Leidy, and both Benjamin Sillimans, father and son. Perhaps most impressive to Californians was his 1854 publication, *The Metallic Wealth of the United States*, for many years the definitive work on the subject.

Beyond these qualifications, Whitney brought to the survey an infallible eye for choosing subordinates. With him on board the *Golden Age* was his new first assistant, William Brewer. Though nine years younger than Whitney, Brewer had acquired a comparable

education. Among the first class to take degrees from Yale's new Sheffield Scientific School in 1852, he had gone on to study chemistry and geology under Liebig and Bunsen in Germany and with Chevreul in Paris. He was teaching at Washington and Jefferson College when Whitney's offer reached him. As leader of the survey's field crew, Brewer supervised a remarkable staff that included Charles F. Hoffmann, a young German-born engineer whose topographic skills helped set a new standard for American cartographers; and Clarence King, the future director of the U.S. Geological Survey whose *Mountaineering in the Sierra Nevada* (1872) won international fame for California's survey.[6]

Whitney reached San Francisco on November 15, 1860, "a perfectly heavenly" Indian summer day. Like Davidson a decade before them, he and Brewer climbed the nearest hill to view their new headquarters. The miners' tents and lean-to shops that had greeted Davidson were gone. Instead, Brewer was "astounded" to find "large streets, magnificent buildings of brick, and maybe even of granite, built in the most substantial manner." Huge geraniums, acacias, and fuchsias flourished everywhere. Nor did California's isolation seem so impenetrable: news of Lincoln's election had already arrived by the new Pony Express.[7]

But Whitney discerned vestiges of an earlier San Francisco. "Next to the earthquakes," he wrote to his brother William on Christmas Day, "what shocks the stranger most is the scale of prices in this region." A good cook still earned much more than a scientist. Whitney felt encouraged by "the intelligent look of the audience" at Thomas Starr King's First Unitarian Church. But in general, he wrote, "what struck me most at San Francisco (next to the dirt and the fleas) was the restless energy with which people follow the business in which they are engaged."[8]

What concerned Whitney most was the degree to which his new employers expected him to serve that restless energy. Lacking Davidson's knack for combining pure science with practical application, Whitney infuriated politicians, mine operators, and speculators by his apparent indifference toward their demands. To be sure, they often expected unrealistic, even impossible, results from the survey's efforts. ("There are not a few," the California Academy of Natural Sciences lamented, "who seem to think that the function of a State Geologist is to travel around with a wild cherry branch in his hand,

like a clairvoyant, and point to them where they shall plant their stakes and dig their wells.") But a vital aspect of Whitney's job was educational. Because each legislature had to renew the survey's appropriations, Whitney appeared before them periodically to justify its continuation. He could have encouraged their support by explaining, as John B. Trask did in the 1850s, that prehistoric fossils should interest the mine operator as well as the paleontologist. By identifying fossils, geologists could determine the age of gold-rich strata, which would greatly increase their ability to predict the location of other deposits. (In the winter of 1863, Clarence King came across a cigar-shaped cephalopoda and proclaimed that "the age of the gold-belt was discovered!")[9]

Instead, Whitney lectured on the "revelations of Geology" concerning the creation of the earth. From the floor of the state senate, such talk sounded confusing at best, and quite possibly blasphemous. To the legislators' entreaties for practical results Whitney replied that "it is not the business of a geological surveying corps to act . . . as a surveying party." Not surprisingly, his critics responded by denouncing this Eastern "aristocrat" for pursuing his occult practices at public expense. "What respect can we have," the *Pacific Mining Journal* asked, "for a fellow who spends his time in collecting sticks and stones and old bones like a Chinaman?" They had called for an Indian juggler; instead, they had found another red-buttoned Mandarin.[10]

The clash was not simply between pure and applied science or between capital and distinterested intellect. Whitney did not oppose commercial growth. On the contrary, his survey undertook to provide a blueprint for rational development of California. Exhaustive, precise, unhindered by the tunnel vision of single-purpose industries, Whitney's overview actually served the state's economic interests on a greater scale than the legislators imagined. Unfortunately, he rarely tried to explain his opposition to various speculative schemes by appealing to this larger context.

By 1864 the Whitney Survey had completed its most important work. Gradually its more illustrious members drifted back East: Brewer to a professorship at Yale, King to the inner circles in Washington. Whitney himself divided his time between the survey, when funds were appropriated, and teaching geology at Harvard when they were not. Their efforts "to grapple with the geological structure of an unknown region of unlimited extent," as Whitney described it, had

produced one of the most spectacular of all the state surveys. Yet Whitney's status with the legislature only worsened. His refusal to endorse a wave of oil speculation in the mid-1860s placed the future of the entire survey in doubt. By February 1868, the most distinguished scientist west of the Mississippi found himself "running the survey along in a small way at my own expense, waiting to see what the jackasses at Sacramento will do."[11]

Preacher: John Muir and Yosemite Valley

The last week of March 1868 provided conflicting evidence on the condition of science in California. On March 23 the Governor signed the legislature's bill creating a state university. Not even in their characteristic excess of rhetoric could the lawmakers envision the premier role the University of California would come to play as a citadel of publicly supported science. But rival constituencies already clashed over what form that science should take. Fearing intrusion by college "experts," farmers and mechanics distrusted the state's plan to augment the Morrill Act's emphasis on "agriculture and mechanic arts" with the "other scientific and classical studies" of a university. Josiah Dwight Whitney had recommended that the keystone of the new institution be a museum featuring the collections of his survey. Daniel Coit Gilman, who became president of the university in 1872, advised its founders to establish a center for original research. And various clergymen worried that this secular university would become a den of "Godlessness," where materialists, evolutionists, and those "favorable to the most ultra type of rationalistic Unitarianism" would quickly "destroy the students' foundations of religious belief by inculcating a skeptical philosophy." The university's scientists would have to navigate skillfully to avoid these various criticisms, but its very existence promised to harbor a new, more permanent contingent of scientists in California.[12]

Yet four days later, on March 27, the same legislature refused further funding for Whitney's survey, the state government's only science-oriented project. Adhering to a tradition of violent disagreement among themselves on nearly every issue, San Francisco's newspapers debated the wisdom of such a step. The *Chronicle* denounced the legislator's "vulgar utilitarianism and potatoe-growing standard." But a political correspondent reflected the lawmakers' major-

ity opinion when he wrote approvingly in the *Examiner* that one state senator "who is eminently practical in his views, could not appreciate the payment of $40,000 per year for collecting butterflies, reptiles, and other specimens of the Professor's fancy."[13]

Yet, as his Museum Plan for the university attests, Whitney guessed at the educational value of the Survey's collections if presented in the proper context. To the *Pacific Mining Journal*, Whitney's geological and botanical specimens resembled "old rubbishy stuff only fit to macadamize a road with."[14] But what if these "sticks and stones and old bones" were presented as objects of interest and value? Californians understood display. If they perceived science as a form of commerce, then why not lead them, through the trappings of the marketplace, to a broader vision of science?

But this idea had competitors. Readers of the survey's demise had only to turn the page to find compelling evidence of the potential appeal of choice specimens. In an advertisement for the "Grand Re-Opening of the Pacific Anatomical Museum and Gallery of Natural History and Science," San Franciscans learned of "an immense collection of BOTANY, ICHTHYOLOGY, and ENTOMOLOGY," including exhibits of "COMPARATIVE FLORAL and BOTANICAL ANATOMY." Assuring the public of its unsparing efforts "to render this superb collection the most INSTRUCTIVE, AGREEABLE AND USEFUL IN THE WORLD" the "museum" then announced, with a customary flourish of boldface, its featured acquisition: "the celebrated Du Chaillu GORILLA which was exhibited ALIVE in Paris."[15]

The state survey's collections included no gorillas previously alive in Paris. In fact, all their specimens, maps, and reports only hinted at their most significant acquisition: a way of perceiving California's terrain as living evidence of the forces that had shaped it and that shaped it still. From the crest of the High Sierra they had observed the processes that launched rivers and sustained life; in the watersheds destroyed by the logger's clear-cutting or the miner's hydraulicking, they saw the impact of human ignorance with a clarity that no isolated specimens could convey. The landscape itself provided an incomparable display of the lessons scientists could share with the people of California. But as his experience with the state legislature suggested, Whitney was not the man able to persuade Californians to view their new home in this unfamiliar fashion.

New university, stranded survey, stuffed gorilla: these were the newsworthy varieties of natural science on the day of John Muir's arrival in San Francisco. Untrimmed and unkempt even by San Francisco's liberal sartorial standards, Muir was a nearly penniless farmer's son who possessed little more than a sharp eye for detail, great enthusiasm for wilderness, and, at age thirty, a career crisis.

Muir was born in Dunbar, Scotland, in 1838. He spent his early years grappling with his father's view of the world as a great chain of taskmasters: God over man, man over nature. Daniel Muir's forefathers had been among the thousands of Highland crofters displaced by the huge sheep ranches that appeared in the late eighteenth century to supply the new textile towns to the south. (Indelibly impressed in John's memories of his childhood were the cottage-industry weavers, thrown out of work by the factories, quietly starving in doorways or under bridges.) Orphaned since infancy, Daniel Muir sought to overcome his legacy of displacement through religious zeal and hard work. After a brief military career he married a shopkeeper's daughter; and when she died, he married another. By this time he had built up a respectable trade in Dunbar, but he could not dismiss his boyhood dream of abundant land in America. When his church sanctioned that dream as the route to religious freedom, Daniel's gaze again veered westward. Early in 1848, when John was eleven, his father suddenly announced that the family would emigrate to the farmlands of Wisconsin.[16]

Daniel Muir's religious zeal flourished in new soil. Equating his farm's productivity with God's judgment, he worked his children so relentlessly that neighboring farmers expressed alarm. He promptly squelched any sign of undue frivolity. A characteristic episode was the "fire lesson": soon after their arrival in Wisconsin, Daniel put his sons to work clearing and burning brush. When he saw their giddy excitement at the sight of the flames, the father compared the brush to his sons' souls roasting in an eternal hell, quoting the *Book of Revelation* until all outward evidence of enjoyment had subsided.[17]

As the elder son (he had five sisters and a brother), John Muir bore the brunt of his father's evangelical fervor. His first escape was to the countryside, where long moonlight hikes and botanizing between chores relieved the harsh tedium of farmwork. Though seldom speaking out, he gradually rejected his father's vision of the earth as a test of a man's will. Sending his sons to cut down first-growth timber

stands on government land or savagely flogging their aging work-horse so the family might get to church on time, Daniel Muir awak-ened in his son an abiding distaste for the frontier Protestant antipa-thy toward nature.[18]

In his late teens John found a second escape route from the drudg-ery of farm life. A self-taught tinkerer with the simplest of tools, he began constructing inventions of increasing ingenuity: fantastic clocks, waterwheels, and a "washboard thermometer" so sensitive that it registered the body heat of its approaching admirers. His most ambitious project was an "early-rising machine," Jeffersonian in its complexity, that "would strike, register hours and dates, light fires and a lamp, and by means of a set of levers and cogwheels would tip a rudely constructed bed up on end at any desired hour."[19]

Designed to launch him out of bed, this remarkable device eventu-ally catapulted him off the farm and into the university. Convinced by a neighbor to exhibit his inventions at the 1860 state agricultural fair at Madison, John Muir found himself "the attraction of the fair," hailed as a genius by state newspapers. He toured the campus of the new University of Wisconsin and met his first "university people." A few months later he enrolled, promptly winning notoriety as an ec-centric both in appearance ("If I had a beard like that," one student told him, "I'd set fire to it") and in deed (his "desk clock," which dropped books before him at set intervals, became a feature of cam-pus tours).[20]

Muir's image as an unconventional inventor-genius provided a basis for many of the strengths and limitations of his later career. His ingenuity had brought him public recognition of his abilities, and his reputation for eccentricity helped him to overcome the painful shy-ness he had inherited from the social isolation of his childhood. In Madison he learned that, rather than struggling for social acceptance through conformity, he could win respect by confounding prevailing assumptions and expectations.

His two-and-a-half years of coursework also greatly broadened Muir's interest in the natural sciences. In his later life, he exhibited some defensiveness over the brevity of his formal education—often disparaging the value of book-learning, yet sometimes embellishing the duration of his university career.[21] Nor did he discourage admir-ers from characterizing him as an untutored Wunderkind who

learned directly from nature. But his later journals, letters, and articles reveal a versatile literacy in the earth and life sciences.

His most influential teachers were geology professor Ezra Carr, who had studied under Agassiz, and his wife, Jeanne Carr, who informally encouraged Muir's botanizing. Like Jane Owen Fauntleroy for George Davidson, Mrs. Carr became for Muir a spiritual mother, to whom he could write his most unabashed thoughts and impressions of the wilderness. Daniel Muir looked on with consternation. Botany was a frivolous, if harmless, pastime, but geology was clearly blasphemous.

"When I first left home to go to school," Muir later wrote, "I thought of fortune as an inventor, but the glimpse I got of the Cosmos at the University, put all cams and wheels and levers out of my head." In fact, the choice between cams and the Cosmos required nearly a decade of vacillation. Inventor or naturalist? Both pursuits fell within the mid-nineteenth-century popular notion of science; both dealt with the discovery and application of laws. To Muir they differed primarily in workplace—forest or factory—and in their relation to nature and commerce. Increasingly ambitious botanizing expeditions whetted his desire "to be a Humboldt!" Yet even after years of training, few Americans in the 1860s could hope to make a living as naturalists, far from the industrial heart of the nation's growth. For the shrewd inventor, however, opportunities abounded; at the cutting edge of the producer ethic, such work was lucrative, plentiful, and sanctioned by the society at large—even by Daniel Muir.[22]

John Muir was still hovering between "the grateful din of the machines" and "the sweet study of Nature" when the Civil War intervened. Appalled by the carnage of this "farthest reaching and most infernal of all civilized calamities," and faced with the growing possibility of being drafted, Muir followed the example of hundreds of other young men from his region: in March 1864 he set out for Canada.[23] For the next three years he literally wandered from one role to the other, studying flora in the Great Lakes region and stopping to work in factories when his money was gone. At a broom-handle factory on Lake Huron and, after the war, at a carriage parts plant in Indianapolis, Muir devised machines that automated and simplified production. Both inventions might have been marketable, but he declined to apply for patents. Instead, he argued for a shorter workday.

Beneath this apparent confusion loomed Muir's growing recognition of the impact of his role as an inventor. Ideally, labor-saving devices aided everyone. In a letter to Mrs. Carr from the broom-handle factory, Muir tried to convince himself that such was the case with his own efforts:

> I invented and put in operation a few days ago an attachment for a self-acting lathe, which increased its capacity at least one third. We are now using it to turn broom-handles, and as these useful articles may now be made cheaper, and as cleanliness is one of the cardinal virtues, I congratulate myself in having done something like a true philanthropist for the real good of mankind in general. What say you? I have also invented a machine for making rake-teeth, and another for boring them and driving them, and still another for bending them, so that rakes may now be made nearly as fast again. Farmers will be able to produce grain at a lower rate, the poor will get more bread to eat.[24]

Yet as he gained factory experience, Muir began to glimpse what the weavers of Dunbar had signified. Under the factory system, the benefits of labor-saving machinery such as Muir's did not radiate in all directions "for the real good of mankind in general." For his employer they generated profits. For his fellow workers they meant skill displacement, and more frequent unemployment. Cheaper rakes did not produce more bread for the poor.

How, then, could the inventor ensure that his machines would not become instruments of exploitation? At first Muir sought to transcend "the gobble-gobble school of economics" entirely by refusing to patent his devices; "all improvements and inventions," he insisted, "should be the property of the human race." However dramatic as a moral gesture, his abstinence from profit-making left intact the relation of the worker to technological change. So Muir began to examine the production process itself. In the early twentieth century, Frederick Winslow Taylor inaugurated the time-and-motion studies that led him to champion "scientific management." Crudely conceived but widely influential, Taylor's system invoked the neutral terminology of efficiency to remove control of the labor process from the workers, transferring it to an emerging cadre of managers. Anticipating Taylor by nearly a half century, Muir undertook a time-and-motion analysis of the Indianapolis carriage parts factory in 1866.

Unlike Taylor, Muir blamed factory owners as much as workers for wastefulness. His "Chart of one days Labor" espoused shorter hours for workers in the name of efficiency.[25]

Yet Muir's study of the workplace fell short of solving the riddle of Dunbar. He had seen that factories could waste natural resources and wreak social havoc, but he had not grasped the full social meaning of the reforms he sought: under an industrial wage labor system, efficiency was measured in owners' profits, not in productivity. Workers might inadvertently sabotage their own job security by increasing their productivity and reducing the value of the product in the marketplace. Not quite recognizing the systemic nature of industrial problems, Muir blamed individuals. Years later, his campaigns for environmental reform were marked by a similar tendency to waver between social analysis and personalized diatribes against greedy individuals.

Muir appeared to be groping toward a reformulation of the technician's role when an accident recast his plans completely. In March 1867 a file slipped and pierced his right eye. Sympathetic blindness in his left eye left him entirely without eyesight for a month. Forced to spend his recovery time in a darkened room, he emerged with his vision restored and a vow to labor only in "Nature's workshop." After a year of travel highlighted by a thousand-mile walk from Indiana to Florida, he wrote, "fate and flowers carried me to California."[26]

In later recollections of his arrival in California, Muir cast himself as an idiot savant whose view of the landscape inverted social expectations. One day after reaching San Francisco he asked a passerby "for the nearest way out of town." When pressed for his destination, Muir replied, "To any place that is wild." The startled passerby "seemed to fear I might be crazy and therefore the sooner I was out of town the better, so he directed me to the Oakland ferry." Muir walked south, then east; from a pass in the Coast Range he caught his first glimpse of the very different "city" of his destination. Stretching before him was the Central Valley, brimming with knee-deep wildflowers "like a lake of pure sunshine, forty or fifty miles wide, five hundred miles long." And at the eastern horizon he could see "the mighty Sierra, miles in height, and so gloriously colored and so radiant, it seemed not clothed with light, but wholly composed of it, like the wall of some celestial city."[27]

Within a few days Muir reached the Yosemite Valley, the "sanc-

tum sanctorum" of the Sierra range, where he spent most of the next four years. "You cannot warm the heart of the saint of God with your icy-topped mountains," Daniel Muir warned in a letter. But Muir soon found in Yosemite's "living granite" an alternative to his father's "Calvinic doctrine of total depravity." "The Lord has a *natural Elect*," he wrote in the midst of his Sierra apprenticeship, "people whose affinities unite them to the rest of nature." For those few the "grandeur of Yosemite comes as an endless revelation."[28]

A Yosemite journal entry in January 1870 suggested the blend of scientific inquiry and transcendental flight that comprised such a revelation for Muir. If he could only escape from the "so-called prison" of his body, he wrote, he would "follow [the earth's] magnetic streams to their source," "go to the very center of our globe and read the whole splendid page from the beginning." There he could "study Nature's laws in all their crossings and unions."[29]

It was not by coincidence that Muir chose to combine the imagery of religious ecstasy with the aims of the earth scientist. His determination to "read the whole splendid page from the beginning" swept aside his father's denunciation of venturing "beyond what was written." It also described the field research that led him to his new occupation. Glacial scorings and moraines now replaced cogs and pulleys as the objects of his late-night flashes of inspiration. "Waking or sleeping, I have no rest," he wrote to Mrs. Carr in September 1871. "In dreams I read blurred sheets of glacial writing, or follow lines of cleavage, or struggle with the difficulties of some extraordinary rockform." His discovery of living glaciers in Yosemite won Muir recognition from the nation's scientists. California's mountains had opened a new career for Muir.[30]

Or so he thought. From his Sierra vantage, surrounded by "not a single songless particle," Muir spoke of human institutions as a faint and dissonant accompaniment to "the one general harmony of all nature's voices." But making his own voice heard remained a problem. With no credentials as a scientist and no institutional backing for his Yosemite studies, Muir had to tend sheep or work as a sawyer to support himself. Repeatedly he found his work disrupted by the vicissitudes of his employers. And by what authority could he command the public ear when venerable scientists like Whitney dismissed his findings as the solitary musings of a shepherd?[31]

However tentative his role, Muir won fame as an inseparable fea-

ture of Yosemite. In 1869 the Carrs moved to Oakland, where Professor Carr joined the faculty of the new University of California. Mrs. Carr acted as Muir's chief advocate in the Bay Area, sending any noteworthy visitors to him and "his Valley." In the summers of 1871 and 1872 his mountain companions included botanists Asa Gray of Harvard and John Torrey of New York; British mountaineer-physicist John Tyndall; John Runkle, president of the Massachusetts Institute of Technology; and Ralph Waldo Emerson, "the most serene, majestic, sequoia-like soul I ever met."[32]

Meeting these luminaries boosted Muir's confidence but also underscored his uncertain status as a self-styled Yosemite poet-naturalist. "I know that I could under ordinary circumstances accumulate wealth and obtain a fair position in society," he wrote to his sister Sarah, "and I am arrived at an age that requires that I should choose some definite course of life. But I am sure that the mind of no truant schoolboy is more free and disengaged from all the grave plans and purposes and pursuits of ordinary orthodox life than mine."[33]

Muir exaggerated the effortlessness of his truancy. Loneliness, uncertainty, and exhaustion became familiar features of his Yosemite landscape. ("In all God's mountain mansions, I find no human sympathy," he confided to his notebook, "and I hunger.") But if he was unsure what shape his mountain studies would take, he found comfort as well as frustration in the anomalous nature of his work. "There are eight members in our family," he wrote in his notebook. "All are useful members of society—save me." The others cared for the sick, sold dry goods, taught school, raised families—they were "all exemplary, stable, anti-revolutionary. Surely then, thought I, one may be spared for so fine an experiment."[34]

After four years in the mountains, the proper setting for that experiment remained unclear. Despite his rhetorical flourishes, Muir recognized that he could not remain a hotel-keeper's sawyer forever. Emerson, Runkle, and Gray all urged him to come East to Cambridge and "better men." He was flattered by the attention, but their suggestion only exacerbated his uncertainty. Up to that point, Muir had overcome his shyness and self-doubts somewhat by casting himself as an outsider. "I have been wild too long," he told Mrs. Carr, "too befogged and befogged to burn well in their patent high-heated educational furnaces."[35]

Now he longed for recognition, but he had two reasons to fear an

academic affiliation. First, his own scientific training would appear woefully inadequate at "Ha-a-a-rvard" or M.I.T. Beyond that, Muir thought of the scientific disciplines as cataracts, blinding their students to the evidence before them. His misgivings about professional science were apparent in a description he wrote for Emerson of the geology lesson he imparted to Runkle. "I only made gestures & pointed to rockforms and cañons," he reported, hoping that the university president could set aside "his flinty mathematics" and "his gaunt rawboned Euclidal 'Wherefors' " long enough to receive "knowledge by absorption."[36]

As his Yosemite apprenticeship neared its end, Muir sought Agassiz's scientific purview but Emerson's sensibility and independence from institutional affiliation. If heading East seemed even more untenable than remaining in Yosemite, Muir's best hope for an alternative seemed to rest with kindred spirits among his fellow Californians.

Teacher: Joseph Le Conte and the University of California

A key figure among Muir's "natural Elect" was Joseph Le Conte. The University of California's first professor of geology, botany, and natural history, Le Conte arrived in California when the school opened in September 1869. The following summer he accompanied eight students on a six-week excursion through Yosemite and the upper Sierra region. In the course of these ramblings, which he described as "almost an era in my life," Le Conte encountered two major influences on his future scientific career: the "mountain structure and mountain sculpture" of Yosemite, and John Muir. Mrs. Carr had instructed both Le Conte and Muir to seek each other's acquaintance, but they did not meet until Le Conte's party stopped for directions at the sawmill of pioneer Yosemite hotel-keeper J. M. Hutchings. There Le Conte found "a man in rough miller's garb" with a surprising knowledge of the region's geology and botany. Muir identified himself and quickly consented to join the visitors during their tour of Yosemite. In the days to follow, he and Le Conte exchanged theories of the valley's origin, enlivening Le Conte's geologic interests and bringing Muir a step closer to public recognition. Both men described in nearly identical terms their delight in the other's enthusiasm. "Mr. Muir gazes and gazes, and cannot get his fill," Le Conte

wrote in his journal. "He is a most passionate lover of nature. Plants and flowers and forests, and sky and clouds and mountains seem actually to haunt his imagination." Muir, in turn, recalled that the professor "studied the grand show, forgetting all else, riding with loose, dangling rein, allowing his horse to go as it liked. He had a fine poetic appreciation of nature, and never tired of gazing at the noble forests and gardens, lakes and meadows, mountains and streams" of Yosemite.[37]

Yet these kindred spirits came from radically contrasting scientific and family backgrounds. Joseph Le Conte was born in 1823 on a Georgia plantation where his family owned a hundred slaves. He devoted much of his boyhood to hunting, fishing, and camping in the surrounding countryside with his six brothers and sisters. His father thought of himself as a Jeffersonian gentleman farmer-scientist, overseeing his estate with a self-styled air of benevolent paternalism and pursuing his botanical and chemical studies as time permitted. His full-acre, slave-tended botanical garden won acclaim as one of the nation's finest, drawing botanists from both sides of the Atlantic. After the death of his wife in 1826, he found distraction from his grief in his attic laboratory. Joseph, only three years old when his mother died, was mesmerized by his father's "mysterious experiments; with what awe his furnaces and chauffers, his sand-baths, matrasses, and alembics, and his precipitations filled us."[38]

Joseph attended Athens College and, in 1843, enrolled in the College of Physicians and Surgeons in New York where, like many before him, he "studied medicine mainly as the best preparation for science." Among his professors was John Torrey, whose duties at that time included cataloging the botanical collections of the Frémont expeditions. By the spring of 1845, when he received his M.D., Le Conte had befriended several of the nation's most capable scientists, including the great ornithologists John James Audubon and Spencer Fullerton Baird. His interest in geology had been sparked by a tour of the Great Lakes the previous summer. Camping and canoeing with Indians and prospectors, and undaunted by a local innkeeper's observation that he would "rather see a dog-fight" than the unsettled countryside, Le Conte was captivated by the "remarkable features" of the Lake Superior region.[39]

After his marriage in 1847, Joseph Le Conte assessed his future. Up until then he had "simply drifted about and enjoyed life, as I thought,

in a noble way." But with a wife and, by year's end, a daughter, "I had to practice my profession." He settled down to a listless medical practice in Macon, Georgia; but found that his "tastes were far more scientific than practical." In the spring of 1850 a cousin of Le Conte's told him of his plans to study under the great Louis Agassiz at Harvard. At the same time "an old and distinguished physician" in Macon offered Le Conte a promising partnership. "It was now or never," he later recalled, "if I was to make medicine my life-work." By August, he and his family were in Cambridge.[40]

Agassiz had come to Harvard as a professor of geology and zoology in 1846. By 1850, the Swiss-born scholar was already one of the nation's best-known scientists, both for his exhaustive fieldwork and for his incomparable ability to attract public support for science. Le Conte served an intense apprenticeship, working alongside Agassiz "from eight to ten hours a day, every day, usually including Sundays" for fifteen months. In January 1851 they joined an expedition to the Florida coral reefs, under the sponsorship of Bache's Coast Survey. That spring, he and Agassiz joined James Hall in his examination of fossils in the Catskills. Within a few months, Le Conte had obtained his first field training from two of the most eminent scientists in the country.[41]

During his stay in Cambridge, Le Conte enjoyed "almost daily contact" with a "galaxy of stars" that included Asa Gray (with whom he studied botany), geologist Arnold Guyot, and mathematician Benjamin Peirce, as well as the Cambridge literati: Henry Wadsworth Longfellow, James Russell Lowell, Oliver Wendell Holmes, and Richard Henry Dana. He also became "life-long friends" with Bache, Henry, Hall, James Dwight Dana, and other prominent scientists throughout the Northeast. In June 1851 he received a degree with the first class that graduated from Harvard's new Lawrence Scientific School. When he left Cambridge in 1851, Joseph Le Conte had obtained as fine a scientific education as the country could offer.[42]

He returned South to a career as a college professor, eventually settling at South Carolina College, where his brother John taught physics. He might have remained there permanently had not the Civil War intervened. Le Conte later characterized himself as "extremely reluctant to join in, and . . .even opposed to the secession movement"; but by 1862 the college closed down, and he went to work as a chemist for the Confederacy's Niter and Mining Bureau.

His family's plantation stood in Sherman's path. By the end of the war he had "lost everything I had in the world." With Southern schools in chaos and positions in the North closed to veterans of the Confederacy, Le Conte had to look elsewhere. At the 1856 meeting of the American Association for the Advancement of Science, Le Conte, like Josiah Dwight Whitney, had taken an interest in California after hearing the reports of geologists and naturalists from the Mexican Boundary and Pacific Railroad surveys. When the University of California announced plans to assemble a faculty, Joseph and his brother John were among the first to apply.[43]

Forty-six years old, superbly trained for a career that had not yet materialized, Joseph Le Conte crossed the country on the newly completed transcontinental railroad. When he arrived in San Francisco in September 1869, the state's population had reached a half million (about that of Connecticut) and was growing at more than double the rate of the nation at large.[44]

Across the bay in Oakland, the new university faced its own growing pains. Classes began in temporary quarters with ten instructors and thirty-eight students. In 1873 the school opened its doors (both of them) at its new permanent campus in nearby Berkeley. Le Conte praised the new site as "certainly one of the most beautiful in the world," perched against the Berkeley hills, facing the Golden Gate and "the limitless Pacific." But President Gilman reported in 1875 that the new town boasted "no school, no practicing physicians, and but few and indifferent stores. The walks and roads are in bad condition most of the year, and the inconveniences of family life are great." Professors commuted by horse-car from Oakland or lived in "picturesque" faculty cottages on campus (Le Conte's floor fell through). Teaching and research facilities depended largely on individual ingenuity.[45]

Yet Joseph Le Conte thrived in "the wonderful new country, so different from any that I had previously seen, the climate, the splendid scenery, the active energetic people, and the magnificent field for scientific, and especially for geologic investigations." California's topography, with its mountains, glaciers, volcanoes, and earthquakes, focused his wide-ranging scientific interests. His *Elements of Geology*, first published in 1878, became a standard college text. But the people of California provided his major audience. "Family and name have but little influence here," he wrote thirty years after his

arrival; "every man must stand on his own merits. I confess I enjoyed this freedom." He also harbored great hopes for the favorable influence of California's natural environment on its people. He became not only the most popular lecturer on campus, but one of the region's best-known public speakers as well.[46]

As a defender of science, the university, and the importance of preserving California's "magnificent field" of natural resources, Le Conte served as a bellwether for scientists in this "wonderful new country." Like George Davidson twenty years earlier and Stanford's David Starr Jordan twenty years later, he found in the unfinished quality of California's social structure, and in the great promise of its terrain and climate, a correlative to his own aspirations. The tasks before them were to construct, from this succession of arrivals, a coherent vision of the role of science in California and to convince Californians, as John Muir exhorted them, "to come and see."

two

Scientists and the California Terrain

3

This Daily Spectacle:
Deciphering California

Long after the gold dust of the forty-niners had settled, immigrants reserved some of their highest praise, and their most vigorous censure, for that aspect of California they understood least: the shape of the terrain. The streets of San Francisco marked the triumph of Eastern preconception over Western reality: a neat, rectilinear grid of avenues struggling to contain the city's steep hills and fog canyons. In much the same way, California's new population of farmers, miners, and lumbermen brought notions of land and resource use that often did not fit the conditions of their new home.

It was the natural scientists and surveyors who first sought an overview of California that matched the contours of the new state. Like many of their fellow Californians, they saw the terrain as their workplace, but they viewed it as a laboratory rather than a warehouse of salable goods. Ranging from coastal bays to the crests of the High Sierra, they acquired a rare degree of familiarity with California's geographic character.

They began by mapping and inventorying their new surroundings. Botanists set out to collect and classify plant specimens, and geologists were instructed to chart terrain and locate gold. But they also brought with them the issues and questions confronting nineteenth-century geology and botany. Did the High Sierra's abundance of glacial scorings indicate that Agassiz's ice age was a global phenomenon? And did it occur more than once? Did the stratigraphy of the montane West support Lyell's claim that the earth had evolved over

49

vast stretches of time? Did the singular features of Yosemite Valley conform to the theories of catastrophists, who saw geological change occuring in sudden spasms of activity, or did it fit the model of slow, steady transformation proposed by uniformitarians? The fossil record of the West, as well as patterns of plant and animal distribution on the Pacific slope, appeared to corroborate evolutionary theory. But did Darwin's recently published concept of natural selection, stressing competition among species, best explain the dynamics of biological change? Or did California's ecological history support Lamarck's emphasis on adaptation to the environment as the engine of evolution?[1]

Preoccupied with the task of surveying the West and hindered by scarce resources and sponsors, many of the region's professional and amateur scientists considered this backdrop of theoretical inquiry to be secondary or irrelevant. Yet certain qualities of California's natural environment—diversity of topography and climate, vivid evidence of environmental adaptation and interdependence, a profusion of endemic species—led many of the region's scientific explorers to seek new ways of conceptualizing their natural environment. Over time, their perception of California's backcountry profoundly affected their thinking, not just about these issues, but about the social development of California, the public role of the scientist, and the human uses of nature.

Surveying Eldorado

Scientists and surveyors found much to ponder in the California terrain. To begin with, its dimensions invited disbelief among those accustomed to the relative compactness of the East. "I have found that the state of California is a prodigiously large place," J. D. Whitney wrote to his father at the outset of the state survey. "It is as big as Great Britain, Belgium, Hanover, and Bavaria put together!" By doubling his staff and working at the same pace and level of detail as English survey scientists, Whitney estimated that he could complete his task "in 450 years or thereabouts." Not just the size of the state—nearly one hundred million acres—but the scale of its features impressed the scientists: it had the world's tallest trees and also the biggest, the nation's longest continuous mountain chain and its highest peak (excluding Alaska).[2]

Vastness, however, was not uncommon in the West. Equally important to California's regional identity was its isolation. When California joined the Union in 1850, an arid half-continent separated it from the nation's westward line of contiguous settlement. Overlanders faced a grueling six to eight months' journey, culminating in a Sierra crossing so treacherous in bad weather that even Frémont's expedition of 1842–43 was nearly overcome by it. Seafaring immigrants had to choose either an arduous month's passage around Cape Horn or separate Atlantic and Pacific voyages linked by a trek through the jungles of Panama. For the first two decades of California's statehood, Australia was more accessible than Boston. Even after the transcontinental railroad opened in 1869, a ten-day ride separated the two coasts.

Survey scientists had experienced the remoteness of the Far West before. But California was the first region in the trans-Mississippi West in which they became local residents, compiling their findings from years of observation rather than from a single reconnaissance or a collection of specimens. Their work revealed that the region's geographic isolation had profound environmental implications. California's formidable natural boundaries—rugged coastline, high mountains, and harsh deserts—harbor a regional climate distinct from the rest of the continent. In the Eastern half of the country, a comparatively uniform humid or sub-humid climate prevails, with the annual rainfall diminishing gradually on the plains beyond the Mississippi Valley. West of the hundredth meridian, however, rainfall drops below twenty inches per year. Forest cover is minimal, except for the trees that hug the banks of shallow, sporadic rivers. Traditional Eastern patterns of vegetation, crops, and farming techniques no longer apply. Although two generations of pre–Dust Bowl homesteaders were reluctant to admit it, the plains beyond the hundredth meridian constitute America's arid region. At the close of the Civil War, nearly all Americans lived east of that line and thought of the nation's major regions as North and South. But climate and geography divided the country into humid East and arid West.

The Pacific slope provides the exception to this pattern. Driven by the prevailing westerlies, offshore winds carry precious moisture landward from the ocean; the Sierra-Cascades and Coast Range detain it. California lies almost entirely within this oasis. In the Pacific Northwest, prevailing wind currents, higher latitude, and cooler tem-

peratures increase annual rainfall substantially. But California's winter rains bring just enough water to rescue most of the region from the aridity of Nevada and Arizona. The resulting "Mediterranean" climate of summer drought and winter rain occurs in only four other parts of the world.[3]

Reinforced by geographic isolation, this climate fosters an equally distinct pattern of vegetation. What botanists call the California Floristic Province very nearly matches the state boundaries; it extends from the Pacific coastline to the western face of the Sierra-Cascades and spills over into southern Oregon to the north, Baja California to the south. Chief among the distinguishing characteristics of this great biological island is the diversity it contains. Since its Mediterranean climate introduces a delicate overlay of moisture into an otherwise arid region, the California Floristic Province is unusually susceptible to fluctuations in the distribution of water. Very slight variations in rainfall, topography, wind currents, latitude, temperature, or soil type result in pronounced changes in vegetation. And California encompasses vivid contrasts within each of these categories. Mount Whitney, 14,501 feet high, stands only sixty miles from Death Valley, 280 feet below sea level. Between San Francisco and the Sacramento Valley, temperatures characteristically vary by fifty degrees in as many miles. Between the southeast and northwest corners of the state, annual rainfall ranges from less than one inch to over a hundred.

This rich intermingling of environmental influences checkerboards California with dissimilar ecosystems, each of which in turn supports a proliferation of contrasting microclimates. Environmental changes that spread gradually over hundreds, even thousands of miles in other parts of the continent compress into dramatic adjacency in California. As David Starr Jordan remarked, "there is from end to end of California scarcely a commonplace mile." In an effort to make sense of this environmental crazy quilt, scientists looked for threads of connection. One of their earliest realizations was that, heading east from the coast, they encountered subregional variations arranged in north–south stripes, each powerfully influenced by the prodigal journeys of water back and forth between California's coastline and its great mountain systems.[4]

A traveler "riding through the seasons," as John Muir did from San Francisco to the Sierra Nevada, would first pass through the

temperate "spring" of the coastal belt that rises from the sea, providing occasional shelves and bays for human settlement before climbing three or four thousand feet to the ridge of the Coast Ranges. "The altitude of these mountains," noted John B. Trask in 1855, "is such that they . . . absorb much of the aqueous matter carried from the ocean through the various gaps that occur in the coast-line proper." Along the western flanks of the Coast Ranges, this accumulation of mountain-trapped fog and winter rain harbors thick coniferous and mixed evergreen forests. To their east, however, the mountains cast what ecologists call a rain shadow, in which the barrier effect of the mountains combines with warmer low-elevation temperatures to minimize precipitation on the floor of the great Central Valley.[5]

The broadest expanse of flatlands in the trans-Rockies West, this valley extends for fifty to eighty miles from the Coast Range to the Sierra Nevada and traverses the length of the state for nearly five hundred miles. For thousands of years it remained an expanse of wildflower-laced prairie grasslands, criss-crossed by riverlands and marshes and shading off into desert in the southeast. In the mid-nineteenth century, cattle, first introduced in small numbers by early Spanish and Californio settlers, became significant enough in the Anglo-American economy to induce broad environmental changes in the Valley: new strains of grasses were introduced, marshes were drained, and the effects of grazing multiplied rapidly. Irrigation, another Spanish and Californio innovation in the region, did not fully transform the valley until the twentieth century, when massive state and federal water projects created the most productive—and the most artificially sustained—agricultural region in the nation.

Farther east, the Sierra Nevada lifts from the edge of the valley floor "like waves of stone," as Clarence King described them, cresting nearly three icy miles above sea level before dropping abruptly ten thousand feet to the hot desert floor. Prevailing wind currents ride these waves and much of the state's environmental identity rests on the outcome. Driven upward by the heat of the valley, eastbound ocean moisture encounters the western slopes of the mountains and is carried still higher, until cooler temperatures cause the moisture to condense and fall as rain or snow. The great coniferous forests that blanket the middle elevations of the western Sierra are products as well as perpetuators of this water trap. Their needles weave a canopy that impedes evaporation; their root systems retain the moisture and

create a more erosion-resistant soil, which in turn facilitates the sea-ward redistribution of rain and snowmelt through a nearly silt-free system of rivers and streams.[6]

Like immense waterwheels, the mountains of California circulate the Pacific spindrift that makes the state's climate and much of its vegetation possible. To understand how the region would fare with-out its interplay of ocean and mountain boundaries, scientists had only to look eastward to the deserts of the Sierra rain shadow, where the California Floristic Province gives way to the basin-and-range aridity beyond. "There are but few points in America where such extremes of physical condition meet," King observed of the two views from San Gorgonio Pass. To the west he saw "tranquillity, abundance, the slow, beautiful unfolding of plant life"; looking east, he found "desert, stark and glaring, its rigid hill-chains lying in disor-dered grouping, in attitudes of the dead."[7]

Shoreline, Coast Ranges, Central Valley, High Sierra, desert: super-imposed onto this easterly succession of ecosystems is a more famil-iar northerly pattern of cooler temperatures and greater precipita-tion. And since California spans nearly ten full degrees of latitude, scientists could trace broad northerly shifts in climate and vegetation without crossing the state line.

Elevation also offered clues to California's environment. At the turn of the nineteenth century, the great explorer-naturalist Alexan-der von Humboldt examined the vegetation on the flanks of the Andes and detected similarities to growth patterns in the flatlands below. Humboldt's insight, simply stated, was that altitude recapitu-lates latitude. Cooler temperatures accompanying increased eleva-tion appeared to affect natural communities in ways that corre-sponded with increased distance from the equator. Led by zoologists C. Hart Merriam of the U.S. Biological Survey and Joseph Grinnell of the University of California, American scientists in the 1880s and 1890s applied Humboldt's concept to the mountains of the Far West. Climbing the mountains of California and the Southwest, they could see a clear progression of belts or zones of vegetation: foothill chaparral followed by thick yellow-pine woods, high stands of red fir and lodgepole pine, and aspen-studded meadows, finally giving way to treeless tundra and snow-capped, exfoliating rock. Stretching hori-zontally for hundreds of miles each, these lifezones seemed to dupli-

cate the continent's northward progression of natural communities, from Mexico to the Arctic.[8]

Such correlations of latitude with elevation, modified by longitude, superimposed a tidy geographic pattern onto California's labyrinthine configuration of climate, topography, and vegetation. Closer examination, however, revealed deep crosscurrents of environmental influences at work. In a Mediterranean climate, small variations in topography can deflect the flow of moist air, creating a proliferation of microhabitats. And California's geological youth and complexity assured topographic variations sudden and pronounced enough almost to obscure generalized patterns of natural community formation. Along the Pacific slope, scientists discovered, the direction of a slope's face (also termed its aspect) can shape its natural community as forcefully as elevation or latitude. (Giant sequoias, for example, grow only along the middle elevations of the western Sierra; but groves at the northern end of the mountain range favor south-facing slopes, while those at the southern end hug northerly aspects.)[9]

For most of the late nineteenth century, California's earth and life scientists were nominally occupied with exploration and inventory: mapping topographic and geological features, locating and identifying plants and animals. As that work progressed, however, it influenced their thinking on a number of the larger theoretical issues of the time. Gradually, their Far Western fieldwork prodded the region's scientists in similar directions; their response to Darwinism is a case in point.

American scientists generally were reluctant to accept Darwin's theory of evolution, and they continued to debate (or ignore) it for decades after the publication of *On the Origin of Species* in 1859. Scientists who came to California held to a range of evolutionary thought typical of their colleagues in the East, many of whom had been deeply influenced by America's most illustrious anti-Darwinist, Louis Agassiz. Joseph Le Conte, Clarence King, and David Starr Jordan were among the California scientists who had worked directly under him. Others, like Stanford botanist William Dudley, attended Agassiz's summer institute on Penikese Island shortly after his death. Many of the rest had studied under disciples of Agassiz, as John Muir had with Ezra Carr.

Agassiz's study of glaciation in the Alps gave rise to his theory

that a great ice age had once invaded the temperate zone of the Northern Hemisphere. In California, scientists found evidence of Sierra glaciation that corroborated his theory. They found little, however, to support Agassiz's rejection of the theory of evolution. Even Joseph Le Conte, closest of all the California scientists to Agassiz, and among the most conservative, reversed his opposition to evolution four years after his arrival in Berkeley. Appropriately, he first announced his new position at a memorial address honoring Agassiz in 1873.[10]

In spite of their isolation, California scientists embraced evolution with surprising alacrity, and they attributed their acceptance to their observations in the Far West. One reason was the geologically young, emergent mountain systems of Cordilleran America. Unlike the East, where erosion and vegetation obscured much of the fossil record, the West presented a comparatively direct paleontological account of the region's biotic prehistory. As the first community of American scientists to live in the midst of such evidence, California scientists were everywhere confronted with remarkable geological revelations: that the ocean had once lapped at the slopes of the Sierra Nevada; that the mountain peaks themselves had risen from the ocean floor; that the Central Valley had been, in various epochs, a savanna teeming with tigers and hippos, the bed of a great inland sea, and the home of countless great reptiles, all doomed to extinction.

California's living organisms reinforced the message their ancestors had imprinted onto the rocks. Particularly in the first edition of the *Origin*, Darwin stressed the importance of geographic isolation for the workings of evolutionary change.[11] On the Galapagos Islands, for example, he found a remarkable concentration of endemics—species that, barring human intervention, appear only inside a single locale or province. If Darwin was right, shouldn't California's natural barriers facilitate a similar profusion of endemic species?

Pacific coast scientists found that such, indeed, was the case. A profusion of plants and animals exhibited speciated differences from their counterparts east of the Sierra. Scientists were astonished by such exotic cone-bearing trees as the giant sequoia, the redwood, and the Monterey cypress, each growing only in certain areas of the Sierra, the Coast Ranges, and the coastline, respectively. Eventually, their fieldwork revealed that California's unsurpassed wealth of conifers included nearly sixty species, of which twenty-seven were en-

demic to the California Floristic Province. (Arizona, by contrast, has only thirty-two conifers, with only a single endemic.)[12]

But if their assessment of the Far West helped to speed California scientists' acceptance of evolution, it tended to strengthen their resistance to the idea of natural selection. Darwin encountered spirited disputation over this aspect of his theory, particularly from American scientists; in subsequent editions of the *Origin*, he revised and softened his position on natural selection repeatedly. It is important to recall, however, that Darwin's conception of evolution was deeply rooted in his observations in the tropical jungles and islands of South America. In such climates, abundant heat and rainfall permit an unusually thick profusion of plant and animal life. This "entangled bank" of life, as Darwin called it, supports an extremely intricate network of predatory relationships among species.

Such a network, which twentieth-century animal ecologists called the food web, is characterized by great numbers of simple organisms providing sustenance for proportionally fewer complex organisms— all linked in overlapping food chains. In the tropics, the food web is far too convoluted to be traced by the unaided eye of the naturalist. But the density of population throughout the web reinforced Darwin's interest in a Malthusian model of increasing numbers of organisms competing for dwindling sources of food.[13] Furthermore, nineteenth-century zoologists were more likely to stress competitive behavior in natural communities, whereas botanists tended to apply an adaptive model. For Darwin and most of his contemporaries, the tropical web's capacity to support greater numbers of large animals seemed to highlight predatory competition.

California, by contrast, offered scientists a biotic realm of more subtle complexity, less conducive to what John Muir called "the dark chilly reasoning that chance and the survival of the fittest accounted for all things." Like the tropics, California defied environmental uniformity in ways that encouraged scientists to view natural communities as dynamic processes rather than static assemblages. In California, however, the food web is stretched more precariously; with smaller populations and limited water sources, competition among predators was less salient a feature than adaptation to environmental conditions.

Scientists in California only gradually discerned the degree to which organisms had developed integrated communities of compati-

ble, adaptive behavior. They knew, for example, that California quail helped to regulate the growth of herbaceous plants on which they fed; they were not aware that during dry seasons, these plants produced a substance that impeded the quail's reproduction, thereby benefiting bird and plant alike. Only by careful observation did they recognize the role of seasonal isolation of species. Evergreens seeking identical climatic and soil conditions can protect their speciated identities by pollinating at different times in the region's lengthy growing season. Different species of cormorants maximize the use of scarce coastal nesting sites either by developing slightly different preferences (one favors shallow indentations in high, sheer-sloped rock; another seeks deep tunnels at lower, less steep areas), or by occupying the same nests at different times of year.[14]

The adaptive behavior that scientists witnessed in California was not unique to that region—simply more apparent. Drawing upon his observations of the birds of California, Joseph Grinnell noted that in any given natural community, no two species had identical feeding and nesting habits. Darwin had written somewhat vaguely of the "place" occupied by organisms and species in relation to each other. Grinnell wished to refine this notion to indicate more precisely the environmental function of various species. He called this function a niche—a term that later evolved into an important part of the vocabulary of ecologists. The concept of the niche emphasized an ecological perspective on organisms, rather than a taxonomic concentration on classification. It also stressed a relatively indirect form of competition: each species struggling to exclude similar species from a particular environment or developing traits that would differentiate it from other species, thereby minimizing competition. Although it did not directly challenge Darwin's theory of natural selection, this approach to competition and adaptation provided scientists with a way of bringing to the foreground Darwin's incipient ecological perspective while modifying or rejecting his application of Malthus.[15]

Pacific scientists also looked to Darwin's predecessors for approaches to evolution that relied less on a "tooth and claw" interpretation of the transmutation of species. Particularly in America, a number of scientists who resisted natural selection looked to the environmental determinism of Lamarck. Working without the benefit of Mendelian genetics, Lamarck argued that organisms can adjust

to their environment and then genetically transmit those acquired characteristics to their progeny. Although Lamarck's understanding of heredity proved to be misguided, his theory pointed toward the ecological dimensions of plant and animal behavior; it also offered a less mechanistic anticipation of evolution. Among scientists working in the Far West, the most prominent neo-Lamarckians were Joseph Le Conte, Clarence King, and William Healey Dall.[16]

But perhaps the most important pre-Darwinian figure in the estimation of California scientists was Alexander von Humboldt. Although he traveled through many of the regions that Darwin saw during the voyage of the *Beagle,* Humboldt possessed an environmental perspective closer to that of California's first scientists than to Darwin's. Humboldt began his global explorations in 1799, when he set out for South America "to find out how nature's forces act upon one another, and in what manner the geographic environment exerts its influence on animals and plants." For the next sixty years he undertook "to find out about the unity of nature."[17]

Humboldt criticized the Linnaean concentration on taxonomy for failing to consider the "external phenomena" of plant life. Neatly labeled specimens of "plants languishing in our hothouses can give but a very faint idea of the majestic vegetation of the tropical zone," he wrote in *Aspects of Nature.* The task of the scientist, he countered, "does not consist in a sterile accumulation of isolated facts." Only by observing "the silent life of vegetation" in its natural habitat could one discern "the hidden activities of forces and powers operating in the sanctuaries of nature."[18]

Asserting that "each region of the earth has a natural physiognomy peculiar to itself," Humboldt stressed the importance of locale. He proposed to trace the geographic distribution of species, correlating regional variations with shifts in climate and topography. Linnaeus had classified plants by counting pistils and stamens; Humboldt looked to environmental characteristics to determine "the chain of connection, by which all natural forces are linked together, and made mutually dependent on each other."[19]

Humboldt cautioned scientists against seeing nature as an extension of "the uniform and saddening spectacle of man at variance with man." Such a vision of conflict falsely attributed human weakness to natural law. "The Knowledge of the laws of nature . . . in-

creases our sense of the calm of nature," he wrote in *Cosmos;* while "the belief in a 'discord of the elements' seems gradually to vanish in proportion as science extends her empire."[20]

Even before heading West, many of California's first scientists had found in Humboldt the apotheosis of the explorer-scientist. Whitney derived inspiration for his own career from "*Humboldt,* the *doyen* of scientific men," whose lectures he attended at the University of Berlin in 1844. Fifteen years later, just prior to his departure for California, Whitney delivered a lecture on "Science, and Humboldt as Its Representative Man." Brewer, too, had studied Humboldt during his scientific apprenticeship in Germany. He bought the English translation of *Aspects of Nature* in 1859. Clarence King knew Humboldt's *Personal Narrative* well enough to cite passages during his first reconnaissance of the Sierra Nevada. John Muir embraced Humboldt's ecological perspective with unsurpassed enthusiasm. Only a severe bout of malaria dissuaded him from retracing Humboldt's South American voyages. His declaration in 1866 that "I wish to be a Humboldt!" was more than an idle fantasy.

The real significance of Humboldt's influence on California scientists, however, resulted from the close correspondence they discovered between his comprehensive outlook and their new environment. Their repeated invocation of his work was not a throwback to a pre-Darwinian era in the natural sciences; rather, it acknowledged their affinity with his response to the diversity, and the interconnectedness, of the natural environment.

In part, the Californians' interest in a Humboldtean overview of nature's geographic and environmental dynamics grew out of their day-to-day work in the field. Among survey scientists, the techniques and conditions of surveying contributed to their way of seeing the new terrain before them. Most early survey work in the region operated under two conflicting mandates: speed and detail. Far from the "reassuring sameness" of the East and Midwest, survey scientists in California required new methods for recording and interpreting vivid contrasts in topography, vegetation, and geological structure. Previous land surveying had been dominated by the "meandering method" favored by the U.S. Army Corps of Engineers. After establishing a base line, surveyors stepped off distances with an odometer—a procedure not unlike surveying the landscape with a gigantic measuring tape. California provided an important setting for the development of

newer survey techniques based on triangulation. Surveyors could con-
nect fixed points by a series of triangles, then apply basic principles of
trigonometry to establish relative positions and distances between
points. Since prominent, clearly visible landmarks were vital to deter-
mining fixed points, triangulation worked best where there were abun-
dant high peaks unobscured by thick vegetation. As William Brewer
noted, California provided "an ideal place to develop this system of
topographic work."[21]

The Coast Survey introduced a form of triangulation into general
use in the United States. Ferdinand Hassler, the Swiss-born survey
director who preceded Bache, adopted triangulation techniques simi-
lar to those employed by French engineers. Beginning in the 1850s,
Davidson and his staff applied this method in California and the
Pacific slope, constructing observatories and signal posts as they
went. At about the same time, Lieutenant William Emory of the
Mexican Boundary Survey executed triangulation more rapidly in
the Southwest by setting fires on mountain peaks.[22]

Whitney decided that the complexity of California's terrain neces-
sitated reliable topographic maps as the basis for any meaningful
geological survey. He consulted the work of the surveyors and geolo-
gists who had preceded him to California, but found their maps too
limited in scope, too imprecise, or lacking in detail for the California
terrain. Although he was impressed by the Coast Survey's maps, he
found their methods too costly and time-consuming. He hired
Charles Hoffmann, a young German topographer, to develop a form
of "rude triangulation in the field" that would permit his staff to map
great variations in elevation and relief features with both speed and
accuracy.[23]

One of the key features of the method developed by Hoffmann,
King, and Gardner was the use of mountain peaks as triangulation
points. Especially in the High Sierra, climbing mountains with a
barometer to establish altitude could be a daunting task. Since the
survey's accuracy rested on plotting the state's most inaccessible
spots, survey scientists found themselves in precisely those areas of
the Pacific slope that were least known by residents and least altered
by human enterprise. And given the complexity of coastline and
mountain landscapes, sketching in the detail between fixed points
required a greater facility at depicting topographic change than any
of the region's early surveyors had previously required.

The net effect of this baptism by surveillance was not simple; California's first scientists did not begin or end their work with identical interpretations or sensibilities. Their published work and extant letters, however, suggest that most of them moved in a similar direction in the course of their fieldwork. Without the benefit of adequate laboratories or modern ecological theory, they groped toward a view of California, and of nature, that took into account the intricate and sweeping environmental forces surrounding them.

One means of determining the importance of fieldwork for California scientists is to compare the impact it had on very different individuals. George Davidson, Josiah Dwight Whitney, Clarence King, and John Muir were four of the names most frequently cited among Californians who spoke of the region's scientists. They differed greatly in background, training and temperament; what they had most in common was close examination of the California terrain. Muir and King (whose published accounts of exploring the Sierra are compared in chapter 4) brought with them contrasting personalities, conflicting cultural preconceptions about mountains and wilderness, and profoundly different interpretive methods and results. Yet their writings reveal shared notions of the scientific and social implications of their Sierra observations. Davidson and Whitney arrived in California with none of Muir's or King's philosopher-poet inclinations. Davidson's shifting perceptions of the California landscape and Whitney's role in establishing Yosemite State Park illustrate how universally scientists in California attributed changes in their thinking to the influence of their new environment.

The Reeducation of George Davidson

George Davidson began his duties in California with little affinity for Humboldtean panoramas. Professional ambition directed his attitudes toward his work far more emphatically than did the internal dynamics of the natural environment. He preferred the freedom of fieldwork to the demands of the office, but his survey experience in the Gulf of Mexico had taught him to adopt the widely shared Victorian view of the natural environment as a test of personal character and strength.

Upon his arrival in California, Davidson found the Coast Survey's task along the Pacific coast well suited for one who perceived his

physical surroundings as a test of stamina. Their assignment was to determine "latitude, longitude and magnetic variation, and also the topographic survey of the vicinity, including the selection of a site for a light house" at dozens of sites between San Diego and Puget Sound—an undertaking that would have required considerable fortitude under ideal conditions. And a few weeks along the coast demonstrated to Davidson that conditions were rarely ideal: "cook ran away—apple of discord tossed among the young fellows—rugged country—hard work—whew!—no rainy days to rest upon—no Christian face for leagues—and provisions getting towards the bottom of everything."[24]

In the Pacific Northwest, severe weather frequently interrupted fieldwork. From Cape Disappointment, near the mouth of the Columbia River, he wrote of "25 days successive foggggggs" in July of 1851. The following December in southern Oregon Territory, Davidson's party spent four days trying to protect their camp and equipment from a gale that "increased almost to a hurricane, and I was forced to keep my wet clothes on till they dried, which not to be envied predicament brought on an old attack of Rheumatism, and you may imagine a specimen of thoroughly disgusted 'hombre' in search of 'honors' on the Western Coast." When the storm had subsided, they found "tents in among branches of trees—provisions—spoiled . . . bedding saturated—books ditto & mud covering every thing." Davidson's rheumatism remained with him for the rest of his life, often curtailing his seasons in the field. For solace he assured himself that adversity strengthens. "By brooding upon imaginary difficulties and probable defeats we lessen our vigor & self reliance." Occasionally, those imaginary difficulties included fear of attack by Indians, as when the surveying party stumbled onto internecine feuds among Northwest tribes: "At [Cape] Flattery we stood on our arms all night once expecting an attack of 250 Nootkas who lay in the kelp about 600 yds from my camp."[25]

Yet as Davidson's familiarity with the Pacific slope, and with California in general, grew, his descriptions of his relation to its terrain gradually lost their adversarial tone. "I doubt if in all your travels you will meet with a climate & scenery equal to the one in which I have passed three years," he wrote to Jane Owen Fauntleroy from San Pedro in April 1853. "Can you imagine an unclouded sky for weeks & weeks in succession, until the eye craves for a cloud, and

rain would be a delight." In such a place, he marveled, "even the shock of an earthquake has its unstable charms."[26]

Earthquakes became a subject of special investigation for Davidson, as did the effects of ocean and air currents on California's climate and vegetation. Both interests reflected the peculiar conditions in the state. They also represented two areas of earth studies pioneered by Humboldt, whose interests Davidson increasingly shared during his fieldwork in California. In contrast to the Atlantic coast, the Pacific shoreline confronted Davidson with the exaggerated features of a diverse, emergent coast. Building in dramatic effect from its smooth southern beaches to the sheer northern sea cliffs, California's coastline seemed designed to illustrate Humboldt's concept of local diversity within overarching unity. Gradually the "feverish excitement" of Davidson's first California letters gave way to a more meditative tone. "Whenever I contemplate the effort that produced [Humboldt's] 'Cosmos,' " he wrote from the deck of a Coast Survey brig in 1855, "and dream of the vast multitude of facts and laws stored away in that calm, prolific brain, I recoil & shrink at my sheer & undisputed ignorance." But he appended his own Humboldtean observation on the purview of the scientist: "one's mind will be absorbed in . . . microscopic investigation; another creates universes [with the telescope]; one will be searching a drop of water for a reputed animalcula, another controls vast oceans." From minute detail to lofty overview, "knowledge is a web of connections & dependent principles evolved from the laws of nature. Like the web of the spider it is beautiful, symmetrical." Davidson had begun to speak from a vantage decidedly absent from his correspondence five years earlier. In California's coastline he caught his first glimpses of ecological interdependence.[27]

Even astronomy, which had launched his interest in science during his high school days, became for Davidson a pursuit intimately bound up with California's regional identity. As the Coast and Geodetic Survey shifted its Pacific domain from exclusively coastal reconnaissance to inland surveys, Davidson became convinced that California's dry climate and high mountains offered some of the best potential observatory sites in the nation. He constructed his own small observatory in San Francisco and periodically opened it to the public to stimulate support for his idea. Eventually his persistence

contributed to the establishment of the Lick Observatory on Mount Hamilton in 1888.[28]

Evidence of Davidson's shifting perception of the California terrain appeared in the routine tasks of his fieldwork. A revealing clue to the survey scientist's attitudes toward the land surveyed is his approach to place-naming. Davidson's first inclination was to populate uncharted regions with familiar names; he named Mount Ellinor, Mount Constance, and The Brothers, all in the Olympic Range, after his fiancée and her siblings. But through the 1850s he acquired a growing fascination for the geographic history of each place. With painstaking care he unearthed original Indian or Spanish names for the physical features he charted. In the 1870s and 1880s, the dizzying speed with which Californians transformed their environment strengthened Davidson's interest in reconstructing the pre–gold rush history of the land, its exploration and settlement. He collected material on the ethnology of Indians of the Pacific slope; published articles on the origin of the name California, the discovery of San Diego, and San Francisco Bay; entered the debate on what Sir Francis Drake's California anchorage site had been in 1579; and urged the planning commission for Golden Gate Park to erect monuments to each of the early Spanish explorers of California.[29]

During Davidson's first years in California, there were few colleagues and almost no sources of information to assist him. But by the 1860s enough scientists had seen California and enough data had drifted eastward to summon geologists, botanists, and surveyors specifically attracted to the Far West. As the California Geological Survey's mountain expeditions demonstrated, in the Civil War decade a community of scientists had begun to form in California.

Science, Scenery, and Politics: Yosemite State Park

In July 1863, Josiah Dwight Whitney returned to San Francisco from his first reconnaissance of the High Sierra and immediately wrote to his good friend and fellow geologist George Brush of Yale. "The view from Mt. Dana is (we reckon) the finest mountain view in the United States," he told Brush. "Language can't do justice to its grandeur. Literally, hundreds of peaks, snow-covered, are around you, in every variety of fantastic form and outline." His was clearly the enthusiasm

of a geologist: "we are in the midst of what was once a great *glacier region*, the valleys all about being most superbly polished and grooved by glaciers, which once existed here on a stupendous scale." But Whitney also tried to convey the powerful visual effect of the surrounding mountains: "The beauty of the polish on the rocks, covering hundreds of square miles of surface, is something which must be seen to be appreciated. So come and see it, and bring all your brothers (in science)."[30]

Today, Mount Dana overlooks one of the world's most celebrated scenic crossroads. Poised between Yosemite Valley and Mono Lake, it has greeted millions of tourists driving through Yosemite Park from the Tioga Road entrance. But in 1863, Mount Dana showed an exotic and unfamiliar landscape to its rare visitor. For Whitney and his survey team, the view from Mount Dana was laden with meanings both scientific and cultural—meanings that, like snow, could dramatize the profile of the mountains while obscuring detail.

Whitney named this peak after James Dwight Dana, the Yale geologist whose reports on the Wilkes Expedition had sparked his interest in California. Mountain-naming carried considerable significance for the state geologist and his staff. "We claim . . . a full and ample right," he wrote in his *Yosemite Guide-Book*, "as the first explorers, describers and mappers of the High Sierra," to name undesignated peaks for "the most eminent explorers, geographers and geologists," particularly those who "have worked or lived in the region." Naming such an inspiring peak for Dana was partly a way of impressing upon Californians the importance of scientific exploration, "however much our disinclination to bestow on prominent points the names of great politicians and editors may be criticized in California."[31]

Choosing Dana's name also reflected Whitney's interest in demonstrating to scientists the importance of California. If his brothers in science would follow Dana's (and Whitney's) example, they would find much in California's mountains to reward them. The wealth and variety of data surrounding him far surpassed anything he had seen during his previous survey work in New Hampshire and Michigan. The region was geologically and environmentally unique, Whitney told the California legislature; an observer "with an eastern text-book in his hand" would be at a loss to comprehend the region without a thorough study of "the age, position, and char-

acter of the rocks under our feet, the relation of the animal and vegetable remains they contain."[32]

But Whitney's letter to Brush also suggested a close relation between the Sierra Nevada's geological significance and the region's "beauty" and "grandeur." In addition to conducting a rigorous survey, the chief geologist and his staff became publicists for the scenic attractions of the High Sierra. As advocates of state park status for Yosemite, as Yosemite Commissioners, and in their survey reports, the state geological surveyors urged Californians to see their mountains in a new light.

In June 1864, President Lincoln signed a bill granting Yosemite Valley and the Mariposa Big Trees to California as a state park "for public use, resort and recreation," a condition that was to remain "inalienable for all times." Landscape architect Frederick Law Olmsted is generally assigned the major credit for initiating this unprecedented recreational preservation of federal lands. The contributions of Whitney and his subordinates, however, may have been equally important.[33]

Olmsted came to the Sierra foothills in the fall of 1863 to oversee the Mariposa Estate of John C. Frémont, and remained for two years. As a result, he was in the Yosemite environs while the state geologists were surveying the area. Olmsted's first impressions of Yosemite Valley were not altogether positive. In an unusually dry season, the waterfalls had been reduced to trickles, and the meadows were parched. Then too, Olmsted initially viewed Yosemite with the selective vision of a landscape architect. He marveled at the graceful configuration of meadows, river and trees on the Valley floor, but he felt less sure of the three-thousand-foot walls of granite surrounding it.[34]

Like Olmsted, Whitney and his surveyors played a major role in publicizing the unique qualities of the Valley; were the geologists and the landscape architect also instrumental in broadening each other's vision of Yosemite? Whitney's wife and child spent the 1863 season in a hotel near the Mariposa Estate, where Whitney frequently visited at about the time of Olmsted's arrival. The following summer, Olmsted toured the Valley with survey member William Ashburner and ventured into the high country surrounding the Valley with William Brewer. The details of those excursions, and the genesis of Olmsted's friendship with Clarence King and James Gardner, went

unrecorded. But by 1865, Olmsted had come closer to a geologist's perspective on the Valley's rock walls; together with the Valley floor, he wrote, they created a perfect "union of the deepest sublimity and . . . the deepest beauty of nature." The scientists apparently influenced the landscape architect's inclusion of "the value of the district in its present condition as a museum of natural science" among his reasons for seeking strict preservation of the Valley.[35]

Israel Ward Raymond, the California representative of a New York steamship line, was the apparent organizer of a delegation of Californians who asked Senator John Conness to introduce a Yosemite bill in Congress. No clear record remains of all of the participants in that effort, but Whitney's and Olmsted's names were equally prominent in the list of commissioners that Raymond proposed to Conness. After the bill's passage Olmsted, Whitney, and Ashburner were among the eight appointees to the state board of Yosemite Commissioners, with Olmsted's name at the head of the list. But by 1865 a financial crisis had overtaken the Mariposa Estate, and when New York City offered Olmsted a commission to design Central Park, he returned East. In his absence Whitney was elected director, wrote the first commissioners' report, and remained on the commission until he left California. Ashburner served as secretary and author of subsequent commissioners' reports until 1879.[36]

The scientists' promotion of Yosemite's scenic value was more apparent after the park bill had passed. In the commissioners' first report to the legislature, Whitney outlined his plan to write a guidebook as well as a "Yosemite Gift Book" with photographs by Carleton Watkins, in hopes of "drawing attention to the stupendous scenery of the Yosemite and its vicinity." In order to secure accurate maps for the commissioners (and the guidebook), Clarence King and James Gardner measured the boundaries of the new park, while Whitney and Charles Hoffmann surveyed the Mariposa Big Trees.[37]

Whitney also devoted a portion of his *Yosemite Guide-Book* to defending the concept of park preservation against the state legislature's attempt to honor claims of private ownership in the Valley. What individuals can own, Whitney warned, they will market for profit; "and the Yosemite Valley, instead of being 'a joy forever,' will become, like Niagara Falls, a gigantic institution for fleecing the public." The Valley, he argued, "is a unique and wonderful locality; it is

an exceptional creation, and as such has been exceptionally provided for jointly by the Nation and the State." To withdraw parklands from public guardianship would be to "repudiate a noble task which [Californians] undertook to perform—that of holding the Yosemite Valley as a place of public use, resort, and recreation, inalienable for all time!"[38]

This concept of land use was new to Americans and required an educated public for its support. By the 1860s wealthy, urban Americans had learned to emulate the Europeans' growing enthusiasm for alpine tours; but they did so, Whitney lamented, in European mountains. "There are probably ten times as many persons in California who have traveled for pleasure in Switzerland," he observed in 1868, "as among these most interesting portions of the Sierra." Whitney was determined to remedy the situation. Throughout the *Guide-Book* he blended scenery and science, praising the Valley's most distinct geological attributes—for example the "verticality of its walls . . . their great height . . . [and] the very small amount of debris, or talus, at the bottom of these gigantic cliffs"—as "features both of sublimity and of beauty which can hardly be surpassed, if equalled, by those of any mountain scenery in the world."[39]

More extensively trained and experienced than his staff, and pricklier in temperament, Whitney was an unlikely candidate for promoting mountain tourism. He had already demonstrated to legislators and mine speculators his reluctance to link his scientific expertise with the promotion of other, more lucrative mountain interests. Being widely traveled (he and Brewer had seen the Alps, while most of the others had not), he was less likely to be caught up in the sheer novelty of alpine scenery. Nor did he share his younger colleagues' enthusiasm for the joys of roughing it; even in the depths of the Sierra, the fastidious Whitney preferred never to use the same towel twice.[40] Why, then, did the state geologist devote so much attention to a role neither strictly geological nor necessarily politic?

Whitney no doubt recognized that by interesting the general public in the aesthetic appreciation of mountains, he could increase their interest in geology (and geological surveys) as well. Both modes of perception required the viewer to see mountains as more than obstacles to travel or sources of wealth. But Whitney's interest in scenic preservation, which was not evident before he came to Califor-

nia, extended well beyond his role as geologist. In fact, the park he helped to create and maintain at Yosemite had to compete with his own beleaguered survey for funding.[41]

Whitney's contribution to the development of Yosemite Valley might best be explained as part of a larger effort to express a connection between geological and aesthetic responses to the High Sierra. Clarence King and John Muir achieved fame for celebrating that connection. In their different ways, all three sought to express a kind of geological sublime, fashioned from a mixture of cultural and scientific approaches to the California landscape. Scientific inquiry has always been powerfully influenced by (and has, in turn, influenced) cultural assumptions. In the late nineteenth century, geologists made increasingly visible contributions to a gradual shift in cultural attitudes toward mountains, wilderness, and the human uses of nature. Exploring the mountains of California in the 1860s, King and Muir felt compelled to look beyond the descriptive norms of geological surveying to express the environmental characteristics they perceived in the High Sierra. Lacking key conceptual tools and methods available to scientists of later generations (plate tectonics, plant succession, numerical quantification in ecology, paleobotany, and geomorphology), they sought other cultural idioms to convey a sense of underlying patterns in a landscape that appeared, if at all, only as an untamed curiosity in the parlor-books of Victorian America.

4

An Elevated Lookout: Science, Gender, and the Geological Sublime

"I believe that fellow had rather sit on a peak all day, and stare at those snow-mountains, than find a fossil in the metamorphic Sierra," paleontologist William More Gabb observed of Clarence King in the winter of 1863. At age twenty-four, Gabb was a veteran of two seasons with the California Geological Survey. King was not yet twenty-two, and a recent arrival. Whitney's staff considered Gabb to be extremely competent but a rather stiff and reclusive camp companion—"grassy green, but decidedly smart," as William Brewer described him. (The survey members resolved to name a fossilized species *gabbi* to honor the young scientist's work while gently mocking his lack of conviviality.) King possessed great exuberance and irrepressible wit, but he had not made his name as a geologist.[1]

King remembered his colleague's remark ("Satirize Gabb," he noted in a private journal), and included it nearly a decade later in *Mountaineering in the Sierra Nevada*, the serialized book he wrote about his adventures as a survey scientist. There he portrayed Gabb's observation as a catalyst for King's first "discovery of some scientific value": the fossil with which he determined the geological age of the Sierra's gold-bearing strata. With tongue in cheek, King depicted the episode in the language of a religious parable: "Can it be? I asked myself; has a student of geology so far forgotten his devotion to science? Am I really fallen to the level of a mere nature-lover?" Determined to mend his ways, "I re-dedicated myself to geology,"

only to be led astray by a dazzling sunset ("a mosaic of amethyst and opal transfigured with passionate light, as gloriously above words as beyond art"). Once again "obsolete shell-fishes in the metamorphic were promptly forgotten." Only while working in a canyon "whose profound uninterestingness is quite beyond portrayal" could he concentrate on his higher purpose. Chipping at slate outcroppings with his hammer, King spotted a small, fossilized mollusk: "the age of the gold-belt was discovered!" He imagined how, years later, the "spectacled wise men of some scientific society" might eulogize him: "In summing up the character and labors of this fallen follower of science, let it never be forgotten that he discovered the cephalopoda."[2]

King's discovery was important politically as well as geologically. Determining "the age of the gold-belt" meant that geologists could more accurately locate veins of gold deposits; and science in the service of gold was just what the legislature hoped to see. But King used the anecdote as an opportunity to aim his wit at Gabb's severity, the pretensions of scientists, his own uncertainties about a scientific career, and his enthusiasm for mountain scenery. The contrast between the "spectacled wise men" and the "mere nature-lover" was very real for King, who aspired to both roles and was comfortable with neither. John Muir shared King's dilemma but resolved it very differently.

In 1871, Clarence King and John Muir each published an article in the Eastern press concerning glaciers in California. In March, King wrote of Mount Shasta, where he had made the first discovery of an active glacier in the United States. In December, Muir described the remnant of an active glacier that he had discovered in Yosemite Valley. King and Muir both went on to achieve international acclaim as writers, lifting the mountains of California into new prominence on the American landscape.[3]

The two men were strikingly dissimilar in temperament. Dapper, cosmopolitan, and hailed as a brilliant conversationalist while still in his twenties, King inspired Henry Adams to observe that "we would, at any time and always, have left the most agreeable man in Europe or America to go with him." He was equally at home in the salons of Paris, joining Washington's scientific elite at the Cosmos Club, or seated alongside a California stagecoach driver. Muir, by contrast, had always been painfully shy with all but his closest friends. "You will require no photograph to know me," he wrote to a childhood friend in

1872. "The most sun-tanned and round-shouldered and bashful man in the crowd—if you catch me in a crowd—that's me." He never owned a suit until his wedding at age forty-two, and San Francisco was the first city he had seen larger than Madison, Wisconsin.[4]

Of greater importance, however, were the traits the two men shared. Both developed unsurpassed familiarity with California's high terrain and considered it a formative influence on their thinking. Both of them approached the geology of the High Sierra in their search for a career. And both tried to reconcile their scientific and aesthetic responses to the mountains of California by articulating a variety of the geological sublime. King sought to legitimate his role as "mere nature-lover" by cloaking it in prevailing cultural and scientific assumptions about nature and gender; Muir mounted a lifelong polemic against some of those same assumptions, dramatizing (if not proving) key ecological insights in the process. Their differences in outlook led them to develop conflicting explanations for the origins of the Yosemite Valley.

Examined together, King's and Muir's Sierra accounts remind us that science is a social construct, profoundly influenced by the broad concerns and assumptions of its practitioners. Their perceptions of the mountains of California were informed not only by geologists, but by the literature of the sublime and its place in their culture's designation of certain traits as masculine and feminine. Gender— perhaps the most pervasive of all social constructs—provided a familiar frame of reference through which scientists (like anyone else who shared the culture's idioms) could make arbitrary distinctions, sanction or challenge hierarchies of significance, and otherwise situate themselves in relation to nature and society. In very different ways, King's and Muir's depictions of the California terrain were widely read chapters in the ongoing "genderization" of science in Victorian America.[5]

Ways of Seeing Mountains

The idea of the sublime had already accumulated a lengthy and complex history when King and Muir explored the Sierra Nevada. For Victorian America, much of that history was British in origin and dealt with Western civilization's slowly diminishing fear of mountains. In his *Sacred Theory of the Earth* (1681), Rev. Thomas Burnet

attempted to explain the irregular terrain of mountains by proposing that before the Deluge, the earth had been a perfect sphere; mountains were evidence of "a World lying in its Rubbish." In 1757, Edmund Burke's definitive study of the sublime attempted to reconcile neoclassical theories of beauty (as symmetry and repose) with the growing interest in mountains (as emblem of asymmetry and violent action) among aesthetic theorists. The "ruling principle of the sublime," Burke determined, was "terror," or "astonishment." While mountains could never be considered beautiful or picturesque, they could inspire awe in the observer.[6]

At the turn of the nineteenth century, the Romantics' notions of sublimity reflected the shifting attitudes toward nature that occurred during the formative years of industrialization. As the factory system inaugurated a new reshaping of the English and German countryside, writers in those countries took an increased interest in mountains and wilderness as landscapes unaltered by human endeavor. At a time of perceived social routinization, they elaborated upon Burke's notion that the aesthetic effect of nature is centered in the observer; landscape had become a measure of individual feeling.[7]

By the 1850s, the growing appeal of the Alps fostered new variations in Victorian attitudes toward mountains. A century after Burke, John Ruskin argued that the sublime could be beautiful after all and that mountains might be less a source of terror than a means of spiritual elevation. Ruskin had been sufficiently influenced by the emerging science of geology to argue that an understanding of "the organization of the earth" was essential to landscape painting. But for Ruskin, confronting the lessons of the mountains meant a loss of traditional faith. "If only the Geologists would let me alone, I could do very well," he wrote to a friend in 1851, "but those dreadful Hammers! I hear the clink of them at the end of every cadence of the Bible verses."[8]

At the same time, John Tyndall's accounts of his excursions in the Alps signaled the arrival of recreational mountaineers: climbers (including scientists like Tyndall) who were drawn to the high country by the challenge of the ascent. For the mountaineer, sublimity was achieved not simply through perception but by perceptive action: comprehending the obstacles of a mountain terrain and overcoming them.[9]

The frontier experience greatly complicated American writers'

treatment of the sublime. Facing a broad expanse of undomesticated land, few Americans viewed mountains and wilderness as anything more than impediments to progress. By the mid-nineteenth century, much American nature writing had fallen into a stylized, formulaic sentimentality. But by the 1870s, a new generation of scientists, notably geologists, had begun to publish in the magazines and books that graced Victorian America's parlors. The geologists described their work in terms that revealed strong links between the scientific and the aesthetic appeal of mountains. As Ruskin had foreseen, geology itself was providing a new aesthetic perspective, and perhaps a new kind of faith.[10]

The arrival of geologists in California in the 1860s marked the beginning of the most significant effort by American scientists to articulate the geological sublime. Not many of their readers were prepared for the message. At the time of Whitney's Sierra reconnaissance, few Americans had directly experienced the alpine environment of mountains above timberline. In the United States, the high terrain was very much a Western phenomenon: the two great mountain systems flanking cordilleran America, the Rockies and the Sierra-Cascades, rise nearly three miles above sea level, dwarfing the green and rolling Appalachians. The highest peaks extend up to a mile above timberline, where no vegetation or soil obscures the rock and ice. Scientific exploration would have been richly rewarded in any part of these mountains, as well as in the basin-and-range country that extends between them like a vast geological hammock. But in the wake of the gold rush, the mountains of California became the first in the West to receive sustained, detailed scientific attention.

Mapping was the activity around which scientists organized most of their initial study of montane America. And as explorer-scientists learned, mapping is a political act. The cartographer exerts great powers of definition over the land surveyed; in the American West, the name, ownership, and social uses of any given place might be determined by the mapmaker.[11]

In the decades between Lewis and Clark's expedition and those of Frémont, the U.S. government viewed the great mountain ranges of the West primarily as territorial markers in the appropriation of the continent. (Even after 1850, fears of a separate California Republic persisted in Washington.) But mapping had emblematic as well as strategic functions. Frémont risked the safety of his 1842 pathfinding

expedition in the Rockies to climb the highest peak he could find in the Wind River range and plant a flag depicting the American bald eagle. Scaling the mountain, charting the terrain: in the symbolic conquest of the West, nature itself seemed contained in the nets of longitude and latitude cast by the pathfinder.[12]

Overland migrants saw the land through different eyes. For those who followed the Overland Trail, the mountains were formidable obstacles; their lives might depend on the accuracy of their maps. The discovery of gold in the Sierra foothills ushered in a more extractive vision of the landscape; no longer boundaries or barriers, mountains became storehouses to be inventoried. The state's geological surveyors of the 1860s worked in a perpetual state of parallax; everywhere they looked, competing visions of the mountains cluttered their gaze.

The geologists' view of nature was further complicated by society's view of geologists. At best, they occupied an ambiguous position in California's social landscape. Throughout Victorian America, the social role of scientists drew upon centuries of Euro-American cultural assumptions linking science with prevailing myths of masculinity (objectivity, autonomy, control over nature). This genderization of science contributed powerfully to a sexual division of scientific labor that discouraged or barred women from careers in science, but it was much more than a form of sexual discrimination. It accompanied the process by which industrializing societies established social roles for science and nature in the service of industry; it also reinforced an anthropocentric view that emphasized the domination and commodification of nature.[13]

As social constructs, science and gender described arenas of farreaching social change in a culture that considered both to be unchanging categories of truth. For middle-class Victorian Americans, changes in the home (as revealed by the emerging cult of domesticity) and in the workplace (restructured by professionalization and industrialization) created a newly urgent need to maintain stable, if arbitrary, categories of social behavior. And prevailing notions of science and gender proved to be mutually reinforcing. Just as the rhetoric of scientific objectivity lent weight to cultural assumptions about inherent male and female capacities, so gender provided a way to describe hierarchies of science and society.[14]

Genderization has affected scientific disciplines with varying in-

tensity, at different times. Thus the "hard" sciences—mathematics, astronomy, physics—evolved a more masculine social profile than the "soft" life sciences. And as scientists professionalized, the distinctions became finer; in place of antebellum naturalists, zoologists emerged with a more masculine identity than botanists.[15] In nineteenth-century America, the wealth of unexplored natural resources assured prominence for the natural sciences. But where did the relatively new geological sciences fit in this social typology?

Within the sciences, geological surveying was a decidedly masculine realm, far less likely than botany to include women, even as amateur collectors. But relative to American society, did geologists embody qualities deemed by their culture to be significant (and therefore masculine)? Compared with mine operators or timber magnates or ranchers, the West's first generation of career geologists appeared to be marginal to commerce and social growth. Clarence King and John Muir, after all, had come to the mountains of California without pay—not for gold or timber, but to pursue scientific and aesthetic interests. And in Victorian America, to be marginalized by the marketplace was to be feminized.[16]

King and Muir attempted to limit their peripheral relation to California by distinguishing themselves from mountain tourists. The only other group of people who ventured into the Sierra Nevada for noncommercial reasons, tourists (particularly ministers, novelists, poets for women's magazines, and newspaper editors) were the arbiters of Victorian sentimentalism, reducing the scenic grandeur of the mountains to sanctimonious platitudes. King lamented that hordes of such visitors would someday be "honorably dragged up and down our Sierras, with perrenial yellow gaiter, and ostentation of bathtub." At Yosemite Valley in 1864, he bypassed Inspiration Point to avoid "that army of literary travellers" who "down to the last and most sentimental specimen" felt compelled to "dismount and inflate." Even Muir, who urged city-dwellers to see Yosemite, complained of the infusion of indoor shoes and hatboxes that accompanied "*the world* and his ribbony wife," and deplored the young daughters of the Eastern urban elite who described the Valley with "cheap adjectives" like pretty and charming.[17]

What inspired these distancing tactics was most likely the young geologists' uncomfortable awareness of how closely they might appear to resemble the tourists they denounced. Hoping to avoid the

debasing effect of the "literary travellers," King and Muir were forced to generate alternative vocabularies for describing the scenic attributes of the High Sierra. Their efforts to combine scientific and aesthetic modes of description represented a rudimentary expression of a nascent ecological perspective among natural scientists. Although their approaches greatly differed, they struggled to articulate the geological sublime in an effort to arrive at a new way of seeing nature.

Humboldt's Six-Shooter: Clarence King

In the generation of Americans who came into prominence just after the Civil War, few were more enigmatic than Clarence King. In 1867, after four seasons in the field with the California Geological Survey, the twenty-five-year-old King proposed a congressionally sponsored Fortieth Parallel Survey and was selected over a host of older and more prominent candidates to lead it. While still in his thirties, he became the first director of the U.S. Geological Survey, which elevated him to the highest reaches of influence among government scientists in Washington. Yet two years later, in 1881, he resigned his position, primarily to seek an elusive fortune in the gold mines of Mexico. Plagued by ill health and financial setbacks, and determined to protect his secret marriage in 1888 to Ada Todd, a black woman, he spent the remaining twenty years of his life far from the public spotlight.[18]

King was born in Newport, Rhode Island, in 1842. His father, a merchant in the China trade, died in the Orient six years later. An only child, "Clare" received devoted tutelage from his mother, who encouraged his interests in science and the arts and moved to Connecticut primarily to give him access to better schools. King's early interest in botany and geology provided a focus for his extraordinary visual acuity. His childhood friend James Gardner recalled that, during their weekly backwoods excursions, King "seemed to photograph unconsciously everything that passed before his eyes, and to be able to recall the picture at will."[19]

In 1857, the first of several family financial reversals occurred when King's late father's trading company declared bankruptcy. King began clerking for a commercial house with the idea of pursuing a business career like his father's. But his interest in science and the arts still vied for his attention, creating a career uncertainty that

would remain unresolved for twenty-five years. In 1859 he left his job to enter Yale's Sheffield Scientific School, where three years of training, supplemented by a winter of study under Louis Agassiz at Harvard, provided solid credentials but little field experience.

California had become a scientific sensation during King's years in New Haven. His language professor, William Dwight Whitney, reported the adventures of his brother Josiah's new geological survey. Yale geologist James Dwight Dana supplemented Whitney's accounts with his own recollections of the Wilkes Expedition's forays along the Pacific slope. But it was through another professor, George Brush, that King began a decade's preoccupation with the mountains of California. In September 1862, the California Geological Survey Team climbed Mount Shasta—the "grand goal" of their season in the field and the survey's first reconnaissance above fourteen thousand feet. William Brewer wrote of the ascent to his classmate George Brush, and Brush showed the letter to King. A year later, in California, King told Brewer that his description of Mount Shasta "was the magnet that had drawn him irresistibly to the Pacific coast."[20]

What had Brewer written to cause King to cross the West on horseback and volunteer as an assistant field geologist, without pay, to help chart some of the most rugged terrain yet surveyed anywhere in the country? As Brewer recalled, he had sketched "an enthusiastic account of our adventure, emphasizing not only the scientific interest, but also the sublime and majestic scenery connected with it." It was the combination of these three ways of looking at mountains— for their "scientific interest," for the "sublime and majestic scenery," and as a source of "adventure"—that proved so irresistible to King.[21]

Mount Shasta's points of scientific interest were well distributed. Since the mountain itself is an extinct volcano, its slopes presented an excellent setting for the study of volcanic rocks. At the summit, the survey team took barometric readings that provided the first accurate scientific measurement of a major peak anywhere in the country. But Brewer devoted the bulk of his letter to the aesthetic impact of the mountain's physical presence. More than a reconnaissance, the ascent of Mount Shasta was a pursuit of the geological sublime.

Even after three field seasons in California, Whitney's corps had not encountered any natural feature that dominated its surroundings so dramatically as Shasta. Unlike the equally high peaks of the High Sierra to the south, Mount Shasta stands in relative isolation, rising

fully eleven thousand feet from its western valley floor with no inter-
vening high ground to limit visibility. In his letter to Brush, Brewer
took periodic readings of the mountain's visual impact as they ap-
proached from the south. He and Whitney first spotted Shasta's crest
150 miles away. At a distance of 20 miles, he wrote, "its upper 6,000
feet are streaked with glistening snow, its outlines sharply cut
against the intensely blue sky, its sides steep beyond anything I have
ever seen elsewhere." Having reached its base, he recorded, "how
long and earnestly we gazed on the mountain! Nothing else could be
talked about. At sunset it was tinged with a lovely alpenglow; and
then twilight deepened, and then the moon rose, and we sat around
our cheerful campfire (for it was cold) and gazed still. And I got up
from my blankets late in the night, when the moon's illumination
was finer, to look at it by that light." From four thousand feet higher,
"the grand old peak stands out against the clear night sky, and I
watch it from my pillow (if a *saddle* can be called a *pillow*)." Leaving
their mules behind to climb the final stretch on foot, Brewer and his
companions found great ridges of lava "wreathed in curious forms"
and "weathered into fantastic shapes—walls, battlements, pinnacles
shooting up hundreds of feet." From the crest they looked out upon a
"wilderness of mountains stretching up to the Pacific, chain beyond
chain."[22]

To twenty-year-old Clarence King, the work and the surroundings
that Brewer described suggested a solution to his hesitation between
a commercial career like his father's and the scientific and aesthetic
interests his mother had encouraged in him. But in the 1860s, sci-
ence and the arts offered limited opportunities for prestige or excite-
ment. Before he could cast his lot with the scientists, King needed a
way to solidify his image of science as a "manly" pursuit and a
worthy career. The rugged terrain, physical hardships, and adven-
ture that Brewer described provided that setting. In California, King
could invent an outsized role that might propel him beyond his
career doubts while still allowing him to pursue the mountain sub-
limity he detected in Brewer's letter.

King's journey to California in the summer of 1863 offered him
ample opportunity to outfit his image of the survey scientist with the
trappings of the pioneer West. With his friend James Gardner, he
took the train to its Western terminus at St. Joseph, Missouri, then set
out on horseback with a party of overland emigrants. A few years

later, a more Westernized King would lament to his Eastern readers that tourists were "shooting our buffaloes" as part of a stylized ritual "known as 'doing America.' " But crossing Nebraska that first summer, King himself insisted on hunting a buffalo and barely escaped being trampled to death by the ensuing stampede.[23]

In Virginia City he and Gardner lost all of their possessions in a fire, worked in the Comstock Lode mines to recoup their losses, and headed across the Sierra into Sacramento wearing borrowed miners' work clothes. On board the steamer from Sacramento to San Francisco, Gardner noticed a fellow passenger dressed in "a coarse grey flannel shirt and a rough coat" with an "old felt hat, a quick eye, a sunburned face with different lines from the other mountaineers." As if seeing through a disguise, King identified the mountaineer as Brewer and explained, "I had a letter of introduction to you, but it was burned up the other day." By the end of the conversation, King's career as a California scientist was underway.[24]

His flair for striking poses in his new Western surroundings remained with him in California. Shortly after King joined the survey in 1863, Whitney assembled several of the members of his staff to pose for a formal photograph. Whitney stood in grand severity at the center, while a half-dozen of his surveyor-scientists stiffly displayed their dark suits, tightly buttoned waistcoats, and starched shirts with varying degrees of discomfort. After a year in the field, King returned to the same studio, accompanied only by his closest friends on the survey team: James Gardner, William Brewer, and Richard Cotter. This time, they were dressed for fieldwork: flannel shirts, baggy Western pants, high boots, felt hats, and field gear draped about them. King sported a neck scarf, a barometer strapped to his back, and a geologist's hammer in his hand. Only the presence of barometers and a sextant distinguished them from the countless gold seekers who had posed in their miner's regalia for the folks back home.

For King, both portraits were half disguises, illustrating the incongruities separating the surveyors' social role from their work in the field. Examined alongside his progress in his new career, the poses he struck followed a consistent pattern. In the formal photograph, King wore an overcoat buttoned at the neck—perhaps to hide deficiencies in his wardrobe caused by the Virginia City fire. Just arrived in California as a volunteer surveyor, he had not yet assumed the role of the learned gentleman-scientist suggested by the portrait. A year

later, he was a seasoned veteran of the backcountry and of San Francisco society. By that time his field clothes, not his formal attire, struck the stronger (and thus more savored) chord of dissonance for him in the city. A few years later, when King was spending much lengthier stretches of time in the field, he took to dressing for formal dinner in the mountains. A mining engineer whom King had invited to dine with him at his camp was astonished to find his host resplendent "in immaculate linen, silk stockings, low shoes, and clothing without a wrinkle." Mountain man in the city, refined gentleman in the wilderness: by dressing for the role that most contrasted with his immediate surroundings, King could sustain both extremes of his new profession (scientific sage, swaggering mountaineer) without fully becoming either one. Any doubts he harbored over his career were temporarily lost in the theatricality of the moment.[25]

After a season in the field, King had become a master at lending a frontier aura to his scientific duties. In a grove of giant sequoias in June 1864, the surveyors puzzled over the best way of obtaining a specimen of the Big Trees' high-branch foliage. Their solution—"we shot down a branch"—reminded King of Humboldt's complaint "of being for years in the tropics without being able to examine the flowers of the palm which hung sixty feet overhead because he could hire no native to climb for him." "The great Humboldt," King concluded, "would have been better off with a six-shooter."[26]

Humboldt with a six-shooter: King could not have expressed more succinctly the divergent views of nature he sought to resolve. While he was in the mountains, he filled his private journals with descriptions and sketches of his surroundings, blending scientific with aesthetic details and adding occasional meditations on the inner harmony of nature. But in *Mountaineering in the Sierra Nevada* he adopted cultural models that depicted the mountains as his adversaries. By shifting between receptive and aggressive narrative voices, King sought a role that would allow him to combine a Humboldtean vision of interdependence with the self-assurance of a Western sharpshooter. In the process, he characterized these opposing modes with traits that his audience would identify as feminine and masculine.[27]

Like other earth and life scientists of his generation, King was influenced by a broad range of writers who helped to define the geological sublime. Brewer recalled that when King first arrived in California, he was "saturated chiefly with Ruskin and Tyndall."

King's ascent of Lassen Peak, his first expedition with the state survey, demonstrated Brewer's point. From the summit, King had his first full glimpse of Mount Shasta, which Brewer had described in the letter that inspired him to come to California. Standing next to Brewer, gazing at Mount Shasta, King exclaimed, "What would Ruskin have said if he had seen this!" Descending the same peak a few days later, King persuaded Brewer to slide down the icy slopes, hundreds of feet at a stretch, by quoting "Tyndall's praises of swift glissades."[28] This schematic pattern—Tyndall on the slopes, Ruskin at the summit—neatly characterized the influence of these writers on King's mountain perceptions.

Tyndall's published accounts of his excursions into the Alps in the 1850s and 1860s impressed King not only as superb glaciological studies, but as examples of an emerging European genre of mountaineering narratives. As Tyndall described it, the mountaineer's stance toward the terrain was a combative one. The mountain tested the climber's agility, stamina, and acuity; reaching the summit marked a victory over the elements. Although Tyndall did much to define mountaineering as sport, he claimed no connections between his mode of ascent and his scientific interests or methods. "I have not attempted to mix Narrative and Science," he wrote in the preface to *The Glaciers of the Alps* in 1860, "believing that the mind once interested in the one, cannot with satisfaction pass abruptly to the other." The first half of the book recounted Tyndall's exploits as a climber, while the second half detailed the scientific implications of his findings.[29]

Ruskin brought the concerns of the modern art critic and aesthetic theorist to the mountains. Like Tyndall, he assumed an essentially anthropocentric stance toward nature. But for Ruskin, it was not the climber's physical agility and stamina that the mountains measured; instead, it was the observer's aesthetic and emotional responsiveness to a landscape that revealed the "truth of earth." In place of the language of the military campaign and the obstacle course, Ruskin applied the metaphor of painter and model. "Ground is to the landscape painter what the naked human body is to the historical," he wrote in *Modern Painters*. Vegetation, water, even clouds provide adornments, like "the folds of the dress and the fall of the hair"; but to understand the earth's sublimity, the artist must study the "bare ground," "divested of vegetation," undisguised by "the clothing of the landscape." Only when "seen in its naked purity" did the earth

reveal "the laws of hill anatomy." But unlike the human body, which reveals the action of muscles and bones through the flesh, "the excited earth casts off the flesh altogether, and its bones come out from beneath. Mountains are the bones of the earth," Ruskin concluded; the viewer contemplates the meaning of human mortality in their realm of exposed rock, "lifeless, like the walls of a sepulchre."[30]

Ruskin's influence on King was pronounced. Before enrolling in the Sheffield School, King belonged to the Society for the Advancement of Truth of Art, a group of American Pre-Raphaelites who proclaimed Ruskin and Turner their heroes. Years later, Ruskin overheard King commenting on a painting in a London gallery and was so impressed that he introduced himself, invited King to his estate, and even offered him a painting by Turner, allowing him to choose between two landscapes. King's reply—"One good Turner deserves another!"—so delighted Ruskin that he gave both paintings to King.[31]

King saw in Ruskin a fusion of aesthetic and geological sensibilities; for in calling for an understanding of the "laws of the organization of the earth" and "knowledge of [its] interior mechanism," Ruskin seemed to call for the skills of the geologist alongside the responsiveness of the artist. But King also retained Ruskin's correlation of earthly beauty with vegetation and sublimity with barren rock. Describing the view from San Gorgonio Pass, above San Bernadino, King characterized the rainshadow effect in a grand, Ruskinian flourish. To the east he saw the desert's "bare hills" as "emaciated corses of once noble ranges now lifeless": "over their stone skeletons scanty earth clings in folds, like shrunken flesh." To the west, however, King saw vistas of pastoral domesticity: "rolling hills covered with a fresh vernal carpet of grass," fields of grain "just tinged with the first ripening yellow," and at the horizon, the "bounding Coast Ranges" wreathed in the "cool shadow" of coastal fog. "Tranquillity, abundance, the slow, beautiful unfolding of plant life, dark shadowed spots to rest our tired eyes upon, the shade of giant oaks to lie down under, while listening to brooks, contralto larks, and the soft distant lowing of cattle."[32]

As different as they seemed, Tyndall's mountaineering stance and Ruskin's aesthetic theories shared an adversarial view of high mountain terrain; by reaching the summit, climbers either conquered the mountain or confronted their own insignificance. In both modes, nature became a hall of mirrors, revealing (or distorting) qualities of the climber. In his Sierra journals, King rarely mentioned the difficulty of

his ascents or the desolation of the peaks. Instead, he recorded moments of alert receptivity to the natural environment: notations on the geological and biological details of the area and descriptions of aesthetic effects (qualities of light, shapes of mountains and clouds, gradations of color in rock and sky). But later, when he rewrote his Sierra notes for *Mountaineering in the Sierra Nevada*, Tyndall and Ruskin served as his narrative costumes for confronting the wilderness: the rough flannel of the intrepid mountaineer, the linen and silk of the Byronic grappler with the sublime. The details and nuances of the journals survived primarily as backdrop; only after brandishing his verbal six-shooters could King be a Humboldt.

In his private journals King described his mountain surroundings from what he called his "tender" perspective. Even among friends, he was careful to qualify that tenderness with strength. At the outbreak of the Civil War, he confided to his friend James Gardner that he had decided not to enlist for fear of how his character would be altered by the act of killing. But he quickly added, "don't think that because I show you my tender side, Jim, my weak side if you will, that I have no fire, no firmness, no mental power. Don't think that I never lead men, for in my way I do."[33]

Sometimes King's journal entries simply described the poetry of commonplace tasks in the high terrain. The state surveyors verified the latitude of their position by astronomical readings with a zenith telescope; among their celestial checkpoints was the measurement of intervals during which the moons of Jupiter were obscured by their planet. But in a July 1866 journal entry, King's twilight astronomical sightings from the summit of Merced Peak became a word-painting: "Jupiter & moons in exquisite violet belt it sails up into blue 8 pm low arch of light." On the western ridges, the bright wash of alpenglow illuminated the pines so clearly that the needles of each twig seemed etched in glass. Stretching below him to the south, dozens of placid lakes and glacial tarns mirrored the first appearances of stars ("Casseopia reflected in lake beneath us then another star in another lake"). To the east, moonrise cast the "topog[raphy] of moon through glassy reflection of moon in lake bisected by pines."[34]

His mountain journals also provided King with an opportunity to speculate on the philosophical implications of the scientist's stance toward nature. In an entry labeled "Nature the key to Art & Science," he described nature as "a veil which He has drawn before us just fine

enough for us to bear the intense light," so that "dignified humility should mark our journeyings into it and when we strain our vision into the mesh mark of the veil to learn its building & its form its color and its texture." By studying the veil and analyzing "the ancient mountain threads that weave into the wondrous finish of colored draperies," the scientist and the artist might discern the "law of perfectness," the "harmonies of structure" therein. "You Clarence King never dare to look or speak of nature," he admonished himself, "save with respect and the admiration you are capable of."[35]

Other entries suggested that King lamented the separation he sensed between scientific and aesthetic responses to nature. "[Scientific] analysis is unsympathetic," he wrote in an 1869 journal, noting the "intense yearning I feel to get through my analytical study of nature" and to "drink in" the "sympathetic" effect of his natural surroundings. He used very similar language in an 1867 entry questioning the immutability of separate male and female social attributes. "Man's is the larger nature, Woman's the most perceptive," he wrote. "Man's [nature is] analytical, hers deductive. Both should be equally logical, critical—equally appreciative and equally creative, equally tender. It is a falsity to suppose woman all tender," he concluded, "and man all strength."[36]

Science, like men, was analytical and logical; art, like women, was sympathetic and appreciative. Could the scientist integrate—or transcend—these categories? King's public and private stances toward nature and science corresponded with these masculine and feminine social constructions. In *Mountaineering in the Sierra Nevada,* science cloaked in social myths of masculinity equated surveying and classification with the domination of nature ("administering the physical world") and the stamina of the surveyor. King's private notebooks brought him very close to considering scientific inquiry that drew upon a perspective culturally defined as feminine: receptivity rather than control; monitoring interaction as a process rather than sighting specimens as products; measuring the adaptivity of organisms and elements within an environment rather than judging their usefulness for human comfort or profit. What was there about the arbitrary socialization of genderized traits, his journals implied, that made one model (the cultural configuration of masculinity) more conducive to science than the other?

When speaking publicly to scientists, however, King reverted to the language of conquest, describing science and exploration alike as efforts to "penetrate the Terra Incognita." Addressing Yale's Sheffield Scientific School in 1877, he told the students of his alma mater that the "honest, manly growth" of the school depended on the scientific method, by which they might join "that resolute band of nature-workers who both propel and guide the great plowshare of science on through the virgin sod of the unknown." He expressed his hope "that year by year men might stand here, fresh from the battle-field of life, out of the very heat of the strife, to tell us of their struggles, and hang the shields they have won along the walls of this temple of science."[37]

Geologist as Viking marauder: King rarely described the genderization of science quite so unambiguously. Throughout *Mountaineering*, he established his role as a scientist through culturally familiar metaphors—either sexual or military—for the conquest of nature. He generally modified the rhetoric of conquest, however, into an alpine variation of the Victorian cult of domesticity. If the life zones developed by C. Hart Merriam and Joseph Grinnell indicated ecological changes at different elevations and latitudes, King's adaptation of Ruskin and Tyndall created zones of social analogy with public (masculine) and private (feminine) spheres of behavior. Like the businessman, the geologist ventures out into an unsheltered public domain of "titanic power" and "awful stress" (above timberline) where "you hold yourself accountable for seeing everything, for analyzing, for instituting perpetual comparison, and as it were, sharing in the administering of the physical world." Upon returning to the "virgin hospitality" of meadows and trees, he finds mountain oaks "altogether domestic in their generous way of reaching out long boughs, roofing in spots of shade," so that upon reaching them "you are at home. A cottage or a castle would seem in keeping, nor would the savage gorges and snow-capped Sierras overcome the sober kindliness of these affectionate trees." Located "far enough below the rugged wildness of pine and ice and rock to leave you in peace, and not forever challenge you to combat," mountainside oak groves "are almost the only places in the Sierras impressing me as rightly fitted for human company." To ascend the mountain was to conduct science, and confront sublimity; to return was to "withdraw scientific

observation, and let Nature impress you in the dear old way with all her mystery and glory, with those vague indescribable emotions which tremble between wonder and sympathy."[38]

Ironically, the presence of high peaks, which King identified as the arena of scientific "combat," seemed to distract him from purely professional considerations. A comparison of his two most detailed accounts in *Mountaineering in the Sierra Nevada*—the ascents of Mount Tyndall and Mount Shasta—suggests that the more geologically exposed his surroundings were, the less perceptive his scientific eye.

On July 4, 1864, King and survey assistant Richard Cotter set out "to reach the highest peak" in the Sierra Nevada. William Brewer called their ascent of Mount Tyndall "by far the greatest feat of strength and endurance that has yet been performed on the Survey." A rope provided their only mountaineering equipment. At one point they had to shave kindling from their barometer case to keep from freezing.

But King's emphasis on the difficulties of the expedition increased with the size of his audience. In his notes to Whitney, he minimized the difficulty of the ascent. But seven years later, in his narrative for the *Atlantic Monthly*, slopes acquired an exaggerated steepness and the landscape became a backdrop for mountain machismo. Hoping to be the first to reach the nation's "highest land," he overcame one "hopeless difficulty" after another: an "inaccessible" peak, an "impossible descent," a path that "no human being could climb." Yet "to turn back was to give up in defeat"; he and Cotter pressed on, "animated by a faith that the mountains could not defy us." And through it all, "danger added only an exhilarating thrill to the nerves"; "At that moment, when hanging between heaven and earth, it was a deep satisfaction to look down at the wild gulf of desolation beneath, and up to the unknown dangers ahead, and feel my nerves cool and unshaken." Within five hundred feet of the summit, their ascent bore the markings of a military campaign: "if Nature had intended to secure the summit from all assailants, she could not have planned her defences better." At the crest, King "rang my hammer upon the topmost rock" and "reverently named the grand peak MOUNT TYNDALL."[39]

At the summit, King's narrative shifted from Tyndall's mountaineering language to that of Ruskin's sublime. Flanked on three sides

by closely crowded peaks, including the three highest mountains in California, King looked westward toward "a thousand sculptures of stone, hard, sharp, shattered by cold into infiniteness of fractures and rift, springing up, mutely severe, into the dark, austere blue of heaven." To the east, he saw the flat desert floor of the Owens Valley, where "stark, wind-swept floors of white" glared in "an unfeeling brillance of light." "I have never seen Nature when she seemed so little 'Mother Nature' as in this place of rocks and snow, echoes and emptiness," King wrote. Wherever he rested his eyes he found a geologist's paradise; "but looking from this summit with all desire to see everything, the one overwhelming feeling is desolation, desolation!" The key to King's alarm was the absence of vegetation. "No greenness soothes, no shadow cools the glare." As a result, he could find "no sentiment of beauty in the whole scene; no suggestion, however far remote, of sheltered landscape; not even the air of virgin hospitality that greets us explorers in so many uninhabited spots which by their fertility and loveliness of grove or meadow seem to offer a man a home." Instead, "the two halves of this view, both in sight at once, express the highest, the most acute, aspects of desolation—inanimate forms out of which something living has gone forever."[40]

From the crest of Mt. Tyndall, King encountered the limits of his ability to integrate the perspectives of scientist, artist, and mountaineer. He could lead the readership of the *Atlantic Monthly* out of their drawing rooms and into the uninhabited back country of California as if they were on a Sunday stroll. But the third mile above sea level became a "specimen of chaos which has defied the finishing hand of Time."[41] Precisely when the landscape became the most geologically revealing, his scientific observation had to compete, first with the mountaineer's celebration of his fortitude, then with Ruskinian "gloom" and "terror" in the "lifeless" realm above timberline.

His eye for detail suffered accordingly. He had set out to climb the highest peak in the nation; but from Mount Tyndall he could see two loftier summits: Mount Whitney, the true "highest land," and Mount Langley. In 1871 he returned to ascend Whitney and looked back at what he thought was the path he and Cotter had followed to Tyndall. In *Mountaineering in the Sierra Nevada*, King proclaimed himself the first white man to climb Mount Whitney. Two years later, W. A. Goodyear of the California Geological Survey demonstrated that

King had mistakenly climbed Mount Langley, not Whitney. The peak he had recognized as Tyndall was the true Mount Whitney—storm clouds had partly obscured King's vision. But careful attention to the terrain or a verification of his barometric readings could have corrected his error. "Six-shooter" science had thus led King to the country's most elevated cul-de-sac.

Yet given the proper setting, King could attain and articulate a Humboldtean "comprehensive glance" of California with unsurpassed brilliance. Mount Shasta, the "magnet" that had attracted him to California at the outset, provided just such an environment. Like Mount Tyndall, Shasta towers over fourteen thousand feet above sea level. But its slopes describe the clean lines of a volcanic cone, relatively free of the "infiniteness of fractures and rift" that had overwhelmed King from Mt. Tyndall. And the view from Shasta's summit—broad, open vistas extending hundreds of miles, with the nearest comparable peak seventy-five miles away—contrasts sharply with the crowded walls of exposed granite that King perceived as Ruskinian desolation. Finally, Shasta presented a comparatively easy climb after the dramatic obstacles of the High Sierra. King's emulation of John Tyndall's mountaineering exploits would be considerably muted here. At Mount Shasta, King was free to give more complete attention to the terrain itself.

Although he first saw Mount Shasta with Brewer soon after his arrival in California, King did not climb it until September 1870. Now directing his own Fortieth Parallel Survey, King undertook a geodetic and geological reconnaissance of Shasta with four others, including veteran Western field geologist Samuel F. Emmons and the great Yosemite photographer Carleton Watkins. Unencumbered by "unknown dangers" or desolate vistas of mountain "bones," King remained geologically alert at every turn. Seven years earlier he and Brewer had noticed, near the mountain's western base, an uncharacteristically muddy stream—not unlike the silt and runoff one would expect a glacier to produce. Evidence of an ancient glacial era along California's interior ranges had been well established by 1870; but the leading geologists and glaciologists—including King's former director, J. D. Whitney—were confident that no active glaciers existed anywhere in United States territory (except Alaska). Every preceding scientific exploration of Shasta had climbed the south face. King's party, however, approached from the west and made a "somewhat

startling discovery." All along Shasta's north face, King found three massive streams of ice that had been hidden from Dana, Whitney, and Brewer before him: he thus made the first officially verified discovery of living glaciers in the United States. Perhaps with a sly touch of irony, he named the principal glacier after Whitney.[42]

At the summit, King described the effect of the view with the same precision he had brought to the verification of his glaciers. The clarity of high altitude light and detail that he had found so oppressive on Mount Tyndall now had the opposite effect: "A singularly transparent air revealed every plain and peak on till the earth's curve rolled them under remote horizons. The whole great disc of the world outspread beneath wore an aspect of glorious cheerfulness. The cascade range, a roll of blue forest land, stretched northward" into Oregon before dropping from view. To the east, "the greenness of forest and meadow" shaded off into desert, revealing the "transparent air" and "unmistakable purity and delicacy of tint" that "give all desert scenes the aspect of water-color drawings." Along the western horizon "stretches a vast sea of ridges, chains, peaks, and sharp walls of canyons, as wild and tumultuous as an ocean storm." Every feature seemed to blend by "indistinguishable" gradations into all the rest. "So high is Shasta, so dominant above the field of view, we looked over it all as upon a great shield which rose gently in all directions to the sky."[43]

Above all else, this panoramic field of view clarified the geological complexity of the region: "What volumes of geographical history lay in view! Old mountain uplift; volcanoes built upon the plain of fiery lava; the chill of ice and wearing force of torrent, written in glacier-gorge and water-curved cañon!" If the High Sierras had blinded him with "the savage sharpness of their details," the view from Mt. Shasta expanded his comprehension as a scientist: "I think such vastness of prospect now and then extremely valuable in itself; it forcibly widens one's conception of country, driving away such false notions of extent or narrowing idea of limitation as we get in living on lower plains." By "overlooking these great wide fields, studying their rich variety, and giving myself up to the expansion," King derived a geological overview commensurate with the "vast spaces and all but unbounded outlook" surrounding him.[44]

Yet for King, giving up to the expansion permitted only temporary suspension of his Ruskinian stance toward mountains above timber-

line. Descending from Shasta, he felt a profound sense of relief to be back among trees: "the groves were absolutely alive like ourselves, and drinking in the broad, affluent light in their silent, beautiful way." The tree line was the border between the kinship of living things and confrontation with the sublime.

> I always feel a strange renewal of life when I come down from one of these climbs; they are with me points of departure more marked and powerful than I can account for upon any reasonable ground. In spite of any scientific labor or presence of fatigue the lifeless region, with its savage elements of sky, ice and rock, grasps one's nature, and whether he will or no, compels it into a stern, strong accord. Then, as you come again into softer air, and enter comforting presence of trees and feel the grass under your feet, one fetter after another seems to unbind you from your soul, leaving it free, joyous, grateful![45]

In his private notebooks, King's use of gender distinctions provided a context for questioning prevailing social depictions of science and nature. In *Mountaineering in the Sierra Nevada*, King masculinized his public persona, loading his rhetorical six-shooter with Ruskin and Tyndall, popular images of the American frontier, and a landscape corresponding to masculine perceptions of the cult of domesticity. With the publication of his *Systematic Geology* in 1878, and his appointment as director of the new U.S. Geological Survey the following year, King took his place among the most respected scientists of his generation. But his departure from government science in 1881 revealed that in his larger conflict between commercial and scientific aspirations, rhetorical six-shooters were not enough. It was left to another mountaineer to pose as California's Humboldt.

Hitched to Everything Else: John Muir

"When we try to pick out anything by itself," John Muir wrote, "we find it hitched to everything else in the universe." Seen clearly, "the whole wilderness in unity and inter-relation is alive and familiar."[46] From his first summer in the Sierra Nevada in 1869, Muir preached the gospel of interdependence, denouncing the prevailing anthropocentric view of nature as a warehouse of commodities for human

consumption. A generation later, scientists began to develop field and laboratory techniques for tracing the dynamics of ecological interdependence, while environmental activists struggled to construct a cultural and political alternative to anthropocentrism. Muir's greatest contribution to both groups was indirect: by sheer reiteration (often unscientific, sometimes impolitic), he did more than perhaps any other individual of his generation to foster cultural recognition of ecological principles destined to assume scientific as well as political importance.

For Muir, interdependence was the essence of the geological sublime. Like Whitney before him, he saw the view from Mount Dana as a dramatic record of previous glaciation; but Muir considered the glacial scorings as only one chapter in "the lessons of unity and interrelation of all the features of the landscape." From Mount Dana's crest "every rock, mountain, stream, plant, lake, forest, garden, bird, beast, insect seems to call and invite us to come and learn something of its history and relationship." In 1871 Muir climbed Mount Clark, one of the highest peaks above the rim of Yosemite Valley. Clarence King and James Gardner had climbed the same peak five years earlier, and King's published account stressed the "life and death" struggles of an ascent from which they returned satisfied that the mountain "had not vanquished us." Muir made a rare passing reference to its steepness ("difficult of ascent, but it is possible to go up on the east side") before elaborating on the geological and botanical details of the high country, which "we are wrongly taught to call wild, desolate, deserted!" "In streams of ice, of water, of minerals, of plants, of animals," he concluded, "the tendency is to unification."[47]

To perceive this interconnectedness required a broadened perception of time as well as an intensified sense of place. "Standing here in the deep, brooding silence all the wilderness seems motionless, as if the work of creation were done," Muir wrote of the view from Mount Ritter. "But in the midst of this outer steadfastness we know there is incessant motion and change." Seemingly immobile glaciers were flowing, lakes quietly eroded mountainsides, and mountian streams were "carrying the mountains to the plains." These simple processes made possible "all the life of the valleys, and here more simply than elsewhere is the eternal flux of nature manifested. Ice changing to water, lakes to meadows, and mountains to plains."[48]

Sense of place was as important as geological time in Muir's effort

to depict landscape as a process. In the Humboldtean tradition of the "comprehensive glance," he maintained that "to one who can leisurely contemplate Yosemite from some commanding outlook," its features become less imposing than from the valley floor, and the viewer's mind "gradually rises to a comprehension of their unity and of the poised harmony of their general relations."[49] At the same time, he urged careful scrutiny of each site for patterns of interaction, both present and past.

Muir's favorite metaphor for this comprehension of nature was one of reading and writing. Yosemite presented "a grand page of mountain manuscript" to those who could translate it. "Glaciers, avalanches, and torrents are the pens with which Nature produces written characters most like our own"; although human eyes often failed to detect it, "nothing goes unrecorded." To read Yosemite's history one first had to recognize "the *magnitude of the characters* in which it is written." Consider how indecipherable the English alphabet would be, he continued, "if it were carved upon the flank of the Sierra in letters sixty or seventy miles long, their bases set in the foothills, their tops leaning back among the glaciers and shattered peaks of the summit." To read the "sculptured alphabet cañons of the Sierra" required "years of laborious research," brooding over "a thousand blurred fragments," then stepping back to read their reconstructed message.[50]

The metaphor of writing also permitted Muir to link his emphasis on specificity of place with his criticisms of science. Frustrated by the tendency of scientific texts to emphasize taxonomy rather than environmental interdependence, Muir rhetorically discarded the medium along with the message: "No scientific book in the world can tell me how this Yosemite granite is put together or how it has been taken down," he wrote. Instead, "patient observation and constant brooding above the rocks, lying upon them for years as the ice did, is the way to arrive at the truths which are graven so lavishly upon them."[51]

If pressed, even Muir might have admitted that without a method, brooding too would prove inadequate. In part, his criticism of the "angular factiness" of the state survey scientists reflected his attempt to minimize the importance of the formal training he lacked. His insights and his insecurity fed each other, and his denunciations of conventional thinking sometimes slipped into oversimplified, anti-

intellectual tirades. But his impatience with preconceptions also allowed him to challenge his readers' view of nature and to stand them conceptually on their heads. If books were nothing more than "piles of stones set up to allow coming travelers where other minds have been," then the walls of Sierra canyons were "stone books gloriously illustrated," offering the geologically literate visitor "a library where many a secret in mountain-building may be explained."[52]

Rhetorical flourishes aside, Muir continued to read books in addition to rocks, even while inhabiting Yosemite. Like Clarence King, he read Tyndall and Ruskin with great interest. But Muir criticized both authors for distracting the reader from immersion in the natural environment of the mountains. He was never willing to adopt Tyndall's narrative technique of dramatizing his exploits as a mountaineer; in all of his journals and published work, Muir almost never focused on his own efforts as a climber. He also worried that Tyndall's physical and chemical analysis of glaciers obscured the interactive harmony among agents of geological change. "If Tyndall would leave his lectures & books & dwell with the Alps," Muir wrote to Ralph Waldo Emerson, "he would finally make a speech or book of everlasting worth, but he does not allow himself time to fill." Yet the glaciologist played an important emblematic role for Muir. As if in counterpoint to Ruskin's presentation of the Turner watercolors to King, Tyndall met Muir in California and gave him an aneroid barometer with which to measure the elevation of Sierra peaks. In spite of King's attraction to the world of art and belles lettres, his Turners remained an emblem of a road not taken in his career. In much the same way, Tyndall's barometer was not so much a tool as a reminder to Muir of a scientific career never pursued.[53]

Muir found Ruskin more problematic. Reading *Modern Painters* in Yosemite Valley, Muir complained that Ruskin "goes to the Alps and improves and superintends and reports on Nature with the conceit and lofty importance of a factor of a Duke's estate." Unlike King, Muir rejected Ruskin's correlation of the sublimity of mountain peaks with lifelessness. "Ruskin says that the idea of foulness is essentially connected with what he calls dead unorganized matter," he wrote while watching the glow of Yosemite's walls in the moonlight. "How cordially I disbelieve him tonight!" Near the end of his Yosemite residency Muir wrote that he had never encountered Ruskin's "mtn. gloom wh doubtless is bogle humbug."[54]

In *Mountaineering in the Sierra Nevada,* Clarence King adapted Ruskin's demarcation of sublimity above the vegetation line to masculinize and demarginalize his role as a geologist and an aesthete. Muir, who self-consciously gloried in his social marginality, played the trickster with Ruskin's categories by extending the feminine qualities of the meadows and groves to the highest, most rugged Sierra summits. King proclaimed his kinship with Sierra forests, "absolutely alive like ourselves"; for Muir "every rock seems to glow with life."

King applied Ruskin to help situate himself at a formative stage in the genderization of science; Muir sabotaged the Ruskinian sublime to challenge prevailing patterns in the genderization of nature. Muir considered anthropocentrism to be one of civilization's most dangerous and misguided social idioms. To question this view, he subverted his readers' expectations in the closely related social categorization of gender.

If Muir's place in the world seemed unclear, he would make the mountains his home—not by transforming or domesticating them, but by redefining domesticity and reversing accepted notions of nature and culture, the wild and the domesticated. Even in the High Sierra, "the cleanness of the ground suggests Nature taking pains like a housewife, the rock pavements seem as if carefully swept and dusted and polished every day." Returning to the mountains from San Francisco, Muir noted that "every feature became more rigidly alpine, without, however, producing any chilling effect; for going to the mountains is like going home."[55]

Muir's recasting of domesticity challenged accepted notions of civilization as a haven from nature's imperfections. In contrast to King's adaptation of Tyndall's mountaineering stance, Muir stressed the accessibility of even the most remote mountain terrain. He had carried out his studies "all along the highest portion of the chain, with far less danger than one would naturally count on." The "timid traveler, fresh from the sedimentary levels of the lowlands," might find the high terrain "terribly forbidding—cold, dead, gloomy gashes in the bones of the mountains." But Muir assured them that "accidents in the mountains are less common than in the lowlands" and that "few places in this world are more dangerous than home." Canyons that at first appeared to be "raw, gloomy, jagged-walled gorges,

savage and inaccessible," were really "mountain streets full of charm-
ing life and light, graded and sculptured by the ancient glaciers."[56]

For Muir, Yosemite was a "hospitable, Godful wilderness"; it was
the city—that "howling metropolis of dwelling boxes"—that con-
fused and overwhelmed the visitor with its "artificial cañons" and
"fogged jungle of human plants." "Tell me what you will of the
benefactions of city civilization, of the sweet security of streets—all
as part of the natural upgrowth of man towards the high destiny we
hear so much of," he wrote en route to Yosemite after a winter in
Oakland; but from his Sierra vantage, it seemed clear that "there is
not a perfectly sane man in San Francisco."[57]

Muir called upon his readers not to transform nature but to find
new ways of seeing it. Stop seeking combat with the elements, he
argued, and you will begin to perceive the interconnectedness sur-
rounding you. King described the view from Mount Tyndall as a
bleak "specimen of chaos" where "the one overmastering feeling is
desolation, desolation!" As if directly responding to King, Muir pro-
claimed that "nothing is more wonderful than to find smooth har-
mony in this lofty cragged region where at first sight all seems so
rough." From the summit of Mount Ritter, he acknowledged that
"when looking for the first time from an all-embracing standpoint
like this, the inexperienced observer is oppressed by the incompre-
hensible grandeur, variety, and abundance of the mountains rising
shoulder to shoulder beyond the reach of vision"; but "after they
have been studied one by one . . . their far-reaching harmonies be-
come manifest." Viewed as agents of geological change stretching
across hundreds of millions of years, "the very stones seem talkative,
sympathetic, brotherly."[58]

The change in perspective that Muir aimed for was grounded in
feminine social traits. To perceive the dynamics of interdependence,
to feel connected with nature and "kin to everything," to see the
natural environment from the point of view of its inhabitants—all
required skills for which scientists (and men in general) were rarely
trained or socialized. Yet with this receptiveness to nature as pro-
cess, the attentive observer could perceive even the most barren
mountain vistas as moments in a rich procession of animation and
change over geological time. In the Sierra rainshadow near Mono
Lake, Muir discovered a "country of wonderful contrasts. Hot deserts

bounded by snow-laden mountains,—cinders and ashes scattered on glacier-polished pavements—frost and fire working together in the making of beauty." Translating the inert terrain into dynamic geological processes of "upheaving volcanoes and down-grinding glaciers, we see that everything in Nature called destruction must be called creation—a change from beauty to beauty."[59]

Muir's reversal of customary attitudes toward nature became most apparent when his mountains seemed least inviting. "Storms of every sort," he insisted, "torrents, earthquakes, cataclysms, 'convulsions of nature,' etc., however mysterious and lawless at first sight they may seem, are only harmonious notes in the song of creation." When a series of earthquakes struck Yosemite in 1873, Muir astonished onlookers by rushing out to watch, delighted that the rocks had "spoken with audible voices."[60]

The following year, he happened to be in a Sierra forest during "one of the most bracing wind-storms conceivable," and Muir "lost no time in pushing out into the woods to enjoy it. For on such occasions Nature has always something rare to show us, and the danger to life and limb is hardly greater than one would experience crouching deprecatingly beneath a roof." Not content with "the highest ridge in the neighborhood," he "decided it would be a fine thing to climb one of the trees to obtain a wider outlook." From the upper reaches of a hundred-foot Douglas Fir, he found himself "bending and swirling backward and forward, round and round, tracing indescribable combinations of vertical and horizontal curves." From this unlikely vantage, Muir noted in minute detail the varying arcs of sway among different species of trees; the windborne scents of forests, fields, and even the distant seacoast; and the clear layering of sounds, with each "keen metallic click of leaf on leaf" traceable to its source "when the attention was calmly bent." Of this "wild exuberance of light and motion" Muir wrote: "we hear much nowadays concerning the universal struggle for existence, but no struggle . . . was manifest here." On the contrary, "Nature was holding high festival."[61]

In his effort to lure readers into the wilderness, Muir was as likely to downplay the difficulties of mountain exploration as King was to amplify them. Usually traveling alone and on foot, he typically carried nothing more than a blanket, with one pocketful of tea and another of bread for provisions. During his first ascent of Mount Shasta in November 1874, he was stranded by the first major snow-

storm of winter. After three days of snow, he wrote in his journal: "wild wind and snow. Drifts changing the outlines of mountains— pulsing outlines. Three inches of snow on my blankets. Sifted into my hair. Glorious storm!"[62]

Even in a rare acknowledgement of mountain perils, Muir's account avoided the language of conquest, stressing instead his contention that California's mountains "call forth every faculty into vigorous, enthusiastic action." In 1872 he set out to scale Mount Ritter—over 13,000 feet high, "fenced round by steeply inclined glaciers, and cañons of tremendous depth and ruggedness," and with no record of anyone having reached its summit. After two days of arduous scrambling, Muir had reached an elevation of 12,800 feet when "I found myself at the foot of a sheer drop in the bed of the avalanche channel I was tracing." Unable to find a path around the precipice before him, Muir started scaling it, "picking my holds with extreme caution." But halfway up, "I was suddenly brought to a dead stop, with arms outspread, clinging close to the face of the rock, unable to move hand or foot either up or down." Muir pictured his impending death as "a moment of bewilderment, and then a lifeless rumble down the one general precipice to the glacier below." At first "my mind seemed to fill with a stifling smoke," he recalled. "But this terrible eclipse lasted only a moment, when life blazed forth again with preternatural clearness. I seemed suddenly to become possessed of a new sense." In his newly alert state "every rift and flaw in the rock was seen as though through a microscope, and my limbs moved with a positiveness and precision with which I seemed to have nothing to do. Had I been borne aloft upon wings," Muir concluded, "my deliverance could not have been more complete."[63]

Although Clarence King considered his mountaineering adventures to be incidental to his geology, he approached both as challenges. To Muir, the same mountain clarity that saved his life also revealed "Nature's methods of landscape creation"; both required a receptivity to the internal dynamics of the forces at work around him.

In describing their experiences in the mountains of California, King and Muir chose contrasting approaches—one embellishing and combining existing narrative conventions, the other deliberately subverting them. Both men focused international attention on Yosemite

Valley and the Sierra Nevada, and both contributed to California scientists' notion of the dimensions of their task. But what did their descriptive techniques reveal about their methods of scientific analysis? Their conflicting theories of Yosemite's origins provide a vivid example of the relation of scientific findings to the scientist's predisposition toward the evidence at hand.

The Origins of Yosemite Valley: Two Theories

"I believe no one can study from an elevated lookout the length and depth of one of these great Sierra cañons without asking himself some profound geological questions," Clarence King wrote in 1872. And for California's first geologists, the origin of Yosemite Valley posed the most perplexing question of all. Seven miles long and about a half mile wide, the floor of the valley was a flat, stream-laced meadow sheltering "a luxurious growth of sedges and ferns" and "noble pines and oaks," interspersed by "thickets of azalea, willow," and alpine wildflowers. Frederick Law Olmsted, one of the leaders in the campaign to create state park status for Yosemite in 1864, praised the valley's vegetation as a natural embodiment of his principles of landscape architecture.[64]

For geologists, however, the primary attraction was not the park-like valley floor but the walls of granite that hovered over either side of the valley from heights reaching above three thousand feet. What intrigued them was the near-verticality of these "sublime rock forms." Mountain stream erosion normally forms V-shaped valleys, but in Yosemite they found strikingly perpendicular walls lifting with architectural precision from a smooth, level floor. El Capitan, the world's largest single piece of exposed granite, rose thirty-six hundred feet from the meadows below at a near-ninety degree angle. Geologists also pointed to the almost complete absence of talus, or erosive rock debris, at the bases of these massive formations. "This is one of the most striking and unique features of the scene," Whitney reported, "for it is a condition of things of the rarest possible occurrence. We know of nothing like it in any other part of the world."[65]

How did such a geological curiosity originate? In the fall of 1864 Clarence King and James Gardner found "unmistakeable ice striae" leading from Mt. Hoffmann into Yosemite Valley. In his unpublished field notes, King observed that El Capitan's surface was marked by "a

number of holes bored into the rocks" in parallel lines. Puzzled by their origin, King noted that "in all probability, they were worn when the glacier occupied the Valley, for one can hardly hardly [sic] imagine their being made with the granite; or worn by water trickling down the vertical face of the cliff." Elsewhere in the Valley King found "four morainal ridges, which will require great ingenuity to attribute to any other cause than glaciers." Perpendicular walls, minimal talus, moraines: only glacial action could have carved such valley walls while carrying away the debris and depositing it in moraines. All told, Yosemite Valley presented King with "a mass of evidence" to "establish beyond *doubt* the former occupation of the Valley by a glacier *at least* a thousand ft thick."[66]

Whitney dismissed King's findings in his volume on the geology of California the following year: "there is no reason to suppose . . . that glaciers have ever occupied the Valley or any portion of it." Instead, he concluded, the "process of upheaval" that formed the Sierra caused "the bottom of the Yosemite . . . [to] drop out" in a great geological cataclysm that "may truly be said to have been 'the wreck of matter and the crush of worlds.' "[67]

Muir took issue with Whitney's theory. Like King before him, he found abundant glacial scorings throughout the valley. Although convinced of Yosemite's glacial origin, he lacked proof. Then, in October 1871, while "following the footprints of ancient glaciers that once flowed grandly from their ample fountains . . . I came upon a small stream that was carrying mud of a kind I had never seen." As King had done at Mount Shasta, Muir followed the stream's trail to a snowbank supported by "clear green ice." He had found a living glacier in Yosemite, testifying to the valley's geological heritage.[68]

Whitney discounted Muir's discovery, assuring his readers that Muir's glacial theory of Yosemite's origin was "based on entire ignorance of the whole subject" and "may be dropped without wasting any more time upon it." King added fuel to the controversy by disavowing his earlier findings and concurring with Whitney's cataclysmic theory. "It is to be hoped that Mr. Muir's vagaries will not deceive geologists who are personally unacquainted with California," King wrote in his *Systematic Geology*, "and that the ambitious amateur himself may divert his evident enthusiastic love of nature into a channel, if there is one, in which his attainments would save him from hopeless floundering."[69]

Perhaps King simply considered it professionally politic to voice agreement with his prestigious director, rather than provide supporting evidence for an "ambitious amateur." But their clash over Yosemite's formation also reflected King's and Muir's divergent approaches to nature and science. In geological terms, their controversy was between catastrophist and uniformitarian schools of thought. The latter pictured "the harmless, undestructive rate of [current geological change] projected backward into the deep past." This view conformed with Muir's vision of nature as a realm of interdependent, harmonious forces through which environmental changes evolved gradually over vast periods of time. Glaciers, "which are only streams of closely compacted snow-crystals," embodied that concept of slow, steady change. Catastrophists, by contrast, hypothesized periodic cataclysms in which the earth suffered violent change. King adopted a "modified" catastrophism, whereby "catastrophic change bursts in upon the ages of uniformity" from time to time.[70]

Not by coincidence, King and Muir both embraced scientific theories that reflected their respective experiences in the mountains of California. For Muir, the peaks and valleys of the Sierra Nevada inscribed their history "like a line of writing across the sky": "Nature never leaps," he asserted. He belittled King's and Whitney's "violent hypothesis" for sweeping away contradictory evidence and "letting the super-incumbent domes and peaks fall rumbling into the abyss, like coal into the bunker of a ship."[64]

King, by contrast, saw Muir's "far-reaching harmonies" as extending no farther than "the magical faculty displayed by [Yosemite's] vegetation in redeeming the aspect of wreck and masking a vast geological tragedy behind draperies of fresh and living green." Muir's vision of "currents of life that flow through the pores of the rock" not only violated King's Ruskinian zones of sublimity, it also discarded the equation of barren rock with catastrophism that underlay King's geological interpretation of the montane West. Two notions of the geological sublime had fostered two explanations for the formation of Yosemite Valley.[71]

Twentieth-century geologists discredited Whitney's (and therefore King's) Yosemite theory, establishing not just one but three periods of glacial occupation of the Valley. They also determined that Muir had overestimated the role of glaciers, as opposed to erosion and other common agents, in the Valley's formation. Muir's biogra-

phers generally depict the direction of geological thinking as a vindi-
cation for the shepherd over the distinguished scientist. Yosemite
geologist François Matthes concluded that Muir was "more inti-
mately familiar with the facts and more nearly right in their interpre-
tation than any professional geologist of his time."[72]

More important, however, was the underlying stratum of agree-
ment between King and Muir on the nature of their common
workplace. King's theory, like Muir's, was grounded in the singular-
ity of California's geological structure. He saw his modified catas-
trophism as a distinctly Western phenomenon: "The rate of subsi-
dence in the east . . . may be called uniformitarian. That on the west
was distinctly catastrophic in the widest dynamic sense." And he
saw California as the likeliest field for the development of the con-
cept of "evolution of environment, a distinct branch of geology
which must soon take form." Muir would have agreed with King
"that the evolution of environment has been the major cause of the
evolution of life; that a mere Malthusian struggle was not the author
and finisher of evolution"; that "adaptivity" occurs primarily "be-
tween life-forms and the environment." Their disagreement was over
the rate and the agent of change.[73]

That disagreement, however, acquired significance in a wider so-
cial context. For Clarence King, and for most scientists, human inter-
action with nature—and with other humans—simply reflected na-
ture's own pattern of periodic violence. But for Muir, and for the
scientists who set out to reconcile California's physical and social
environments, human destructiveness was an aberration—one that
the scientist might fail to correct, but could not ignore.

three

Scientists, Institutions, and Patrons in California

5

A Field of Richer Promise: Making a Home for Science

When George Davidson called the California Academy of Sciences to order on the evening of September 2, 1872, "the rooms of the Academy were filled to their utmost capacity." The number of distinguished visitors in the crowd testified to the meeting's significance. Daniel Coit Gilman of Yale's Sheffield Scientific School addressed the gathering—his first public appearance as newly appointed president of the University of California. The list of speakers also included John Torrey of Columbia, whose reports on the botanical collections of a number of Western expeditions, including those of Frémont, the Mexican Boundary Survey, and the railroad survey expeditions, had inspired international scientific interest in the far West. Many in the audience that night had heard Torrey address the academy during his first visit to California in 1865. Some of them had been sending him botanical specimens for years. Most of his audience could corroborate from first-hand experience Torrey's admission "that for many years I have had California on the brain."[1]

The presence of either Gilman or Torrey would have ensured an enthusiastic crowd. Tonight, however, academy members and friends had packed the hall to hear Louis Agassiz. For Bay Area scientists, a visit from Harvard's "big geologico-everything-French-Swiss gun" signaled more than an occasion for honoring America's most celebrated man of science. Whether they had worked directly under him or absorbed his teachings through his texts and disciples, most early California scientists regarded him as a mentor. His theory of a prehistoric

global ice age had given them a model for charting and interpreting the glacial scorings of the Sierra Nevada. Now Agassiz himself was en route from his first examination of South American glaciation. What better place than California, where evidence of an American ice age had been most clearly established, to discuss the *Eiszeit* in light of fresh findings?[2]

Agassiz was also the nation's most distinguished opponent of Darwin's theory of evolution—a position that most California scientists no longer shared. Was the elderly Agassiz finally reconsidering his categorical rejection of Darwinism? Surely his just completed voyage aboard the *Hassler*, which retraced much of Darwin's path through South America and the Galapagos Islands, provided Agassiz with an unsurpassed opportunity to reexamine his insistence on the immutability of the species. And this roomful of Californians was his first audience since departing for the expedition; perhaps they would hear Agassiz at last embrace evolution.[3]

The guest of honor, however, did not choose to speak of ice or fossils or natural selection. Instead, he lectured the fledgling California scientific community on the need for local patronage. "You are surrounded with wealth as no State ever was," he told them. "You have men among you who are richer than kings of the Old World, and yet I see you are still in close quarters." For want of exhibit halls, most of the academy's collections remained in storage. Their headquarters—"two or three wretched rooms on Clay Street," as George Davidson described them—did not begin to compare with the venerable academies in the East or in Europe.[4]

Yet this lack of prior institutional support, according to Agassiz, could be turned to great advantage. "The institutions of science in the Old World have grown through centuries," he observed. As such they had become elegant but aging artifacts of "superannuated" scientific methods and instruments. American academies and museums, however, could embody "the ideas of to-day." Their task, he concluded, "besides fostering and nursing the interest you individually feel for science, is to arouse the general interest in the community" upon which their success depended. What San Franciscans had accomplished so rapidly in material prosperity, argued Agassiz, they could match in intellectual growth. But scientists would have to show them the way.[5]

Agassiz's message was a familiar one for the scientists in his audi-

ence. But survey scientists, academy members, and university scientists alike had discovered that the methods of building institutional support for science in California differed in several respects from those of their Eastern predecessors. When Agassiz came to Harvard in the 1840s, he drew his support from an area with over two hundred years of settlement behind it. Two science-oriented organizations in Boston—the American Academy of Arts and Sciences and the Boston Society of Natural History—had been developing community patronage for science, the academy for over sixty years. In Bache's Philadelphia, the American Philosophical Society and the Academy of Natural Sciences boasted even longer histories. In such a community, those who shared an interest in science were easily identified within an established social structure.[6]

The California Academy of Sciences, the first scientific institution in the West, was established in 1853. When Agassiz addressed its members in 1872, the organization was nineteen years old, in a state that had just turned twenty-two. California scientists had to create not just scientific organizations but social contexts through which Californians could appreciate and support their work.

There were other problems as well. For Californians, the geography of the American economy created friction between science and capital. Throughout the late nineteenth century, most manufacturing industries remained severely stunted on the West Coast, hindered first by distance, then by imports from well-established Eastern rivals. Extractive industries, however, flourished in a region so rich in natural resources. Accordingly, California's commercial vitality came to depend heavily on precisely those natural features that had attracted scientists. Since both groups were concerned, in different ways, with making a living from California's terrain, their contrasting attitudes toward land and economic growth provided the context for an ongoing debate over the role of science in California.

A further obstacle to public support of science in California rested with the scientists themselves, and with the effects of the region's social identity on the volatile role of science in Victorian America. European patterns of scientific patronage (by the aristocracy or the state) had only begun to develop in antebellum America. Lacking an established pattern of support, American scientists had to develop a new system of patronage. Agassiz and his successors in the East were forging a new public identity for scientists, first through federal sup-

port, then by means of corporate sponsorship. But California's scientists remained isolated from these changes in the social role of science. Early federal survey scientists in the Far West had little contact with the world of government science in Washington. And for the rest of the century, industry jobs in California remained extremely rare for earth and life scientists. To them a scientific career still meant abstention from commercial gain, and nearly all endured financial sacrifice by choosing to become scientists. Unlike most Californians, they expected their relocation to the West Coast to reduce their financial prospects still further. Clearly, scientists and their fellow Californians had many differences to overcome before they could establish a pattern of support for science.[7]

The Survey Scientists

"For over a month the sky has not been covered with clouds for 24 hours in the aggregate," George Davidson wrote in March 1856; "and the most delicate flowers have been blooming in the open air. What a pity," he reflected, "that such a blue sky, bracing air & smiling landscape should be totally forgotten in the exciting race for wealth— even at the price of honor." In California, he complained, "wealth is nearly the only criterion for standing: it gilds crime, throws a halo around the suspicious . . . and scoffs & jeers at unflinching integrity. It macadamizes the highway to Heaven."[8]

Davidson's lament spanned the two Californias with which he had become familiar: its smiling landscape and the race for wealth. In the 1850s, scientists had adopted the one as a workplace, while barely gaining a foothold in the other. Yet Davidson had great hopes for the "vigorous talent" of the cities, once it met the stabilizing influence of the countryside. For the time being, "the Almighty Dollar swallows & consumes every attempt at solid and profound knowledge." But surely it would not devour the landscape surrounding it. Twenty years later he discerned the same disparity between present conditions and future possibilities. The pre–gold rush estates of the Californios had long since been "divided among squatters, lawyers and land sharks," and "the inevitable 'pioneer' has gone over the land like the Western grasshopper." But Davidson still felt certain that "a nobler race cannot help arising from such a glorious country with its bold coasts, its valleys greater & richer than the Nile, its

noble moutains gold and silver ribbed, its climate more invigorating than any in Europe."[9]

Implicit in Davidson's mixed response was the assumption that in California, science and society alike were linked to their physical environment. Clarence King sketched the social impact of Californians' interaction with their environment in still bolder strokes. "We must admit the facts," he wrote in 1871. "California people are not living in a tranquil, healthy social *regime*. . . . Aspirations for wealth and ease rise conspicuously above any thirst for intellectual culture and moral peace. Energy and a glorious audacity," coupled with "light-hearted gayety," "are their leading traits." How could one account for these social characteristics? "I believe it climatic," King asserted. Here, if anywhere, Humboldt's method of measuring cultural as well as biological traits by "isothermal lines and topography" seemed to have merit. In California, King believed, "time shall separate a noble race," drawn together not by lineage or by the state's gold-launched history, but by common exposure to the beneficial effects of their environment.[10]

For the rest of the century, California's scientists reiterated this twofold appraisal of their new home as socially stark but physically blessed. With each passing decade, as the "nobler race" of enlightened, regionally adapted Californians postponed its appearance, scientists invested less faith in the reforming power of the environment. By the 1890s, an increasing number of them advocated social reform of the state's laissez-faire approach to the protection of natural resources.

The survey scientists of the 1850s and 1860s, however, saw California when its landscape was least altered, its society least developed. Forbidden by law from applying the knowledge they acquired for personal gain, they were expected to serve commercial interests without participating in them. Yet when they sought regional patronage for their work, they often were vilified for failing to produce more profitable information. In such an atmosphere, the survey scientist was apt to become, at best, ambivalent toward commerce and its relation to science in California.

Davidson seemed to thrive on the ambivalence. His half-admiring, half-damning descriptions of Californians' "reckless" speculation and "go-ahead principles" in the 1850s testified to his uncertainty about the effect of California's "feverish" economy on his status as a

scientist. He and his staff had been specially chosen to withstand the lure of the mines. "Nothing but their known character as gentlemen," Davidson observed of his assistants, but clearly including himself, "could have enabled them to withstand the tempting offers that have been held out to all."[11]

Yet their earnings were hopelessly inadequate in the face of gold rush inflation. One of their first tempting offers occurred four months after their arrival, when the townspeople of Santa Barbara offered them three thousand dollars to survey the town. Davidson refused, since it would have violated the Coast Survey's rules. But upon hearing of the incident, Superintendent Bache "laughed heartily, and did not hestitate to intimate plainly that we were fools, and we began to think so too." After that, Davidson handsomely supplemented his income by shrewd investments unrelated to his work; but he located his professional identity with his fieldwork, far from the more lucrative pursuits offered by the city. "I trot around the streets regardless of mud or appearances" on money-making schemes, he wrote in 1853, "but in a couple of weeks this will all be exchanged for the quiet and contentment of camp life."[12]

Camp life meant hard work with little compensation, but it provided survey scientists with a sense of dedication to their work that distinguished them, in Davidson's estimation, from the "slaves of Mammon." Far from the temptations of San Francisco, their fieldwork also created a powerful camaraderie among "the only persons in California who were concerned with the earth, and were not trying to make money out of it." As field scientists, they thought of their work and their workplace as inseparable aspects of their profession. As late as the 1880s, when two people crossed paths in the High Sierra, chances were excellent that they knew each other and that at least one of them was a scientist.[13]

Yet this backcountry kinship changed along with the rest of the state. Twenty-five years after his first California assignment, Davidson wrote to a former survey associate in 1876 of "the good old times when we rather delighted in the unique 'roughing it' inseparable from early California life." Insulated by modern transportation, "the well housed, well paid, & well fed Californian of today" could scarcely imagine the respect for distance and topography inspired by the landscape a quarter century earlier: "He makes his trip (to California) in Pullman cars, drives into Yosemite (by coach), steamboats

it . . . up & down the coast, even visits the mighty Shasta by rail."
Davidson quickly added, "I don't object to the modern innovations
on the Pacific Slope." He saw himself as a public servant to "the large
development which pervades its people." Yet he knew that the cama-
raderie among the state's early survey scientists derived from an
older California where, even in the 1850s, most of the backcountry
had scarcely changed in hundreds of years. "When two or three of us
meet together over a campfire in the mountains," he observed, "we
rehash the old well known trails and feel that bond of friendship
which I am sure cannot be approached in strength & sincerity any-
where else on the face of the Earth."[14]

Josiah Dwight Whitney, too, saw his professional identity closely
bound up with the commercial ambience of the state; but he suffered
from none of Davidson's uncertainties. Like the Coast Survey, the
State Geological Survey stipulated that "no member of the survey
should use his knowledge of California geology to make a penny for
himself." Beyond that, Whitney's self-imposed rule—"never, so long
as he might be called upon to give an opinion upon one mine, to own
the least part of any other"—won his staff's admiration for a man
who could "deliberately turn his back on a fortune."[15]

But Whitney's scrupulous reliance on public funding only intensi-
fied his outrage when the legislature periodically cut his appropria-
tions. "We have escaped perils by flood and field," he told them,
"have evaded the friendly embrace of the grizzly, and now [find]
ourselves in the jaws of the legislature." To his brother William he
complained, "there is so little appreciation of, or care for, anything but
money-making in this state." After so much squabbling for funds "I
could not help being . . . relieved, if the survey were stopped," he
confessed, "yet my scientific instincts make me fight for its continu-
ance." Whitney had further reason to despair. At the same time that
the survey's funding was being cut, legislators, and even a governor,
were secretly approaching him for tips on mine speculation. He soon
came to define his professional integrity in direct opposition to the
commercial objectives of his sponsors. He would not take advantage
of his familiarity with the mining region for his own gain; but neither
would he comply with the lawmakers' promptings that he do so on
their behalf.[16]

California's early survey scientists measured their tenuous social
role in other terms as well: they lacked not just funding but a local

institutional home. While technically sponsored by lawmakers or federal science agencies, they had no official gathering place where they could meet, discuss their findings, and display the fruits of their labor to the public. By the 1860s, many of them turned to the California Academy of Sciences, the one organization that might serve as a clearinghouse where professional scientists, amateurs, and potential patrons of science could foster mutual support.

The California Academy of Sciences

Like the earliest of the Eastern societies, the California Academy of Sciences was established in part because of its founders' desire to associate their names and their relatively undeveloped social community with science and advanced learning. Just as Whitney, King and Davidson bestowed the names of scientists on California's mountains and trees, so did the academy's founders undertake to add the name of science to the social landscape of their new home.

None of the seven men who founded the academy in 1853 were professional scientists. The majority of them, however, practiced medicine. Having come of age at a time when formal scientific training was difficult to pursue without going abroad, the academy founders were typical of a generation that associated medicine with a knowledgeable interest in the natural sciences. When they praised California's natural environment as "a field of richer promise in the department of natural history in all its variety than has previously been discovered," most of them spoke from personal observation. Physician John B. Trask, for example, devoted all of his free time to studying the intricate geology of California. In 1853, the state senate asked him to submit his findings from a survey of the gold regions. Trask's report, followed by three others, won the legislators' praise and encouraged their interest in scientific surveys.[17]

Trask's fellow academy founders included Albert Kellogg, an accomplished amateur botanist; Henry Gibbons, whose interest in meteorology produced the first systematic records of San Francisco's rainfall; and Thomas Nevins, founder and first superintendent of the city's public schools. Together they promoted the cause of science in California, calling for "a thorough survey of the State and the collection of a cabinet of her rare and rich productions." Scientific societies in the East sent their congratulations, and Smithsonian director

Joseph Henry wrote an "encouraging letter" offering his assistance to the new academy. As the first—and for several years the only—scientific society in the Far West, the academy provided a logical stopping place for scientists and other eminent visitors. By 1872, Agassiz was the most prominent of a succession of academy guests that had included Joseph Henry, O. C. Marsh, John Torrey, Horace Mann, and Benjamin Silliman, Jr. [18]

In spite of these auspicious signs, academy members found that conducting a society for the promotion of natural science in a region almost devoid of resident scientists required perseverance. For the first decade, they held their weekly meetings in a cramped room where "the lights used were tallow candles and few of them, and the furniture of the cheapest description." In 1855 monthly dues dropped from two dollars to one. In that same year, the Chicago Academy of Science was founded; over two thousand miles away, it was the California academy's closest neighbor. Yet the academy members managed to present and publish a steady variety of technical papers. At their August 14, 1854, meeting, for example, members heard a paper on California fishes by William Ayres, a discussion of California plants by Albert Kellogg, and Henry Gibbons' meteorological observations on wind patterns in the San Jose Valley.[19] The career of the academy's first president testifies to the youth of the region's society. Andrew Randall assisted David Dale Owen on his territorial survey of Minnesota and Wisconsin. Returning to Owen's home in New Harmony, Indiana (where he very likely met George Davidson), Randall decided to join an overland party to California in 1849. In 1851 he was elected to a single term in the California legislature, where he tried but failed to establish a state survey. In 1853 he helped to organize the academy and was elected its first president. On July 24, 1856, a gambler shot him dead for failing to pay a debt. Two days later his fellow academy members marched in Randall's funeral procession. On July 29 they met to discuss "the trees of California" while, a few blocks away, the San Francisco Vigilance Committee hanged Randall's murderer at the public gallows.[20]

The academy received its first infusion of scientists in the 1860s with the arrival of the California Geological Survey staff. Josiah Dwight Whitney and William Brewer went before the academy in June 1861 with Whitney's "grand scheme for erecting a great building" to serve as a museum for the survey's collections. The academy

members petitioned the legislature on behalf of Whitney's proposal (with no result), and by the following year Whitney and Brewer were librarian and corresponding secretary, respectively, of the academy. Survey members Clarence King, James Gardner, William Ashburner, William More Gabb, W. A. Goodyear, and John G. Cooper eventually joined. The surveyors contributed a steady flow of papers and mineral and botanical specimens. In 1867 Whitney became president of the academy. The state surveyors lent stature to the academy during their brief tenure in California. They also provided desperately needed financial support, absorbing much of the cost of relocating the meeting room in the 1860s.[21]

Although the state survey technically continued until 1874, the legislature's reluctance to provide funds turned into near abandonment of the project after 1868. Most of the staff had to be dismissed, and Whitney returned to a post at Harvard, coming back periodically to California and completing as much of the work as he could, often at his own expense. Frequently at Whitney's instigation, the academy made several efforts to secure financial support: they repeatedly requested appropriations from the legislature, drew up a plan to merge with the city's Mechanics Institute, and even promoted a proposal to combine with the new University of California. But each of these attempts failed. The state geologists were returning to the East. The founding of the university in 1868 brought more scientists into the academy's membership, but the professors in Berkeley did not play so important a role in the academy as had the state geologists. Unlike Whitney and his staff, the University of California scientists had their own institution to support—one that suffered nearly as much financial uncertainty as did the academy and the state survey. The painfully slow growth of the university also meant that for the first twenty years its faculty added very few new scientists to the Bay Area community.[22]

Yet the California academy that Agassiz addressed in 1872 had already begun a new phase in its development, drawing it closer to the goals he outlined for its members. In 1871, George Davidson became president of the academy. For the next sixteen years, he poured his organizational energies into reviving and strengthening the institution. Like Whitney before him, Davidson sought to overcome the survey scientist's lack of a local institutional base by creating a home for himself in the academy. He set out to develop a more

professional framework for the organization, emphasizing the delivery of formal papers at meetings and upgrading the quality and frequency of its publications. Drawing from a largely nonprofessional membership, Davidson found that he was often the only speaker available. Undeterred, he lectured on his work in astronomy, meteorology, earthquakes, new designs for survey equipment, California Indians, and on one occasion, the habits of the walrus.[23]

The academy witnessed other important changes during the Davidson years. At one of its earliest meetings in 1853, the academy had voted to "approve of the aid of females in every department of natural history," and to "earnestly invite their cooperation"—possibly the nation's earliest institutional recognition of women as equals in the realm of science. But this policy remained abstract until January 1878, when the first seven women became academy members. In the 1880s, when its resources and collections warranted a staff of curators, the academy was the first scientific organization in America (and possibly the first in the world) to include women among its paid curators.[24]

The most prominent woman among the academy's early curators was Alice Eastwood. Born in Toronto in 1859, she grew up in Denver, where she taught botany at Denver High School before succeeding Katherine Brandegee as Curator of Botany at the California Academy of Sciences in 1892. (In 1953, when the academy observed its one-hundredth anniversary, Eastwood, ninety-four years old, was in attendance.) Soon after her arrival she began to conduct botanical outings in the Bay Area and traveled the length and breadth of the state, often unaccompanied, to observe vegetation and collect flora until the academy's herbarium was the largest in the West. All of the academy's botanical collections were destroyed in the fire that followed the 1906 San Fransciso earthquake—except for those Eastwood rescued by climbing the bannisters to the sixth floor herbarium (the stairs had collapsed in the quake) and pitching the most valuable specimens out the window. In the course of her career as a botanist, Eastwood studied at Kew Gardens and the British Museum, published extensively on the flora of California, and contributed botanical specimens, field research, and chapters of text for eminent Eastern botanists. She also undertook botanical expeditions along the entire Pacific slope, from Baja California to Alaska. In the Yukon, she traveled alone on horseback to report on the willows of the far

Northwest for Boston botanist Charles Sargent. By the early twentieth century she had become the most prominent woman botanist in the West, and perhaps in the country.[25]

In a regional culture that was reluctant to invest in scientific research, and even less eager to accept women in positions of expertise, the career of Alice Eastwood attests to her own abilities as well as to the peculiar institutional flexibility of the academy. Nowhere else in the area could the scientific professional, the accomplished amateur, and the idly curious so readily mingle and provide mutual support. For survey scientists, the academy provided a base. For its curators, it offered work for those with some scientific training but limited possibilities for local employment. For the public, the academy gradually emerged as a showcase for the display value of science.

To attract the public, however, the academy desperately needed the financial backing prescribed by Agassiz. Finding patrons thus remained its first priority during the Davidson years. Upon becoming president in 1871, Davidson and his fellow academy officers created a board of trustees composed of prominent San Franciscans with an interest in the academy's welfare. "The life of the Institution has been a hard struggle in this city," Davidson observed in his annual president's address in January 1873, "but from the sheer vitality of scientific truth, it has succeeded, in spite of the indifference of those who were devoting their energies to business." Thanks in part to Agassiz's recent visit, he felt certain that at last a "deep and active interest has been awakened among our citizens having scientific instincts." To encourage those interests, he appointed an advisory board of wealthy Bay Area residents in 1874 to remedy the academy's lack of adequate quarters. Led by Southern Pacific Railroad magnates Leland Stanford, Charles Crocker, and their associate David Colton, this committee donated sufficient funds to move the academy from the stuffy rooms Agassiz had criticized to more spacious, if unusual, quarters. For the next seventeen years, the academy occupied the former First Congregational Church building on California Street, replacing the pews with cabinets full of minerals, reptiles, and prehistoric skeletons.[26]

By far the largest donor to the early academy, and to science in general in late nineteenth-century California, was James Lick. In February 1873, just five months after Agassiz's visit, the aging local millionaire donated to the academy a valuable Market Street lot in

downtown San Francisco. When Davidson appeared at the Lick Hotel to thank their benefactor for the unsolicited gift, he found a bedridden, reclusive bachelor with a reputation for eccentricity. The millionaire and the scientist took great interest in each other. Lick sought worthy benefactors for his estate, and Davidson was looking for a patron for science in California. The eventual result was one of the finest astronomical observatories in the world, marking California's first step into national scientific prominence. The interaction of scientist and patron, however, revealed how far California had to go to establish a social context for the support of science.[27]

Unlike most of San Francisco's first millionaires, James Lick accumulated his fortune before the gold rush. The son of a rural Pennsylvania cabinetmaker, Lick followed in his father's footsteps until, as one biographer phrased it, he "became enamoured of the daughter of the local miller, and in the course of time necessity compelled the couple to ask the father permission that they be wed." The miller refused to consent until Lick could produce a mill as fine as his own. The young cabinetmaker departed for Baltimore, became a successful pianomaker, took his business to South America and made a fortune. He returned to Pennsylvania to find that his sweetheart and their son had disappeared.[28]

Lick moved to San Francisco on January 7, 1848, seventeen days before James Marshall discovered gold at Sutter's Fort. While others rushed to the mines, Lick quietly acquired San Francisco real estate. He also constructed a mill considerably more substantial than the one owned by his lost sweetheart's father. In 1860 he built the most elaborate hotel in San Francisco, named it after himself, and moved into one of its smallest rooms. There he remained for the rest of his life, rarely socializing and eschewing conspicuous consumption. By the 1870s Lick, who had located his son but never married, became anxious to perpetuate his name. He began a campaign of public generosity in an effort to fill the emptiness, and correct the failures, of his private life. Feeling cheated out of a wife and son, he built homes for widows and orphans. Cut off from his pre-California past, he earmarked over $600,000 for the Society of California Pioneers. He ignored his aging sisters but established a nursing home that bore the unfortunate name of Lick Old Ladies Home. His first will practically disinherited his son, allotting him $3000 while setting aside $150,000 for the construction of public baths in San Francisco.[29]

When Davidson met him, Lick's foremost concern was the con-
struction of some final monument to himself. One of his plans, a
century before its time, was to construct a huge pyramid in down-
town San Francisco. Another was to build an astronomical observa-
tory. Davidson's interest in science had begun in Bache's observatory
in Philadelphia; since 1869 he had been "feeling the ground" con-
cerning a major observatory on the West Coast. Now, it seemed, he
had struck pay dirt.[30]

But much remained to be done. In a series of regular visits to the
Lick Hotel, Davidson gradually persuaded Lick to adopt the observa-
tory plan. The old cabinetmaker thought a downtown San Francisco
site would be best; he envisioned a prominent dome enhanced by
statues of Tom Paine, Francis Scott Key, and himself. Davidson re-
plied that such a structure might be impressive to behold, but city
lights and ocean fog would render it nearly useless to look through.
Lick wanted the observatory to "rank first of any of the World," with
a telescope "that shall surpass in power anything yet attempted."
Davidson noted that the size of the telescope mattered little unless
the bequest allowed for a sufficient scientific staff to operate it. Lick
told him that he had discussed the observatory idea with Joseph
Henry when the Smithsonian director stayed at the Lick Hotel in
1871. Davidson promptly wrote to Henry and enlisted his aid in
convincing Lick that a well-situated, fully staffed research facility
would contribute far more to science than an ornately housed city
telescope.[31]

Lick died in 1876. In 1888 the Lick Observatory, located on forty-
two-hundred foot Mount Hamilton, began operation under the aus-
pices of the University of California. Its thirty-six-inch telescope re-
mained, for a few years, the largest in the world. Three years later the
Academy of Sciences moved into the Market Street headquarters
made possible by Lick's bequest. When Agassiz bemoaned its shabby
quarters in 1872, the academy could not even match the Barnum-
esque "Pacific Anatomical Museum and Gallery of Natural History
and Science" with its "celebrated Du Chaillu GORILLA" and compara-
ble wonders. Twenty years later, its new six-story stone structure
housed the most substantial natural science museum in the West.
Visitors entered the main exhibit hall to find a restored woolly mam-
moth, surrounded by mastadon tusks and selected skeletal remains
of "other extinct elephants." Arranged throughout the museum were

hundreds of thousands of specimens, including mammals, fish, birds, plants and flowers, reptiles, insects, fossils, minerals, all carefully identified, and a display of reconstructed skeletons ranging "from the gray whale of California to the humming bird." The building also featured a room "devoted to the woods of California and the Pacific Coast" and a sizable lecture hall "where the meetings of the Academy are held, and where science is popularized for the benefit of the people by means of lectures illustrated by the stereopticon and delivered by distinguished scientists."[32]

When the academy moved into these lavish new quarters, however, George Davidson was no longer president. In the absence of clear professional roles, the academy's day-to-day operations had become enmeshed in personality conflicts. Never reluctant to speak his mind in a dispute, Davidson defended his authority against repeated criticism from H. W. Harkness, a physician and amateur specialist in fungi. In 1887 Harkness defeated Davidson's bid for a seventeenth term as academy president. For the next several years Davidson shifted his organizational energies to several other science-related groups, particularly the Geographic Society of the Pacific, of which he was a cofounder in 1881. He also devoted more time to the tiny astronomical observatory, the first one on the West Coast, that he had installed in 1879 in San Francisco's Lafayette Square.[33]

In 1895, Davidson's interest in securing patronage for science acquired a personal urgency when, without warning, pressure on Congress to cut the budget led to his dismissal, at age seventy, from the Coast Survey. For the next three years he hired himself out as a consulting engineer. Advising shipping firms at noon and charting the stars at midnight, he moved between pure and applied science as readily as in his early years with the Coast Survey. In 1898 he accepted a position as professor of geography at the University of California. Occupying the office adjacent to that of his old friend and fellow septuagenarian Joseph Le Conte, Davidson enjoyed the companionship of university scientists until failing eyesight forced him to retire in 1905.[34]

By the end of his career, Davidson had participated in nearly every institutional variety of science in California. He found complete security and professional fulfillment in none of them: only in the amalgam could they support his activities as a scientist. Much of the effort that might have gone into his work went instead to develop-

ing a network of regional support for science. And in his scramble for an institutional foundation, he found little opportunity to act upon his growing concern over the commercial plundering of the land and waterways he had mapped and studied for half a century. But if Davidson ever spoke wistfully of his friend's relatively serene professional life in a single institution, Le Conte no doubt reminded him that the problems of patronage and identity did not leave off where the college campus began.

George Davidson
(Bancroft Library,
University of Cali-
fornia, Berkeley)

John Muir (Bancroft
Library, University of
California, Berkeley)

Joseph Le Conte
(Bancroft Library,
University of Cali-
fornia, Berkeley)

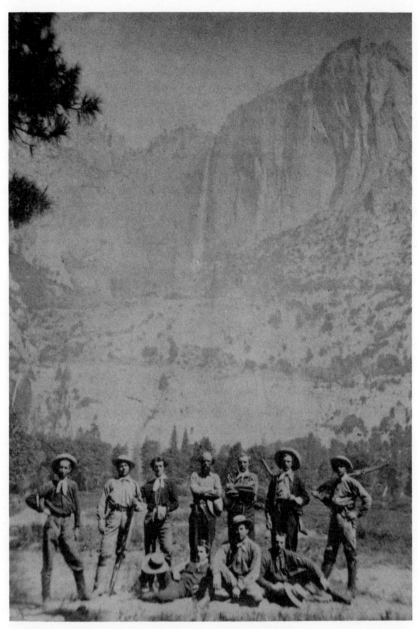

Joseph Le Conte (standing, fourth from left) with the University
Excursion party in Yosemite Valley, 1870. (Bancroft Library,
University of California, Berkeley)

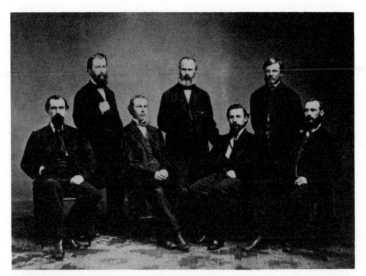

California State Geological Survey, December 1863.
Standing: William More Gabb, J. D. Whitney,
Clarence King. Seated: Chester Averill, William
Ashburner, Charles Hoffmann, William Brewer.
(Bancroft Library, University of
California, Berkeley)

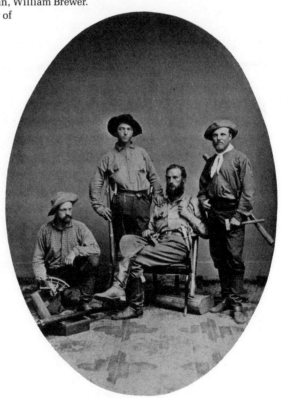

California State
Geological Survey,
1864 field crew:
James Gardner,
Richard Cotter,
William Brewer,
Clarence King.
(Bancroft Library,
University of Cali-
fornia, Berkeley)

California Geological Survey topographer Charles Hoffmann
surveying the mountain that bears his name. (Bancroft Library,
University of California, Berkeley)

Field party, California Geological Survey. (Bancroft Library, University of California, Berkeley)

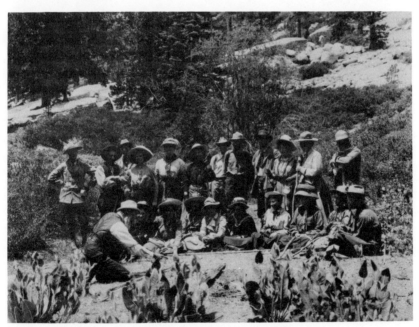

John Muir delivering a trailside lecture during a Sierra Club outing to Hetch Hetchy. (Bancroft Library, University of California, Berkeley)

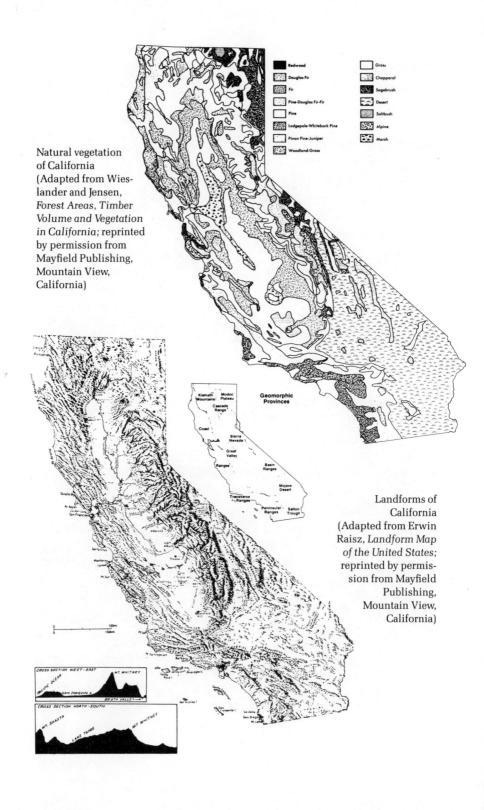

Natural vegetation of California (Adapted from Wieslander and Jensen, *Forest Areas, Timber Volume and Vegetation in California*; reprinted by permission from Mayfield Publishing, Mountain View, California)

Redwood
Douglas Fir
Fir
Pine-Douglas Fir-Fir
Pine
Lodgepole-Whitebark Pine
Pinon Pine-Juniper
Woodland-Grass

Grass
Chaparral
Sagebrush
Desert
Saltbush
Alpine
Marsh

Geomorphic Provinces

Klamath Mountains
Modoc Plateau
Cascade Range
Coast
Sierra Nevada
Great Valley
Ranges
Basin Ranges
Mojave Desert
Transverse Ranges
Peninsular Ranges
Salton Trough

Landforms of California (Adapted from Erwin Raisz, *Landform Map of the United States*; reprinted by permission from Mayfield Publishing, Mountain View, California)

CROSS SECTION WEST-EAST
MT. WHITNEY
PACIFIC OCEAN
SAN JOAQUIN V.
DEATH VALLEY

CROSS SECTION NORTH-SOUTH
MT. SHASTA
LAKE TAHOE
MT. WHITNEY

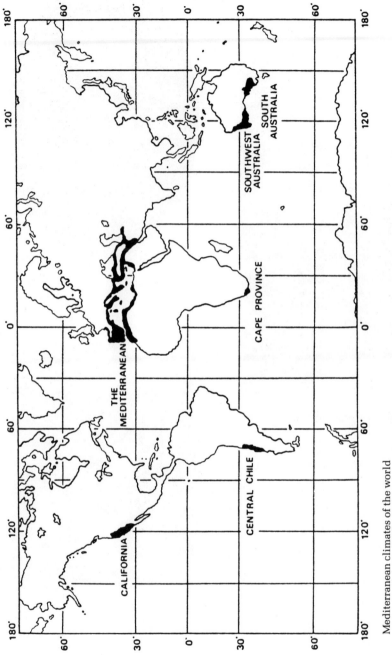

Mediterranean climates of the world
(Henry J. Bruman, "Sovereign California: The State's Most Plausible Alternative Scenario," in Henry J. Bruman and Clement W. Meighan, *Early California: Perception and Reality* [Los Angeles: William Andrews Clark Memorial Library, 1981], p. 5)

William Dudley
(Stanford Univer-
sity Archives,
Palo Alto)

Alice Eastwood (1859–1953)
was Curator of Botany, Cali-
fornia Academy of Sciences,
and saved valuable type
specimens from the 1906
earthquake-damaged
academy. (California
Academy of Sciences,
San Francisco)

Interior of the Market Street
museum of the California
Academy of Sciences, which
was destroyed in the 1906
earthquake and fire. (California
Academy of Sciences,
San Francisco)

"The duty of the Sierra Club," said Stanford University president David Starr Jordan, "is to stand between California scenery and California greed." (Stanford University Archives, Palo Alto)

Toppled statue of Louis Agassiz following the 1906 earthquake, Stanford University Campus. Despite Agassiz's strong influence on California's first scientists, most of them rejected his stand against Darwinian evolution. (Stanford University Archives, Palo Alto)

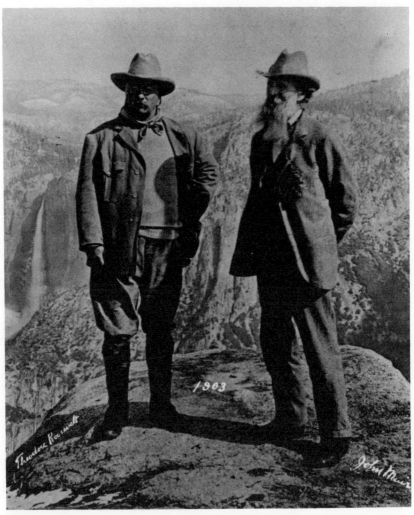

Yosemite camping companions: President Theodore Roosevelt
with John Muir at Glacier Point, 1903. (Bancroft Library, Univer-
sity of California, Berkeley)

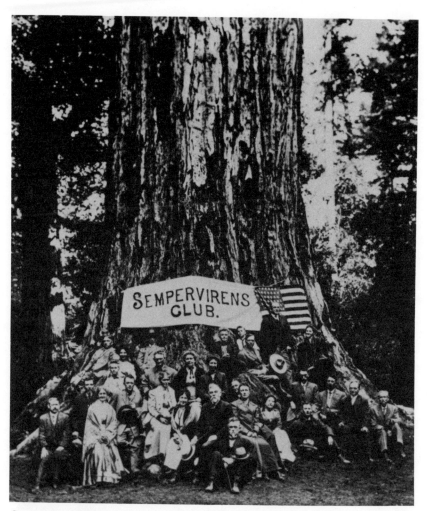

Sempervirens Club members in Big Basin Redwood Park, 1901.
(Sempervirens Fund)

Sweeping Back the Flood

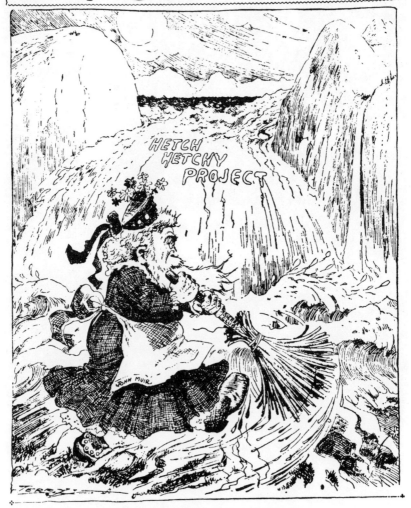

John Muir was a favorite target in the genderization of environmental reform that surrounded the Hetch Hetchy controversy, as this cartoon from the San Francisco *Call* demonstrates. (Bancroft Library, University of California, Berkeley)

6

The Struggle for Existence:
The Early University Years

"You are, after all, not so very much isolated in California," William James wrote to Josiah Royce in 1879. "We are all isolated. . . . Books are our companions more than men." But the young philosopher found little comfort in James' sanguine assurances. Educated at the new University of California, at Göttingen and Leipzig, and at Johns Hopkins, Royce knew too much about the geography of academia to feel content as an instructor at his young and struggling alma mater. Three years later, he left Berkeley to accept the position James had secured for him at Harvard.[1]

For earth and life scientists, the disparity between East and West was even more acute. Throughout the first half-century of California's statehood, they lamented that a region so rich in natural resources lacked an adequate system of higher education to support their work. When James' letter arrived in 1879, Royce's home state had only sixteen public high schools; most of California's few colleges functioned primarily as preparatory schools.

The geographic imbalance was as much a matter of timing as location. Anglo-American Californians habitually dated their region's history only as far back as the gold rush; and after all, they asked, how many schools had Boston or Philadelphia built after thirty years of settlement? What further complicated matters was that Eastern schools, and the academic sciences in particular, were themselves changing. Scientists developed a place for themselves in nineteenth-century American colleges through a process that generally fell into

three stages. During an initial period, science courses began to appear with some regularity, and faculty were hired for the express purpose of teaching those courses. A second stage was marked by further division of science courses into separate disciplines, as colleges struggled (often through elective courses) to find a place for science alongside the classical curriculum. A dynamic third stage emerged when scientists borrowed and adapted from European universities to establish their own graduate and scientific schools, emphasizing research and theory. As these stages of development progressed, sources of patronage became more institutionalized, and the public profile of scientists diminished.[2]

In many of the older colleges of the Northeast, the first period of this development occurred roughly between the 1820s and the 1840s; the second emerged between the 1840s and the 1870s; and the third began in the 1870s, reaching fruition in the early twentieth century. Academic scientists in California, by contrast, tried to duplicate the entire process between 1870 and 1915, with most of the changes occurring after 1890. One important result of this compressed transformation was that California scientists maintained a highly visible public role long after their Eastern counterparts had withdrawn from the lyceum to the laboratory. The acceleration also affected various scientific disciplines differently. Chemists and physicists were more hindered than most academic scientists by the lack of laboratory facilities and the relative absence of science-based industries in the Far West. As a result, geologists and life scientists dominated the academic sciences in California universities even more than in the rest of the country.[3]

As they had done in the East, religious organizations led the way in founding California colleges. A San Jose academy opened by Methodists in 1851 eventually became the University of the Pacific, in Stockton. Schools established in the 1850s by Jesuits in Santa Clara and San Francisco slowly evolved into universities. An Oakland seminary for women opened in 1871; in 1885 it was rechartered as Mills College, the first women's college in the West. And a men's boarding school organized by Congregationalist and Presbyterian ministers in Oakland in 1853 was absorbed into the new University of California in 1869.[4]

Small sectarian schools, however, offered few teaching positions for scientists, and no research opportunities. The first sign that California might participate in the national transformation of academic

science came with congressional passage of the Morrill Act and the subsequent effort to found the University of California. The Morrill Land Grant Act of 1862 provided federal endowments to establish and support colleges; the momentum for creating a state university in California began with the state's desire to get its share of the funds. Even more important for scientists was the Morrill Act's stipulation that eligible colleges must offer instruction in "agriculture and the mechanic arts" as well as "other scientific and classical studies." At a time when most colleges treated the sciences as peripheral, the Morrill Act institutionalized the possibility of a broader curriculum. Provided that they could convince the public of the value of science courses, scientists in the West might particularly benefit from the timing of the legislation. Many older Eastern colleges had resisted the development of science in their curricula; even the scientific schools at Harvard and Yale were held at arm's length from the main college until late in the century. But for California, the mandate of the Morrill Act was more of a precedent than a departure. Perhaps the new university would prove the state's lack of prior educational tradition to be a blessing for science.

Berkeley

Champions of university science in California discerned mixed omens in 1872. The University of California had completed three years of classes, but the faculty remained few and underpaid, and the rudimentary condition of the state's secondary schools meant that in the classrooms the university served as little more than a glorified high school. Yet the first building on its permanent Berkeley campus was within a year of completion, and—most promising of all— Daniel Coit Gilman had become president of the university.[6]

A former student, professor, and administrator at Yale's Sheffield Scientific School, Gilman had witnessed the struggle between proponents of the classical college curriculum and those who favored the emerging scientific disciplines. At Berkeley he urged expansion of the university's scientific faculty and facilities, emphasized the importance of original research, and deftly assured advocates of classical as well as vocational courses that scientific research would not detract from the liberal or manual arts. The California Grange and other farmers' organizations nonetheless denounced his views on

education as insufficiently utilitarian. The state university, they insisted, should provide practical training in agricultural and mechanical skills; anything else exceeded the state's mandate. With no comparable citizens' group to lobby for scientific research, Gilman discovered that Californians were not yet prepared to implement his proposals for a research institution. In 1875 he returned east to become the founding president of Johns Hopkins, the nation's first modern graduate school. For the next two decades, the University of California accommodated itself to nondescript presidents and lukewarm legislative support.[7]

Throughout the 1870s, Joseph Le Conte almost single-handedly covered the university's offerings in geology and biology, with indirect assistance from the vocational colleges of the university. Beginning in 1874, when Eugene Hilgard was hired to direct the College of Agriculture, a growing staff of agricultural geologists, horticulturists, and viticulturists contributed their knowledge of the earth and life sciences. The fledgling College of Mining provided some help in mineralogy and geology; former California Geological Surveyor William Ashburner taught briefly in the mid-1870s, and in 1879 Samuel B. Christy, one of Le Conte's first students at Berkeley, joined the College of Mining staff, of which he eventually became the director. Significantly, Hans Behr, the university's first professor of botany, was hired for the College of Pharmacy in San Francisco, not for the Berkeley campus.[8]

The first significant addition to the university's courses in geology did not come until 1890 with the hiring of Andrew C. Lawson. Trained by the Canadian Geological Survey as well as at Johns Hopkins, Lawson embraced the new microscopic research techniques as well as the older generation of geologists' veneration for fieldwork. Charles Palache was a student and teaching assistant at Berkeley in the late 1880s and early 1890s. "My own interest was natural science," he recalled, but the courses were so sparse that he took mining classes because "there was more natural science [in them] than in any other course" except Le Conte's. Palache found Le Conte's lectures on geology and evolution "delightful," and wrote that the "great event of my college career was the horse back trip to the High Sierra" that he and three other students made with Le Conte in the summer of Palache's junior year. But Le Conte was nearly seventy; his field instruction was limited to these brief excursions. It was Lawson's arrival in 1890 that

signaled Palache's initiation into the daily rigors of field examination and geological mapping. Lawson set up petrographic research labs in "crowded and inadequate" storage rooms in South Hall and insisted that his students supplement all their research and reading by "going up there and *seeing the rocks.*" Without Lawson, Palache mused decades later, he would have drifted into the work for which his courses had prepared him: an "assayer with a dreary routine of work in uncongenial surroundings." Instead, he went on to graduate work at the University of Heidelberg and eventually became professor of mineralogy and curator of the Mineralogical Museum at Harvard.[9]

Life sciences at the state university only gradually developed as viable fields of study outside the agricultural college. In 1885 the university hired botanist Edward Lee Greene, a former Episcopal minister who once hatcheted his way into his church when a dissident faction of his congregation tried to prevent him from preaching. Greene's botanical methods were similarly intrepid; his habit of declaring his discovery of a new species at every turn exasperated his colleagues at the university and the Academy of Sciences. But he established the botanical gardens at Berkeley and attracted a number of enthusiastic students, one of whom, Willis Linn Jepson, joined the faculty and remained long after Greene had gone on to the Smithsonian. Less heretical than Greene, Jepson carried on the task of studying and classifying the flowering plants and trees of the state. His voluminous *Flora of California* owed "its great merit," according to one of Jepson's contemporaries, "to the wealth of field observation, ecological and geographic data, profuse illustration, and careful documentation . . . as well as to the eminently sane taxonomic judgment" that had sometimes eluded Greene.[10]

Two students of Le Conte and Greene—John C. Merriam and William Emerson Ritter—were primarily responsible for the emergence of zoology as a viable field at the University of California in the 1890s. Merriam left Berkeley for Munich to earn his doctorate, returning in 1894 as the university's first instructor of paleontology. Eventually the chairman of his own department, Merriam generated local interest in vertebrate and invertebrate fossils of the region. Annie Alexander, heiress to a Hawaiian sugar-cane fortune, audited Merriam's classes, and his lectures sparked her lifelong interest in fossils. Although never formally trained, she became an accomplished field paleontologist, conducting and financing expeditions to the Pacific

Northwest, to Alaska, and throughout California. An adept field photographer as well as an African big game hunter, Alexander devoted much of her time and money to her interest in the life sciences. Largely through Merriam's influence, she endowed the university's Museum of Vertebrate Paleontology and installed zoologist Joseph Grinnell as its curator.[11]

William Ritter returned to his alma mater from Harvard and, like Merriam, played an important role both as a teacher and as a securer of patronage for science at the University of California. Hired as an instructor in 1891, Ritter went on to become the first chairman of the university's new zoology department. What Lawson did for geological instruction at the university, Ritter did for zoology, initiating his students in field zoology and "confining [his] attention almost exclusively to California fauna."[12]

His most memorable contribution, however, resulted from his friendship with newspaper magnate E. W. Scripps. A self-styled "damned old crank," Scripps became convinced that "the only way to make democracy safe is to make it more scientific." Yet scientists, he felt, were "writing their books at each other, and using such big words and such technical language that the average man, even if he attempts to read their books, can't understand what they say or what it is all about." "They need an interpreter," he concluded, "who can translate their language into plain United States that the people can understand."[13]

Scripps found his interpreter in Ritter. With the growing emphasis on research at the turn of the century, many Eastern scientists disdained the popularization of science. Ritter thought both were essential. Scripps applauded the zoologist's belief that "an aristocracy of Learning is but a little better than an aristocracy of Wealth," sharing his fear that social decision-making might disappear from the public eye behind the mask of expertise. Ritter encouraged the publisher's interest in marine biology but insisted that popularization of any scientific discipline was useless without an equal commitment to original research. Their friendship led to the establishment of two institutions. Scripps persuaded Ritter to direct his Science Service, a project dedicated to the public dissemination of science; and Ritter convinced Scripps to found a marine biology research facility for the University of California. Located in La Jolla, the Scripps Institution

for Oceanographic Research became one of the finest facilities of its kind in the world.[14]

The Lick Observatory, the Museum of Vertebrate Paleontology, and the Scripps Institution added greatly to the stature of the state university. They were also part of an emerging recognition among wealthy Californians that science, like art, might provide a suitable subject for patronage. Part of the university's growth in the 1890s, however, was due to increased public funding. A principal reason for the legislature's new generosity was that a private benefactor had established, not a museum or an observatory, but an entire university—just across the bay from, and in direct competition with, the University of California. For Bay Area earth and life scientists, the founding of Stanford University meant the arrival of new colleagues at a crucial moment in the social development of the California scientist.

Stanford

On May 10, 1869, four months before the University of California began its first classes, several hundred troops and onlookers watched Leland Stanford drive the golden spike that marked the completion of the first transcontinental railroad. Stanford first came to California in 1852 and operated a successful grocery business in Sacramento. In 1861, at the prompting of a civil engineer named Theodore Judah, he cofounded the Central Pacific Railroad and petitioned Congress for subsidies to underwrite construction of the Western half of a coast-to-coast railroad. In that same year, Stanford was elected governor of California. Two years later, Judah died, but Stanford and his partners Collis P. Huntington, Mark Hopkins, and Charles Crocker went on to parlay Judah's idea into a multimillion-dollar fortune for each of them.[15]

Stanford made several gifts to the California Academy of Sciences in the 1880s. But his major contribution to science and learning in California developed after the death of his only child, fifteen-year-old Leland Stanford, Jr., in 1884. Although neither of them had graduated from college, Leland and Jane Lathrop Stanford decided to build a university on their Palo Alto estate in memory of their son. Disappointed that a lavish twenty-five-thousand-dollar salary could not

lure any of the major Eastern university presidents out to California to head their new school, the Stanfords decided to settle for a lesser-known man at a smaller salary. Cornell president Andrew D. White recommended a former student of his, Indiana University president David Starr Jordan.[16]

At age forty, Jordan impressed Stanford as a man who could "grow up with the university." Born on a farm near Gainesville, New York, Jordan was the fourth of five children in a family with no great wealth, but proud to be "all of the old Puritan stock." Like many scientists of his generation, he first became interested in the natural sciences during childhood botanizing expeditions in the surrounding countryside. In the spring of 1869 he enrolled in the new university established by Ezra Cornell at Ithaca, where he intended to become either "a botanist or a breeder of fine sheep."[17]

"Cornell began in the mud of a poor hill farm on the edge of a country village," Jordan recalled, "with a group of boy professors, few books, no traditions, and no achievements." Yet its lack of traditions led this "frontier school" quickly to develop courses in the sciences that matched or surpassed the offerings of the older Eastern colleges. Cornell also encouraged "impecunious" students like Jordan, allowing them to pay their way through college by working on the construction of the campus.[18]

Jordan received his Master of Science in June 1872, but jobs for young biologists were scarce. In September he took his first teaching position at Lombard College in Illinois, where his responsibilities included "Zoology, Botany, Geology, Mineralogy, Chemistry, Physics, Political Economy, Paley's 'Evidences of Christianity,' and, incidentally, German and Spanish!" The following summer he joined fifty students and teachers on Penikese Island, where Louis Agassiz had just returned from South America and California to conduct a summer school for zoologists. Penikese confirmed Jordan's career interest in ichthyology, and dramatized Agassiz's insistence on "the necessity of going directly to nature" rather than to books or specimens alone for scientific analysis. But Agassiz's emphasis on field observation led Jordan to disagree with his mentor's rejection of evolution. He was eventually "converted," Jordan recalled, "not by [Darwin's] arguments, but rather by the special facts unrolling themselves before my eyes." Even so, the process was a difficult one: "I

went over to the evolutionists with the grace of a cat the boy 'leads' by its tail across the carpet!"[19]

Agassiz died the following December, but Jordan returned to Penikese in the summer of 1874. Agassiz's son Alexander, who conducted the school that summer, brought Jordan to the Museum of Comparative Zoology at Harvard. Money was scarce, however, and Jordan moved on to a series of high school and college teaching posts in Indiana. In the fall of 1879, he was appointed professor of natural history at Indiana University and "thus became the successor of the veteran geologist, Dr. Richard Owen." Like Davidson before him, Jordan was fascinated by the New Harmony community and even became a guest lecturer there at Richard Owen's request.[20]

In 1879 Jordan was appointed by the U.S. Fish Commission to investigate the marine life of the Pacific slope—"one of the most important events in my scientific career." In San Francisco he visited the California Academy of Sciences, unaware that he would serve as its president sixteen years later. He met Muir, whose published work he admired, and discussed the California terrain with Davidson and Le Conte. Jordan returned to Indiana thinking of California as socially primitive but challenging to the scientist.[21]

In 1884, Jordan set aside his plan to concentrate on fieldwork and became president of Indiana University. He labored to shape Indiana in Cornell's image until the spring of 1891, when Leland Stanford arrived in Bloomington and after "a short consultation," convinced Jordan to come to Palo Alto. Privately, Jordan worried that "California was the most individualistic of the States, and still rife with discordant elements"; he also had doubts about the university that "was to be 'personally conducted,' its sole trustee a businessman who was, moreover, active in political life" (Stanford became a U.S. Senator in 1885). "But the possibilities were so challenging"—and, perhaps, the increase in salary from four thousand to ten thousand dollars so enticing—that he soon found himself aboard a westbound train for a preliminary visit.[22]

Jordan's first impression of Leland Stanford Junior University foreshadowed much of his later experience as president. "I have just returned from California," he wrote to Cornell classmate John C. Branner in May 1891, "and I find the prospect in every way even more attractive than I had at first imagined." Admittedly, he added,

"there is a vast amount of preliminary work to be done, and the opening next fall will be on a very small scale and tentative in character." Yet he was convinced that "no more beautiful sight for a university exists in the world." Jordan's accidental substitution of *sight* for *site* was telling; for although he described the promising physical plant of the university ("the campus of eighty-three hundred acres, an arboretum of fifty thousand trees, and twelve hundred and fifty thousand dollars already spent on buildings"), it was the California setting that reassured him when he feared for the project's success. It remained to be seen whether the Stanfords' notions of a fitting memorial to their son would include the research needs of a university faculty; but a stroll of the grounds always seemed to offer auspicious signs. Ensconced in his new office two months later, Jordan continued to locate his optimism in the surroundings. "Nothing could be more promising than the present outlook here, and no place in the universe more delightful than Palo Alto. To do one's work with a background of palms and mountains and the cool atmosphere, in new buildings, is very attractive in the month of July." Only his closing witticism betrayed a nervous edge: "When the students and professors get here, the work of managing the institution will perhaps be more difficult."[23]

It was. When 480 students arrived for the first term, they found a beautiful setting but no books, inadequate housing, and an unfinished campus. Construction proceeded throughout the year, but Jordan had to persuade Senator Stanford that the school's library needed to be more than "such as a gentleman would have for his own use, to cost four or five thousand dollars" out of a total endowment of twenty million. The university received a considerable blow the following year, when Stanford's death led to a lawsuit by the United States government against Stanford's estate for fifteen million dollars in outstanding loans and interest owed by the Central Pacific Railroad. For the next six years the faculty endured reduced salaries; indeed, they owed even that much to a probate judge who ruled that they were Mrs. Stanford's servants and therefore eligible for funds from her estate allowance during the court litigation. For the rest of the decade, Stanford University scientists had to supply their own equipment or do without.[24]

Crucial to the university's survival for the next dozen years was Jordan's influence with Jane Lathrop Stanford. As chief surviving

benefactor and the only active trustee of the university, the senator's widow fully dedicated her energies to her own vision of the university—which was often at odds with Jordan's. (She opposed construction of a campus hospital, for example, on the grounds that the public would then associate the school with illness.) After 1899, when the university won its court case against the government, Jordan pleaded with her for better faculty salaries and research facilities. But Mrs. Stanford replied that she was "appalled at the big sums you quote," chiding Jordan that a "young institution cannot expect in its infancy to be equipped on an equality with Cornell or the Massachusetts Institute of Technology in special departments." Instead, she applied the bulk of the freed endowment to new construction. The ensuing "stone age," as Jordan ruefully labelled it, featured a Memorial Church in memory of her husband, and a new "university museum," in which Mrs. Stanford displayed her son's childhood toys, finery from her wardrobe, and other Stanford family ephemera. While reports circulated that some faculty families were underfed, the campus kept expanding, and Mrs. Stanford insisted "that it is not the time for increasing salaries until the present drain for buildings is past. When the time comes for increasing salaries I shall not have to be urged." Meanwhile, one disgruntled professor wryly advised his colleagues to "feed their families buff sandstone," since "it seems to be the one plentiful thing."[25]

In spite of these obstacles, Jordan managed to assemble an energetic and capable faculty—mostly young professors from Midwestern universities. Many of them, particularly the scientists, were Jordan's old friends and colleagues from his Cornell and Indiana days. His first appointment in geology went to his Cornell companion, John C. Branner. A field geologist who won early distinction for his work in Brazil, Branner followed Jordan to Indiana before becoming the Arkansas state geologist. When Jordan offered him a position at Stanford, Branner was undeterred by his friend's warning about the commercial orientation of California: he had recently been hanged in effigy for refusing to lend credence to speculation on the possibility of diamond mines in Arkansas. Branner later succeeded Jordan as president of Stanford. His Arkansas assistant, James Perrin Smith, came with him and succeeded him as chairman of the geology department.[26]

Charles Gilbert and Douglas Houghton Campbell, two of Jordan's appointees at Indiana, became Stanford's first zoologist and botanist,

respectively. An early addition in botany was William Russell Dudley, Jordan's roommate at Cornell. Rejecting his father's advice to go to nearby Yale, Dudley had gone to Cornell for its superior program in the natural sciences. ("During a visit I paid to the family home in the summer of 1871," Jordan recalled, "Mr. Dudley said to me, 'There comes Willie across the fields with his hands full of flowers. I wonder if he can ever make anything out of that.' ")[27]

As undergraduates, Dudley, Jordan, and Branner belonged to the same boarding club—The Struggle for Existence—and "tramped together every hill, explored every gorge and penetrated every swamp for many miles around Ithaca." Like Jordan, Dudley attended Agassiz's summer session at Penikese. He then returned to Cornell to earn his Master of Science degree and teach botany. In the late 1880s he did graduate work at Berlin and Strasbourg, where he met his future Stanford colleague, Douglas Campbell. When he accepted Jordan's offer to come to Stanford in 1892, Dudley knew he would be among friends.[28]

He did not have much else. Campbell recalled that Dudley's "laboratories, if such they may be called, occupied the attic of one of the shop buildings back of the quadrangle." LeRoy Abrams, one of Dudley's first students at Stanford (and his successor on the faculty) recalled his first visit to that shop attic:

> And here I did find him tucked away in one end of a loft, in a single room, one corner of which had been partitioned off as an office. . . . It was a curious room, this "laboratory," perched high amid the rafters. Three huge beams ran lengthwise of it a good hurdling distance apart, but about five feet and a half from the floor. With an apologetic smile, he warned me of these as he calmly ducked under the first [beam]. . . . Day after day throughout the course, as he went from student to student directing their studies, he patiently dodged those formidable beams.

Ten years passed before Dudley could move to better facilities and install adequate laboratory equipment.[29]

In the interim, the forests of California provided a more suitable laboratory—and considerably more headroom—than his shop attic. Nearly every summer he explored the conifers and flora of the Sierra and Coast Ranges, "camped among the Sequoias," and amassed a collection of botanical specimens that formed the basis for Stanford's

Dudley Herbarium. Within a few years he surpassed the lumbermen themselves in his firsthand knowledge of the forests of California. In the process, Dudley became an increasingly committed advocate of scientific forestry. He found evidence of the need for environmental reform throughout the state. During a visit to the largest lumber mill in the Sierras, he determined that in addition to its prodigious rate of production (two hundred thousand board feet per day in August), the lumber company was destroying half to seven-eighths of each tree through wasteful lumbering. To Dudley, such treatment of twenty-five-hundred-year-old trees revealed "criminal indifference to their real value." "I cannot help thinking," he wrote of the giant sequoias, "we are here in the presence of one of the most remarkable products of the globe, not excepting those of human civilization." How many empires could approach the longevity of these trees? Furthermore, monuments to human achievement were often erected at great social cost; but "in the building of a Sequoia, no blood has been shed through all its twenty-five hundred years, no injustice or oppression has secured the means necessary for its construction . . . no accident occasioning pain or suffering or the extinction of human life has left a stain on the history of its growth."[30]

Dudley's lament was one which an increasing number of his scientific colleagues had come to share. Few Californians knew as vividly as the scientists how rapidly the state's natural resources were being depleted. Yet the scientists' professional role allowed them little opportunity to prescribe social remedies for the state's extractive mentality. Some of them still held out hope that as Californians became more familiar with the physical environment, their social vision would improve. In a December 1898 article in the *Atlantic Monthly*, Jordan readily conceded "that California is commercially asleep, that her industries are gambling ventures, that her local politics is in the hands of professional pickpockets, that her small towns are the shabbiest in Christendom, that her saloons control more constituents than her churches, that she is the slave of corporations, that she knows no such thing as public opinion, that she has not yet learned to distinguish enterprise from highway robbery nor reform from blackmail." Nevertheless, Jordan saw great social strength deriving from "three sources—scenery, climate, and freedom of life." In such an inspiring and invigorating natural setting, children grew "larger, stronger, and better formed than their Eastern cousins," and the "feeling of children

released from school remains with grown people." "In an old civilization," he asserted, "men grow like trees in a close-set forest." But "contact with facts of nature has taught the Californian something in itself. To have elbow-room is to touch nature at more angles, and whenever she is touched, she is an insistent teacher."[31] Once again, Jordan looked to the natural environment for signs of social progress.

The president of Stanford was not arguing a crude form of environmental determinism. On the contrary, he was prominent among scientists who stressed the importance of heredity. But while in California, Jordan distinguished himself from most eugenicists by arguing for the modifying effects of the Far Western environment on nature and society alike. Along with many of his Bay Area colleagues, he discerned far-reaching social implications in improved human uses of nature, and he considered California's rich natural environment to be an ideal starting point for ecologically informed social change.[32]

Gradually, California's earth and life scientists were evolving a social outlook that projected their own interaction with the terrain as a blueprint for the region's social development. Many of their Eastern colleagues embraced a Spencerian appropriation of natural selection as an explanation for individual violence, class struggle, and industrial civilization's adversarial stance toward nature. But Pacific scientists gravitated toward a kind of social Humboldtism, stressing the democratizing effects of interdependent adaptation to the environment.

The optimism in Jordan's article, however, became increasingly difficult to embrace. Californians were ignoring the "lessons of the landscape" surrounding them. If the scientists wanted to gain popular acceptance for their ideas on resources and the social use of expertise, they would have to become more outspoken as advocates of an environmental ethic. Yet to do so meant going well beyond the customary social boundaries of their work. Advocacy of unpopular reforms also risked the loss of badly needed public patronage. What the scientists needed was a figure who shared their environmental concerns yet remained unfettered by institutional restrictions. They found such a person in John Muir.

John Muir: Science without Walls

John Muir was not in the audience when Agassiz addressed the California Academy of Sciences in 1872. Not even the idol of his college years

could lure him down from his cabin in the Yosemite Valley. Muir grew nervous in any crowd of three or more, and he would have experienced particular discomfort in the academy's chambers that night. Considering himself excluded from official scientific recognition by his lack of credentials, Muir was reluctant to address scientists on their own terms. He resisted publishing his glacial findings, claiming that "there is something not quite honorable" in such a "transformation of raw bush sugar and mountain meal into magazine cookies and snaps." His insecurity over submitting his first significant findings to public scrutiny only fed his distrust of commercialization and his assertion of primacy of place over text: "Why should I take the trouble to coin my gold?" he asked in a Yosemite notebook. "Some will say it is Fool's Gold. It cannot be weighed on commercial scales. There is no market." Publications, he implied, merely distanced the reader from the place, commodifying and creating a false sense of familiarity. "Only a few may be persuaded to come and see." Muir felt the natural forces at work in California's landscape could be perceived only by direct observation.[33]

Pacific scientists did not share Muir's disdain for the printed word, and Muir reversed his opinion when he discovered his ability to attract public attention to the terrain. Yet even the widespread recognition he received for his work on Yosemite glaciers failed to lure him into pursuing a professional scientific career. Because he was attached to no scientific institution, he was the least reluctant among his peers to risk the "unprofessional" image his social observations might convey. His pronouncements on the need for environmental reform and the stifling effects of established institutions bore a jeremiad quality that prompted good-natured teasing from his friends and ridicule from his enemies. But his message—essentially unchanged since his early years in Yosemite—served as a catalyst in the California scientists' effort to redefine their social role.

Muir's critique began with a rejection of the anthropocentric view of nature that characterized Victorian culture in general. "The world, we are told, was made especially for man," he wrote in his Yosemite journal in 1867, "a presumption not supported by all the facts." Those guilty of this misperception, he noted, had most social institutions on their side, and they were "painfully astonished whenever they find anything, living or dead, in all God's universe, which they cannot eat or render in some way what they call useful to them-

selves." Such a person "is regarded as a civilized, law-abiding gentle-man . . . ; is a warm supporter of the English constitution and Sunday schools and missionary societies; and is as purely a manufactured article as any puppet at a half-penny theater." With a Scots crofter's penchant for lampooning the urban smugness of Anglo-American middle-class culture, Muir maintained that "to such properly trimmed people," "whales are storehouses of oil . . . to help out the stars in lighting our dark ways until the discovery of the Pennsylva-nia oil wells. Among plants, hemp, to say nothing of the cereals, is a case of evident destination for ships' rigging, wrapping packages, and hanging the wicked. Cotton is another plain case of clothing. Iron was made for hammers and ploughs, and lead for bullets; all intended for us."

To Muir, however, this commodification of the earth obscured humanity's familial link with the everyday forces of nature. "Why should man value himself as more than a small part of the one great unit of creation?" Like all other living things, humans had evolved from "the common elementary fund" of genetic material. They ig-nored that kinship at their peril. Muir did not intend his critique to be construed as misanthropic: "the universe would be incomplete without man; but it would also be incomplete without the smallest transmicroscopic creature that dwells beyond our conceitful eyes and knowledge."[34]

Over time Muir charted a topography of human arrogance. In the foothills "the California sheep owner is in haste to get rich, and often does," by overgrazing the public domain. "This quickly acquired wealth creates desire for more. Then indeed the wool is drawn close down over the poor fellow's eyes, dimming or shutting out almost everything worth seeing" until the hillsides were too depleted for further grazing. On the plain, the large-scale farmer was "not content with the so-called subjugation of every terrestrial bog, rock, or moor-land," and "would fain discover some method of reclamation applica-ble to the oceans and the sky." All up and down the valley floor Muir found the "barbarous notion" that "there is in all the manufactures of Nature something coarse which can and must be eradicated by human culture." And like Dudley, he was appalled by the ongoing devastation of California's forests.[35]

Muir's solution was to put his reputation as a naturalist to work, not in the scientific professions, but for environmental reform. In-

spired by the land use ideas of his San Francisco neighbor Henry George, in the late 1870s Muir began lecturing and writing on the corporate devastation of California's natural resources. The title of his first overtly political article foreshadowed the sermonizing quality of his work as a conservationist: "God's First Temples—How Shall We Preserve Our Forests?" But the subtitle revealed how Muir, who had formerly avoided calling himself a scientist at all, now found a legitimating function for that role: "The Question Considered by John Muir, the California Geologist—the Views of a Practical Man and a Scientific Observer."[36]

During the 1880s, Muir married and settled down to the life of a prosperous horticulturist on his father-in-law's fruit farm, with only periodic escapes to Alaska or the High Sierra. Like the surveyors and university scientists of the region, he had wrestled with the relation of science to the marketplace in California and had improvised a solution. But like them, he felt a growing dissatisfaction with scientists' inability to convey the social implications of their findings to their fellow Californians. By the 1890s, Pacific scientists were willing to consider another alternative: a nonscientific organization through which scientists could act as advocates of environmental and social change. Where government surveying, teaching in universities, and freelancing had failed, perhaps the Sierra Club could succeed.

four

Scientists and Environmental Reform

7

The Greatest Good:
Scientists and the Sierra Club

On June 4, 1892, twenty-seven Californians gathered in a San Francisco attorney's office to officially incorporate the Sierra Club. Their Articles of Association specified two very different functions for the new organization. Its members would gather "for the purpose of exploring, enjoying and rendering accessible the mountain regions of the Pacific coast." Unlike its Eastern and European counterparts, however, this mountaineering club was founded with a second, explicitly political goal: "to enlist the support and co-operation of the people and the government in preserving the forests and other features of the Sierra Nevada Mountains."[1]

The majority of the club's charter members no doubt joined simply as enthusiasts of wilderness outings, with little interest in the politics of land use. An activist contingent, however, saw the Sierra Club as a "Defense Association" for Yosemite, the High Sierra, and the promotion of conservation principles in California. Through their efforts, the club helped to lift environmental issues into new prominence in American politics and culture.

How did a small mountaineering club in San Francisco come to exert national influence in environmental policy debates? What positions and tactics did the Sierra Club adopt, and who formulated them? In an effort to answer these questions, historians have provided numerous interpretations of the Sierra Club's part in the Hetch Hetchy controversy, a nationally publicized battle over San Francisco's plan to dam a valley in Yosemite National Park for the city's

water supply. But the complex local and federal struggles surrounding the Hetch Hetchy debate greatly distorted the environmental views of its participants (see chapter 8).

The political and educational activities of the Sierra Club in its first decade, before Hetch Hetchy became a major campaign, offer a clearer picture of the issues behind the club's emerging political identity. Those activities also reveal the crucial leadership provided by Bay Area natural scientists. From the scientists' viewpoint, the Sierra Club provided a forum for the social concerns they had derived from their work.

The resolution of the Hetch Hetchy controversy in 1913, and the death of John Muir the following year, marked the end of the early activist phase of the Sierra Club. The years 1892–1914 also encompassed the scientists' most intense efforts to act as advocates of social change regarding land and resource use.

Organization of the Sierra Club

The Sierra Club was by no means a professional scientific organization. Of its 182 charter members, only 25 (about 14 percent) could be called scientists, even by a generous application of the term.[2] Yet given that the profession was represented by a fraction of 1 percent of the state's population, this number was quite high. No other nonscientific organization in the region could claim so many scientists among its active members. Furthermore, 21 of the 25 charter Sierra Club scientists were earth and life scientists—precisely those scientists for whom the state's mountains and forests served as a workplace. Membership data for the club during the scientists' years of peak activity (1892–1905) are fragmentary; most unpublished records were destroyed in the 1906 San Francisco earthquake. Available materials, however, suggest that while scientists continued to join the Sierra Club, the growth of the club's membership in general—a ten-fold increase by 1914—greatly outpaced them. Thus the percentage of scientists decreased as the club's ranks swelled.[3]

The characteristics of the scientist members, however, appears to have remained fairly constant (see table 7.1). Geologists and biologists accounted for three out of every four scientists known to have joined the club between 1892 and 1906. Two-thirds of the scientists held academic posts at Berkeley or Stanford; 20 percent worked

TABLE 7.1 Scientists in the Sierra Club 1893–1906 (partial list)

Earth-scientists
*John Muir
*Joseph Le Conte (UC)
*Andrew C. Lawson (UC)
*Robert H. Loughridge (UC)
Eugene Hilgard (UC)
*Charles Palache (UC)
*John C. Branner (LSJU)
Grove Karl Gilbert (USGS)
Robert Marshall (USGS)
*Mark B. Kerr (USGS)
*Willard Johnson (USGS)
*R. H. Chapman (USGS)
*R. H. McKee (USGS)
*George Davidson (USCGS, CAS, UC)

Chemists
J. M. Stillman (LSJU)
E. C. Franklin (LSJU)

Physicists
*Fernando Sanford (LSJU)
Joseph Brown (LSJU)
*E. R. Drew (UC)

Climatologists
McAdie, Alexander (U.S. Weather Bureau, San Francisco)

Botanists
William R. Dudley (LSJU)
Douglas H. Campbell (LSJU)
*Emory E. Smith (LSJU)
*Willis Linn Jepson (UC)
William Setchell (UC)
*E. L. Greene (UC, CAS)
*H. H. Behr (UC)
*F. T. Bioletti (UC)
Alice Eastwood (CAS)
Gustav Eisen (CAS)
*H. C. Behr (CAS)
*T. S. Brandegee (CAS)
*John Lemmon

Zoologists
*David Starr Jordan (LSJU)
Vernon Kellogg (LSJU)
*William W. Price (LSJU)
William E. Ritter (UC)

Mathematicians
*George C. Edwards (UC)
*M. W. Haskell (UC)
Albert Whitney (UC)
Rufus Green (LSJU)

UC = University of California (Berkeley)
LSJU = Stanford University
CAS = California Academy of Sciences
USGS = United States Geological Survey
USCGS = United States Coast & Geodetic Survey
* = charter member of Sierra Club

for California offices or federal scientific agencies; and 10 percent relied on the California Academy of Sciences as their principal scientific organization.[4]

The Sierra Club's connection with the natural sciences was not confined to the work of its scientist members. Of the 182 charter members, 73 (or 40 percent) also belonged to the California Academy of Sciences. Among them were several talented amateur botanists, ornithologists, and lepidopterists. And as the club's publications and educational outings attest, the general membership demonstrated an active fascination for the natural history of the region, all of which contributed to their esteem for natural scientists. A further indica-

tion of the club's veneration for explorer-scientists, and for scientific conservation reform, can be found in the list of people elected to honorary membership. Of the ten honorary members chosen at a general meeting in November 1892, five were scientists: J. D. Whitney and Clarence King for their years with the California Geological Survey (William Brewer later joined them on the list); John Wesley Powell, director of the U.S. Geological Survey; B. E. Fernow, director of the National Forestry Bureau; and Irish glaciologist John Tyndall. Of the remaining five honorary members, three occupied positions crucial to the political enactment of environmental reform: Secretary of the Interior John Noble; U.S. Senator A. Sidney Paddock of Nebraska, who had just introduced a bill calling for national forest reserves; and Robert Underwood Johnson, an editor of *Century* magazine who had first proposed to Muir the creation of a national park for Yosemite. Scientists and their relation to the politics of conservation figured prominently in the image that the Sierra Club members wished to project.[5]

The clearest evidence, however, that the scientists exerted a disproportionate influence on the early goals and strategies of the Sierra Club is the consistently high percentage of scientists among the club's directors. Of the nine members elected to the first board of directors, five were associated with earth or life sciences: John Muir (president), David Starr Jordan and John C. Branner of Stanford, and Mark B. Kerr and Willard Johnson of the U.S. Geological Survey. Scientists continued to hold key leadership positions between 1892 and 1914, occupying three to five of the nine positions on the board of directors during each of those years (see table 7.2). In other words, 33–55 percent of the club's officers came from a group that never constituted more than 14 percent of the general membership.

Several of the scientists were directors for many years, thereby becoming something of an institutional presence in their own right. Muir remained president, and the club's most visible member, for twenty-two years until his death in 1914. Davidson served vigorously for fifteen terms between 1894 and 1910, the year before his death. Dudley joined the Sierra Club in 1893, shortly after his arrival in California. He quickly became one of the club's most energetic activists, and served eleven terms as a director before failing health forced him to resign in 1909 (he died in 1911). Le Conte was second vice president from 1893 till 1898; he remained an honorary member

TABLE 7.2 Scientists on Sierra Club Board of Directors, 1892–1914

Term	n / %	
1892–1893	5 (55%)	Muir (a), Branner (b), Kerr (c), Jordan, Johnson
1893–1894	?	Muir (a), Le Conte (b), W. W. Price [others not known]
1894–1895	5 (55%)	Muir (a), Le Conte (b), Davidson, Stillman, Dudley
1895–1896	4 (44%)	Muir (a), Le Conte (b), Davidson, Stillman
1896–1897	5 (55%)	Muir (a), Le Conte (b), Davidson, Stillman, Jordan
1897–1898	5 (55%)	Muir (a), Le Conte (b), Davidson, Stillman, Jordan
1898–1899	4 (44%)	Muir (a), Dudley (c), Davidson, Jordan
1899–1900	3 (33%)	Muir (a), Dudley (c), Jordan
1900–1901	3 (33%)	Muir (a), Dudley (c), Davidson
1901–1902	4 (44%)	Muir (a), Dudley (c), Davidson, Jordan
1902–1903	4 (44%)	Muir (a), Dudley (c), Davidson, Jordan
1903–1904	3 (33%)	Muir (a), Dudley (c), Davidson
1904–1905	4 (44%)	Muir (a), Dudley (c), Davidson, McAdie
1905–1906	4 (44%)	Muir (a), McAdie (d), Davidson, Dudley
1906–1907	3 (33%)	Muir (a), McAdie (d), Davidson
1907–1908	4 (44%)	Muir (a), McAdie (d), Davidson, Dudley
1908–1909	4 (44%)	Muir (a), McAdie (d), Davidson, Dudley
1909–1910	4 (44%)	Muir (a), McAdie (d), Davidson, Franklin
1910–1911	3 (33%)	Muir (a), McAdie (d), Franklin
1911–1912	3 (33%)	Muir (a), McAdie (d), Kellogg
1912–1913	3 (33%)	Muir (a), McAdie (d), Kellogg
1913–1914	3 (33%)	Muir (a), McAdie (d), Kellogg

Mean % of all terms as director occupied by scientists: 42%

n = number of scientists on board of directors (total of 9)
% = percentage of directors who were scientists
(a) = president
(b) = 2d vice president
(c) = corresponding secretary
(d) = vice president

until his death in 1901. Jordan's duties as university president limited his active participation in the Sierra Club leadership; he nevertheless served seven terms as a director between 1892 and 1905, after which time he became a permanent honorary vice president.[6]

In addition to the directors, Sierra Club members who staffed various standing committees strongly affected the organization's actions and outlook. Most important of these was the Committee on Parks and Reservations. Although no minutes of its meetings have survived, evidence of its activities suggests that the parks committee functioned from about 1895 to 1905 as the club's official channel for political advocacy. Its members met with the state commissioners

TABLE 7.3 Scientists on Committee on Parks and Recreation, 1895–1905

Term	n / %	
1895–1896	2 (40%)	Davidson, Stillman
1896–1987	4 (80%)	Jordan, Davidson, Dudley, Kerr
1897–1898	?	[membership not known]
1898–1899	3 (60%)	Jordan (chmn.), Davidson
1899–1900	2 (40%)	Jordan (chmn.), Le Conte
1900–1901	3 (60%)	Davidson (chmn.), Dudley, Jordan
1901–1902	3 (60%)	Davidson (chmn.), Dudley, Jordan
1902–1903	3 (60%)	Davidson (chmn.), Dudley, Jordan
1903–1904	3 (60%)	Davidson (chmn.), Dudley, Jordan
1904–1905	3 (60%)	Davidson (chmn.), Dudley, Jordan

Mean % of all committee positions occupied by scientists: 55.5%

n = number of scientists on committee (total of 5)
% = percentage of committee members who were scientists

regarding the status and condition of Yosemite, and they orchestrated the club's campaign to win support from state legislators, congressmen, and federal officials for new forest reserves. Of the five positions on the Committee on Parks and Reservations, two to four were occupied by scientists in each of the nine years for which records have survived (see table 7.3). Over the course of those nine years, over 55 percent of the committee's members were scientists. And in each year for which a committee chair was designated, that chairman was a scientist.

Like the board of directors, the parks committee owed much of its staffing to a few scientists who served lengthy terms. Davidson's name appeared on the committee roster for eight of the nine years; from 1900 to 1905 he was its chairman. Jordan also served for eight years and chaired for at least two years. Dudley joined the committee in 1896 and served for at least six terms. Le Conte, Stillman, and Kerr also worked with the parks committee.

Scientists consistently appeared on the Admissions Committee, the Auditing Committee, and the Publications Committee as well. The chief responsibility of the Publications Committee was the *Sierra Club Bulletin*, a semiannual periodical that helped to define the image of the organization for its members and for the general public. The *Bulletin* first appeared as a twenty-four page pamphlet in January 1893; by the early 1900s, each year's issues filled nearly two hundred pages. In addition to the business and correspondence of

the club, the *Bulletin* carried out the founders' mandate "to publish authentic information" by printing three basic varieties of articles: narratives of mountain and wilderness excursions, including trail descriptions for hikers; scientifically informed discussions of the flora, fauna, or geological features of a particular area, usually written for interested nonscientists; and political arguments or data pertaining to conservation.

Scientists wrote articles of all three types and were featured in every volume of the *Bulletin* between 1893 and 1914. A few of them, like geologists Grove Karl Gilbert and François Matthes, offered detailed geological accounts of the Sierra—sometimes with titles suitable for scientific journals ("Domes and Dome Structures of the High Sierra," "Systematic Asymmetry of Crest-Lines in the High Sierra of California"). Others, like botanists John Lemmon, Willis Linn Jepson, and William Setchell, described the trees and plants of California in terms accessible to amateurs as well as scientists. Zoologists Joseph Grinnell and Vernon Kellogg wrote similar articles on the birds, insects, and butterflies of the Sierra.[7]

More frequently, scientists popularized their knowledge of the region by writing descriptions of excursions that included information on the natural features of the area. At a time when almost no mountaineering information or equipment was available, the scientists' trail descriptions, maps, and advice on supplies were welcomed by a growing number of wilderness enthusiasts who otherwise might not have ventured into the High Sierra. For the scientists, anything that encouraged people "to come and see," in Muir's words, contributed to the environmental literacy of the region. Muir, Joseph Le Conte, and Mark Kerr interspersed accounts of their mountain travels with geological or botanical details, hoping to lure the general reader into a fuller understanding of the terrain. Alice Eastwood solved the problem of combining descriptive narrative with technical information by appending to her account of the Trinity wilderness a list, with botanical classification, of all the trees and shrubs of the area.[8]

Aside from reports on the club's involvement in issues or items of legislation, overtly political or advocative articles were infrequent in the *Bulletin*. Speeches by Muir and Le Conte on the condition of California forests were published, as well as Muir's impassioned plea for the preservation of Hetch Hetchy.[9] By and large, however, the

Sierra Club Bulletin's primary contribution to the political awareness of conservation-minded Californians came from the pen of William Dudley. From 1898 to 1910, Dudley's "Forestry Notes" identified and analyzed every major state and national development in forestry conservation. Long before most environmental or scientific organizations routinely monitored government activities, Dudley maintained one of the nation's best published updates on conservation issues.

In addition to his forestry column, Dudley wrote feature articles that combined landscape description, scientific information, and proposals for environmental reform. His first report on forest reservations in 1896 presented the scientific and political issues of forest conservation in the format of a vast walking tour of the state. Despite its imposing title and detailed charts, his article "Zonal Distribution of Trees and Shrubs in the Southern Sierra" promised the general reader "that a general familiarity with the trees and shrubs of some of these zones and their relation to mountain topography would serve as a diversion during otherwise monotonous hours" on the trail. Thus an essay claiming only to make its readers' travels less "wearisome" went on to describe with Humboldtean scope and precision the relation of vegetation to altitude, climate, and environment.[10]

As directors, long-term committee members, major contributors to the club's publications, and keynote speakers at public meetings, scientists created within the Sierra Club an extra-professional forum for their educational and political goals. To a great extent, the successes and failures of the early Sierra Club revealed the strengths and weaknesses of the scientists' political and social vision.

Yosemite: Defining National Parks

It became clear very quickly that the Sierra Club would be more than a meeting place for hikers and mountaineers. Its first public meeting, held in September 1892, was designed simply to generate interest, both in the club itself and in the mountains and forests of the Far West. The October general meeting, however, featured a guest lecture by U.S. Geological Survey Director John Wesley Powell. Over five hundred people gathered to hear "the Major" recount his famous Grand Canyon expeditions of 1869 and 1871.[11]

Powell seemed to personify the hopes as well as the pitfalls of science-based land use reform. Director of the USGS since Clarence

King's resignation in 1881, he had proposed withdrawing federal lands in the arid West for an irrigation survey and scientific classification before settlement and development could proceed. His general plan called for dividing the arid West into "hydrographic basins"; in place of the Land Office's homestead grid and the stampede of extractive industries, settlement and development would be contoured to watersheds. As he envisioned it, Powell's plan represented the nation's most comprehensive effort to apply conservation principles to public land and resource use. But his considerable political clout could not prevent congressional dismantling of his plan in 1890.[12]

His colleagues in California applauded Powell's reconfiguration of the land according to environmental features rather than market value; and they took great interest in his belief that the federal government, with its greater resources and authority, was the only channel through which any enactment of such conservation principles could succeed. The failure of Powell's plan demonstrated the political hazards confronting government-sponsored environmental reform. Had he succeeded, Pacific scientists would have had to confront another question: was California's environment protected from overdevelopment, or simply transformed more efficiently, by Powell's technocratic vision of taming the rivers and maximizing efficient development of the West?[13]

The political life of the Sierra Club began immediately after Powell's lecture, when club officers voiced the need for immediate action to block the Caminetti bill—a California congressman's attempt to diminish the size of the new federal forest reserve surrounding Yosemite Valley. This issue, on which a special meeting was held three weeks later, saw the first of a succession of debates over the use and status of the Yosemite region, that dominated the Sierra Club's political activity until 1914. Their defense of Yosemite led the scientists into a much broader national discussion over the use of the public domain and the meaning of conservation. In the process, the valley that had figured so prominently in shaping the scientists' professional identities served as a crucible for their political education as well.[14]

The political history of the Yosemite area involved two related debates concerning the public domain: the status of national and state parks and the proper use of national forests. The park issue surfaced in 1864, when Congress granted the Yosemite Valley to

California as a state park. Even at that early stage, scientists in California helped to create and advocate protection of the park. Josiah Dwight Whitney was among the first to propose park status for the Valley; he and members of his survey team served as commissioners and surveyors for the park, protecting Yosemite's legal exemption from resource development. But in the 1870s the commission, overseen by survey member William Ashburner, encountered growing opposition from political opponents of the governor and Yosemite-area landowners. In 1880 Ashburner and his fellow commissioners were replaced by appointees dominated by the landowners, and Ashburner challenged the legality of the new appointments. While political conflict raged (at one point two separate groups claimed to be the official commissioners), grazing and lumbering interests became increasingly noticeable in the Valley. John Muir observed these new incursions into the park's sanctity with growing consternation. He was especially vexed to learn that the new commissioners had hired a Yosemite innkeeper to "fix" Nevada Falls by rechanneling its crest. "American enterprise with a vengeance," he wrote in a particularly scathing journal entry.[15] In June of 1889 Muir camped in the Valley with *Century* magazine's associate editor Robert Underwood Johnson, enumerating for his new friend the incidents of neglect and plunder in Yosemite. The two men agreed that the Valley would receive better protection if it reverted to federal control. Johnson then commissioned Muir to write articles for *Century* advocating the creation of a Yosemite National Park.[16]

In September 1890, the same month in which his "Features of the Proposed Yosemite National Park" appeared in *Century*, Muir wrote to the Oakland *Tribune*, condemning the Yosemite Commissioners' supervision and repeating his call for a national rather than a state park. Commissioner John P. Irish wrote an angry rebuttal, and the ensuing exchange between the conservationist and the commissioner revealed the difficulties involved in effecting any changes in the Valley's status. Later that same month, however, Muir and Johnson won a small victory, when Congress responded to California's request to enlarge the Yosemite grant by instead declaring the federal land surrounding the Valley to be a federal "reserve" (later termed a "national park") to be protected by army troops rather than by Sacramento's political appointees.[17]

When the Sierra Club met to discuss Yosemite in the fall of 1892,

the park status of the area remained unresolved. The Valley itself was still a state park, but the acreage immediately surrounding it was a national park. Club members addressed the situation in two ways: the Committee on Parks and Reservations worked with the Yosemite Commissioners and memorialized Congress to ensure the protection of the two parks, while an informal group led by Muir, Dudley and attorney William Colby lobbied for recession of the Valley from state to federal hands.[18]

The first challenge to the parks came from U.S. Representative Anthony Caminetti, whose district included the counties surrounding Yosemite. A number of his constituents in the cattle, sheep, and timber industries opposed the withdrawal of local forests and grazing lands from the public domain when Congress created the national park. The Caminetti bill was a brief, unsuccessful attempt to redefine the national park's boundary line; but the issue it raised, concerning parks and the public domain, remained long after the bill died.

In the succession of boundary challenges and resource development proposals that followed, Yosemite's defenders formulated an ideological position on the meaning of a national park. Since only one other such place had been created (at Yellowstone), they found that no clear working definition of a national park had been established. As their arguments against the Caminetti bill demonstrated, the Sierra Club activists did not oppose responsible development of public resources. The directors cited possible damage to commercially important watersheds, forests, and reservoir sites as reasons for opposing the contemplated return of the park's outer fringe to the public domain. Even Muir, the most distrustful among them on the subject of private interests, agreed that properly regulated forestry would be appropriate for many areas of the public domain.[19]

But Yosemite, they argued, was unique. No other region possessed its geological and scenic features. Here, at least, human alteration of the landscape should be minimized, for the region's value as a scientific and recreational resource far outweighed its convenience for local lumbermen and sheepherders. A park, unlike any other variety of American landscape, should be exempt from commerce. Gradually, they convinced the state park commissioners that they were right. In 1893 a Sierra Club parks committee, headed by George Davidson and attorney Elliot McAllister, began meeting with the Yo-

semite Commissioners to devise guidelines for the use of the Valley. By 1894 they had convinced the state officials to establish a patrol system to enforce park regulations in the Valley. Over the next decade, Davidson, Dudley, and Jordan led the efforts by the club's Committee on Parks and Reservations to nurture a cordial working relationship with the commissioners.[20]

Muir, whose confrontational strategy had won much publicity but excited the ire of the commission, remained notably absent from the park committee's activities. Instead, with help from Colby and Dudley, he pursued a protracted campaign for recession of the Valley itself from state to federal control. The Valley and the federal parkland encircling it would then constitute a single national park, and Yosemite's guardians could then work to establish as federal policy the immunity of national parks (as opposed to national forests) from any form of development. Muir was convinced that the federal government would provide much more reliable care of the Valley than would the state commissioners.[21]

The battle for recession entailed ten years of extremely intricate political lobbying. The club's leadership, although united in objective, disagreed over the efficacy of a recession campaign. Davidson and Le Conte, whose negotiations with the state commissioners had been much more successful than Muir's, were concerned that by publicly casting doubt on the state's administrative abilities, the Sierra Club might jeopardize its future dealings with state officials. While club members debated, stockmen and Yosemite-area farmers lined up behind state legislators who denounced the recession proposal as an affront to the state's image. The state's newspapers followed their proclivity for splitting into violently opposing camps; the Southern Pacific Railroad was accused, at various points, of secretly leading both factions. Meanwhile, herdsmen brought eighty thousand sheep ("hoofed locusts," Muir called them) into the Yosemite Valley, set fire to underbrush to clear paths for their herds, and lobbied Congress to oppose recession.[22]

In 1906, after years of intense lobbying in Sacramento and Washington, the Sierra Club won both state and national approval for a unified Yosemite National Park. The legacy of this campaign was mixed. The club's core of activist leaders learned a great deal about the art of politicking; they also discovered how difficult it was to agree on political tactics for shared goals. Several of the club's scientists had seen

their judgments publicly cited and debated; but they gradually recognized that in matters of public policy, the expertise of the club's activist lawyers often proved more essential than theirs. The Sierra Club had gained a new measure of statewide and national attention; but in an atmosphere of polarized political opinion, few of their ideas about conservation had gained undistorted public recognition.[23]

Particularly for the scientists, the most damaging side effect of the recession campaign and other park-related actions was the public's misperception that the Sierra Club's evolving policy toward national parks mirrored their aspirations for all public lands. Like the club's more utilitarian rivals among conservationists, historians have tended to characterize the Sierra Club's ideology as narrowly preservationist, opposing commercial development at every turn. Most Sierra Club activists did argue for minimal resource use within national parks. Concerning other portions of the public domain, however, their message was quite different. National parks were not the only arena for the club's early efforts. National forests provided a second major focus for their attention. And the club's involvement with the creation and definition of national forests was primarily the work of the scientists.[24]

Scientists and the National Forests: West Meets East

The national forest issue had developed during the 1880s, when scientists and irrigationists charged that private interests were damaging forests on public land by clear-cutting and uncontrolled grazing, that their activities were often illegal and wasteful (lumbermen routinely destroyed or abandoned nearly as many board feet as they removed), and that they were seriously affecting regional water supplies. The western slopes of the Sierra Nevada provided a prime example of the relationship of trees to water. For hundreds of miles, a thick belt of conifers helped to regulate the runoff from rain and snowfall; without the trees, melting snows turned to floods, soil erosion accelerated, and streams and irrigation ditches became clogged with silt.[25]

The Forest Reserve Act, an almost unnoticed rider to the General Land Law Revision Act of 1891, attempted to curtail the destruction of the public domain by authorizing the president to proclaim forest reserves wherever he saw fit on federally owned land. Within a month of the act's passage, President Harrison designated several

hundred thousand acres surrounding Yellowstone National Park as the first forest reserve. Before he left office in 1893, he had proclaimed fifteen reserves throughout the Far West. In September 1893, President Cleveland created two more reserves, bringing the total area of forest reserves to more than seventeen million acres.[26]

But then the flurry of forest reserve activity came to a temporary standstill. President Cleveland recognized what conservationists and scientists had been saying since passage of the 1891 act. First, the legislation failed to provide any means for protecting the designated areas from encroachment. Second, it neglected to specify the ultimate purpose of these forests. Were they being reserved for later development? For gradual, regulated harvesting? Or were they to be exempt from commercial use altogether? As a result of these major oversights, plundering of the reserved areas continued virtually uninterrupted while Western congressmen angrily denounced the declaration of reserves as an invasion of the sovereign rights of states.

The national forest controversy was one of the first political issues to be addressed by the Sierra Club. At the general meeting in November 1892, club members instructed their board of directors to memorialize Congress in support of a bill allocating funds for protection of the forest reserve. The bill failed, but the Sierra Club continued to promote protective measures for the existing forest reserves, as well as the creation of new reserves. In May 1894, for example, the directors announced that they had joined "the movement to set aside the Pacific Forest Reserve" in the Mt. Rainier region. The following November, the club passed a resolution advocating that the reserves fall under army protection like the national parks.

The forest reserve issue was brought home to California after February 14, 1893, when President Harrison created the Sierra Forest Reserve. A four-million-acre expanse encompassing Yosemite and much of the southern Sierra, this reserve comprised, as Dudley put it, "a not insignificant portion of the entire forest area of the national domain." Even after the addition of another eight million acres of reserves later that year, the Sierra Reserve contained 23 percent of the total national forest acreage. Much of the mountain terrain that had most concerned the state's earth and life scientists was encompassed by this reserve. For the Yosemite area, the creation of the new national forest added to the region's tree-ring configuration of overlapping designations: a state park, surrounded by a national park, which in turn was sur-

rounded by a national forest. Each of these areas fell within the juris-
diction of a different government body and nobody could agree to the
proper land use guidelines for any of them.[27]

Even for Sierra Club members whose primary concern was Yo-
semite, overall national forest policy now had important implica-
tions. For the scientists, that policy itself was of considerable inter-
est. The forest reserves might be the most effective vehicle for intro-
ducing into the state precisely the environmental reforms they had
been espousing. But how should the reserves be protected? And who
should decide to what uses they should be put, and when? Differing
answers to these questions marked the beginning of the schism be-
tween Sierra Club scientists and an emerging bureaucracy of federal
resource management scientists.

The California scientists' first formal attempt to articulate national
forest policy came at a November 1895 Sierra Club public forum
"The National Parks and Forest Reservations." The circular announc-
ing the meeting stressed the broad social implications of forest and
park policies: "the farmers and irrigationists, who desire the preserva-
tion of the watersheds of our rivers, have the same interest as the
lovers of the mountains." Muir, Le Conte, and Dudley were the fea-
tured speakers. Muir concentrated on the national park issue, a more
immediate concern for him than forest policy. He did assert that
"forest management must be put on a rational, permanent scientific
basis, as in every other civilized country," but he did not elaborate
on how such management should be implemented. He praised the
army troops that had been guarding Yosemite Park since its creation
in 1890 and called for an extension of their jurisdiction into the
surrounding forest reserve. But for Muir, the nation's forests consti-
tuted a moral landscape as well as a scientific one. "The battle we
have fought, and are still fighting, for the forests," he told his audi-
ence, "is a part of the eternal conflict between right and wrong, and
we cannot expect to see the end of it." From this perspective, details
of staffing and administration seemed to matter only to the extent
that they reflected the larger conflict between public rights and pri-
vate cupidity.[28]

Le Conte focused on the "wasteful disappearance of the timber" of
California, which he blamed on fires and misuse. "How often," he
lamented, "do we find the great trunk of a sugar pine, six or eight feet
in diameter and two hundred and fifty feet high . . . destroyed in a

few hours; and only one block cut off for a few shakes, and the rest left to rot on the ground!" Le Conte's remedy was "complete reservation [of national forests] by the Government, and used in a thoroughly rational way for legitimate purposes only, cultivating the trees as well as the soil, and removing only such as can be steadily replaced by fresh growth. In this way the forest will increase and last indefinitely."

Like Muir, Le Conte perceived a moral dimension to this rational solution. But for him, the danger facing the nation's forests rested not just in unscrupulous or profligate corporations but also in the culture's assumption "that society, and the state, and the government, and the nation are made for the individual." Translated into public policy, this doctrine of acquisitive individualism might institutionalize the current de facto forest policy of first come, first served. Paraphrasing the slogan of the utilitarian school of scientific forestry— "the greatest good for the greatest number"—Le Conte added: "True; but the greatest number is Number One! Now this individualism has, as it were, run mad."[29]

Dudley's was the last speech, and the most substantive. After extensive fieldwork throughout the state, he probably knew the conditions of many of the forests better than anyone but the lumbermen themselves. Like Muir and Le Conte, he distinguished between parks, which he believed should be exempt from development, and national forests, which should be scientifically administered to guarantee the wisest use of their resources. And like his colleagues, Dudley condemned the rapacious and wasteful among the extractive industries, the "politician who preys on the prejudices of the ignorant" while catering to such interests. He especially singled out sheepherders, whose flocks and brushfires left a "trail of destruction" through the public forests.

But Dudley went on to specify what should be done and by whom. "I shall not attempt to outline any plan of action for this Club," he claimed with characteristic deference. Certain points, however, could be "agreed upon by most Americans at all informed on this subject." What followed was indeed a plan of action that echoed John Wesley Powell:

> The immediate withdrawal of all public forest land from sale and entry; the appointment of a commission of experts to sur-

vey it, and decide what should be permenently reserved and what should be sold; the consignment of the forest land to the protection of the United States Army until foresters can be trained; the establishment of forest schools, and the giving of instruction in the principles of forestry at West Point,—these are the chief points practically agreed on.[30]

Such a plan, of course, was far from being practically agreed on in 1895. But Dudley had anticipated local opposition to the withdrawal of lands from the public domain. In his unofficial survey of the Sierra Reserve, he had consulted with the ranchers and other residents of the area. His purpose included a recommendation for the appointment of "local assistant commissioners" to the Forest Bureau, "whose duty should be to study the needs of the citizens living within or near the boundaries of the Forest Reservations" and to make ripe timber available to them for the construction of settlements. He also added that stocking the reserves with fish and game "would greatly increase the popularity and usefulness of scientific forest administration."[31]

The *Sierra Club Bulletin* published these speeches by Muir, Le Conte, and Dudley in its January 1896 issue. Soon thereafter, the California scientists had an opportunity to discuss their ideas directly with an impressive cross section of the Eastern scientific establishment. In June 1896, Congress authorized the National Academy of Sciences to appoint a Forestry Commission to tour the national forest reserves and recommend an overall policy. Chairing the commission was Harvard botanist Charles Sargent, an early advocate of conservation and a close correspondent of Muir's. Commission member William Brewer, now of Yale, was delighted that the California leg of their tour would bring the commission into regions he had charted with the Whitney Survey thirty years earlier. Arnold Hague of the U.S. Geological Survey, a close friend and former associate of Clarence King, had led the campaign to create Yellowstone National Park. Army engineer H. L. Abbot was an expert on stream hydraulics.[32]

Also on the commission was an energetic young forester named Gifford Pinchot. A protégé of Sargent and an admirer of Muir, Pinchot—like Sargent and Brewer—soon became an honorary officer of the Sierra Club. In 1896 Pinchot had only begun to articulate the utilitarian notion of conservation against which the Sierra Club would battle fiercely in the years to come. But no indications of

future disagreement were evident when the Sierra Club hosted a San Francisco dinner for the Forestry Commission in November 1896. Nor did any hint of discord arise when Muir accepted the commission's invitation to accompany them through California, Oregon, and Arizona.

At twenty-nine, Pinchot was a full generation younger than Muir and most of the commission members. The son of a wealthy Pennsylvania family, he had gone from Yale to Europe, where he was trained in the discipline of scientific forestry. Trees, he learned, could be "managed"—grown and harvested in an ongoing pattern of sustained yield. He returned to the United States anxious to spread the gospel of efficiency to the nation's forests and to make forestry itself into a profession based on scientific principles.[33]

Muir and Pinchot had met three years earlier, but the Forestry Commission's tour was the first extensive time they spent together. "In his late fifties, tall, thin, cordial, and a most fascinating talker," Pinchot recalled of Muir: "I took to him at once." Riding by horse-drawn wagon through the forests of the Cascade Range en route to Crater Lake, Pinchot listened to Muir and Brewer, who "made the journey short with talk that was worth crossing the continent to hear." At the Grand Canyon, Pinchot "spent an unforgettable day [with Muir] on the rim of the prodigious chasm," so engrossed in the view and their conversation that they camped at the edge of canyon, where Muir "talked until midnight."[34]

Not Muir but Sargent provided the foil for Pinchot's frustration during the Commission's tour. Sargent had been an early supporter of Pinchot's career and was largely responsible for the young forester's presence on the commission; but the two men were bound to have disagreements. A Boston Brahmin whose family's prominence outshone even Pinchot's, Sargent had arrived at his interest in trees by a route very different from Pinchot's. In sharp contrast to Pinchot's professional training in scientific forestry, Sargent owed his position at Harvard to his family connections and to his avid but amateur interest in horticulture. As a result, the two men looked at trees, and at the study of trees, very differently.

Pinchot chafed under the Harvard botanist's regard for the preservation of trees as specimens. Recalling the commission's expedition a half century later, Pinchot lamented that Sargent "couldn't see the forest for the trees—the individual, botanical trees." To Sargent,

Pinchot's interest in rationalizing the timber industry evoked his distaste for those who catered to the new manufacturing class. Each man saw in the other what he had chosen not to be.

Above all, Pinchot resented Sargent's proposal that the army should protect the forest reserves. Sargent viewed the national forests as fortresses, requiring only protection from human intervention. For Pinchot, the millions of acres of new national forests were the working basis for establishing professional, scientific forestry in the United States.

Following its investigations, the Forestry Commission recommended in February 1897 that President Cleveland create thirteen new forest reserves throughout the West. Ten days before leaving the White House, Cleveland did just that, adding over twenty million acres to the national forests. The commission's tour and report also marked the first instance of national attention to forest conservation. The commission's conclusions sparked a bitter and lengthy debate over the most desirable use of the public domain. Did unregulated commercial development of the forests fulfill or thwart the needs and rights of the people?

The clash between Sargent and Pinchot that emerged during the commission's tenure personified this debate. Their rapidly diverging positions also illustrated the opposing political applications of scientific expertise. Sargent saw the forest reserves he helped to create as regions exempt from corporate profiteering. Like Powell, he advocated the temporary withdrawal of the public domain from commercial access until scientists had classified each tract according to its most appropriate use. Pinchot, on the other hand, viewed the extractive industries as servants of public demand. He felt that the scientific approach to the forest reserves should be determined by "forester's facts and not mere botanical observations," and that those facts would provide the basis for sound commercial development.[36]

At the heart of this conflict was an emerging polarization among scientists over their professional identity that called into question their relation to private industry, the federal government, and the general population. As if to illustrate the widening chasm between rhetoric and practice, both Pinchot and Sargent claimed to speak for the people and against special interests. Both men agreed that large-scale land fraud and resource theft had characterized private use of the public domain since the Civil War—particularly in the West,

where federally owned acreage was most concentrated. Both agreed that the federal government should redress this rampant abuse. But to Pinchot, the idea of withdrawing the forest reserves from commercial use smacked of short-sighted elitism. And in Sargent's eyes, Pinchot's notion of government forestry would create an agency whose political power depended on its responsiveness to the demands of the extractive industries.[37]

Although the differences between the two men increased with each new formulation of federal forest policy, their disagreement stemmed primarily from the differences in their training. As Pinchot said, "Sargent was first and always a botanist, interested in trees mainly from the botanist's standpoint." Sargent saw his professional domain as outside the realm of capitalists and politicians; he looked upon the forest reserves as territorial manifestations of his own role. Pinchot, on the other hand, was one of the first of the new professionals to find his way into the woods. For him, the national forests (as he renamed the forest reserves) were the key to creating an entirely new profession in America: forestry as a scientific approach to harvesting and sustaining trees. Sargent's proposal for army protection of the forests irritated Pinchot, not so much because of the defects he listed in that plan, but because it did not recognize the need for professional foresters.

Sargent kept Muir abreast of the heated debates with Pinchot leading up to the Forest Commission's final report on May 1, 1897. President Cleveland's creation of the new reserves recommended by the commission had touched off a congressional attack on the Forest Reserve Act and on the commission itself. ("Why should we be everlastingly grateful and eternally harassed and annoyed and bedeviled," asked one Western senator, "by these scientific gentlemen from Harvard College?") In March, the Senate began debating a bill that specified the purpose of forest reserves as protection for watersheds and sources for timber. This bill (actually an amendment to the Sundry Civil Bill of 1897) also prohibited the inclusion of valuable mining or agricultural land in forest reserves; granted the secretary of the interior broad discretionary powers in administering the forests; and called for the suspension of reserves until March 1898, during which time claimants to lands within the reserves could apply for comparable acreage elsewhere within the public domain. Sargent and Abbot bitterly opposed the reductions permitted by the Petti-

grew Amendment. Pinchot and the rest of the Forest Commission supported it. For Pinchot the question was simple: "should the Commission agree to suspend the [February 1897 forest reserve] proclamations and open the Reserves to entry for a year in order to save the bulk of their area, or take the chance of losing the whole lot? Half a loaf or no bread."[38]

The Pettigrew Amendment became law on June 4, 1897. In the June 6 issue of *Harper's Weekly*, Muir denounced illegal land speculation of the sort that would result from temporary suspension of the reserves. Unlike Sargent, he stressed that public forests were for public use: "let right, commendable, industry be fostered." But too frequently, he noted, the claims and petitions of allegedly lone "settlers" disguised the hidden intentions of "wealthy corporations" seeking more than their share of the public domain. Any unsupervised concessions of public land would open the forests to these "Goths and Vandals of the wilderness."[39]

That summer, Muir and Sargent traveled together in Alaska, where Muir had ample time to hear Sargent's now substantial list of grievances toward Pinchot. Returning through Seattle in August, Muir noticed a local newspaper story reporting that visiting forester Gifford Pinchot had declared that sheep grazing in the national forest reserves would cause little, if any, damage. Pinchot, who happened to be staying in the same hotel as Muir, soon found an irate John Muir at his door demanding to know whether the article was correct and reminding Pinchot that during the previous summer he had voiced his agreement with Muir's strong opposition to grazing in the forest reserves.[40]

In October, Muir first learned that on June 5, the day after the passage of the Pettigrew Amendment, Secretary of the Interior Cornelius Bliss appointed Pinchot as a "confidential forest agent" to reformulate policy on the reserves. Muir took up the gauntlet on Sargent's behalf at once. "One feeble part of the Forestry Commission [Pinchot] has thus been given the work that had already most ably been done by the whole," he declared in a letter to Sargent. "How Mr. Pinchot, without a word to his colleagues, could lightly accept such a commission I can't imagine." Lashing out at "this drygoods forestry," Muir promised to help in the fight to protect the forests from being "Pinchoed."[41]

Pinchot continued to solicit Muir's aid and support. In December 1897, he wrote to Muir, outlining in carefully worded terms the

policy alternatives he foresaw, and requesting that Muir recommend that California forest acreage should be added to the reserves. Muir readily complied. But he soon wrote to Sargent, quoting extensively from Pinchot's letter and dismissing it as "all fog and mush." "I mean simply to go on hammering and thumping as best as I can at public opinion," Muir declared.[42]

Robert Underwood Johnson, who had hoped to catalyze Pinchot, Sargent, and Muir into a single conservation effort, wrote to Muir in March 1898 in an effort to mend fences. "You need not believe that Pinchot has been captured by the politicians." he assured his Yosemite camping companion. "He is not that kind of man, and his differences with Sargent on matters of policy must not be accounted for on that basis." All of them, he added, were working "in favor of a right kind of policy." Drafting his reply, Muir wrote, "I still look for good work from Pinchot. His differences with Sargent as to forest administration I don't mind, but his giving way to the sheep owners and the polished agents of forest robbery is mighty discouraging." Years later, at the height of his public conflict with Pinchot, Muir wrote to Johnson of his regret "to see poor Pinchot running amuck after doing so much good hopeful work—from sound conservation going pellmell to destruction on the wings of crazy inordinate ambition."[43]

Pinchot's professional ambition offended Muir and Sargent, but it got results. On July 1, 1898, B. E. Fernow, the Interior Department's chief forester, resigned to direct the new forestry school at Cornell. Gifford Pinchot replaced him as chief forester. Under Fernow's direction, the Forestry Bureau had served primarily as an information agency; its staff numbered only ten. "This is a good place for [Pinchot]," Sargent wrote to Muir in June. "He can do no harm there and after a very short time people will cease to pay any attention to what he says." But Sargent severely underestimated his former protégé. Over the next decade, Pinchot transformed government forestry, rode (and helped direct) the national wave of interest in conservation to become one of the two or three most influential men in Washington.[44]

For the next eight years, the Sierra Club sustained a cautious working relationship with Pinchot—applauding and sometimes assisting his efforts to direct national attention toward conservation, but wary of the commercial orientation of his "drygoods forestry." Dudley maintained a correspondence with the new chief forester, providing

information on California forests and reporting Pinchot's achievements in the *Sierra Club Bulletin*. Muir and Pinchot camped together in the summers of 1898 and 1899.

But the disagreements over army versus Interior Department supervision of the forests, sheep grazing, and the necessity of political concessions all pointed to a widening rift between Pinchot's and Muir's views on the relations of science, industry, and government. Dudley's proposals of 1895 had anticipated each of these points of contention and had looked for ways of bridging them. A gradual transition from army guards to Interior Department foresters for the reserves, for example, might have permitted Muir and Sargent on the one hand and Pinchot on the other to find common ground on which to base their views of forest policy.

In 1899, California scientists still had cause for hope. The public debate over the Hetch Hetchy Valley, which would cast them irreversibly into opposition to Pinchot, had not yet arisen. In the meantime, campaigns closer to home helped to test the various political strategies available to them.

8

Temple Destroyers
and Nature Fakers:
Defining Conservation

Prompted in part by their Sierra Club activities, California scientists assumed positions of leadership in other environmental action organizations and projects. Alice Eastwood, curator of botany for the California Academy of Sciences and an active Sierra Club member, presided over the Tamalpais Conservation Club, leading its successful campaign to create and maintain a state park for Mount Tamalpais just north of San Francisco. The academy's curator of zoology, Gustav Eisen, spearheaded a movement within the academy to advocate the creation of a Sequoia National Park in the High Sierra. (His ashes are buried on the slopes of Mount Eisen in Sequoia–Kings Canyon National Park.) David Starr Jordan helped to initiate and direct a national committee for the preservation of the fur seal. At the University of California, paleontologist John C. Merriam and botanist Willis Lynn Jepson worked to preserve northern California redwood groves from logging and were instrumental in creating the Save the Redwoods League in 1919. In each of these instances, scientists helped to form ad hoc organizations and invoked their professional expertise in support of single-issue environmental reform.[1]

The Sempervirens Club's campaign to save the redwoods attracted an occupationally varied middle-class membership similar to that of the Sierra Club, but much smaller and more localized. As residents of the peninsula south of San Francisco, Sempervirens Club mem-

bers concentrated on the preservation of redwoods in their immediate area. The role scientists played within this group, and the strategies they used, provide an instructive point of comparison with the Sierra Club.

The Sempervirens Club

The largest and tallest plants in the world are endemic to the California Botanical Region: Big Trees and redwoods, respectively. Scientists classified them as sequoias, loggers felled them, and by the 1890s a small but growing number of Californians became convinced that some of the original groves should be protected. The western slopes of the Sierra Nevada provide the natural habitat of Big Trees; redwoods grow along the Coast Ranges of northern California and southern Oregon, venturing inland only as far as fog or rainfall permit. Efforts to preserve Big Trees began in the 1860s, when J. D. Whitney and his fellow advocates of a Yosemite state park urged that the Mariposa Big Trees be added to the protected area. In 1890, Congress included the Mariposa Grove in the new Yosemite National Park, created Sequoia National Park in the southern Sierra, and extended federal protection to the nearby General Grant Big Tree Grove.[2]

But redwoods were less remote than Big Trees and more plentiful; serious efforts to create a redwood park did not begin until the late 1880s and 90s. One of the first detailed proposals to preserve redwoods came from William Dudley. At a Sierra Club public forum in November 1895, and in an article in the *Sierra Club Bulletin* the following January, Dudley recommended that some of the state's redwoods be protected from logging. His fieldwork convinced him that the two million acres of redwoods that once had stretched for five hundred miles along the coastal hills of northern California and southern Oregon were disappearing at a rate that threatened total obliteration of the ancient groves.[3]

The Sierra Club had chosen to concentrate its efforts on the Sierra region, which included the Big Trees but not the coastal redwoods. Dudley, however, volunteered to pursue the idea of a redwood park. After investigating the U.S. Land Office records to locate the remaining redwoods in the public domain, he inspected the forests of Mendocino, Humboldt, and Del Norte counties. By 1898 he had ascertained that most of the finest redwood stands in the public domain

were either decimated or sold to lumber companies. The best way to secure a redwood park, Dudley concluded, was to purchase it from private owners; and the most promising site for such a park was in the Big Basin area of the Santa Cruz Mountains. Stanford University briefly considered purchasing acreage in the Big Basin area for scientific research. Funds for such an acquisition were unlikely, but three engineering professors agreed to supplement Dudley's earlier surveys of the Big Basin region.[4]

Dudley's efforts were enhanced considerably in 1900, when San Jose artist-photographer Andrew P. Hill set out to photograph a grove of redwoods near Felton for a magazine article. Upon his arrival Hill learned that the owner of the grove charged admission to view the trees, forbade photographs, and was selling off the two-thousand-year-old giants to be made into railroad ties. Incensed, Hill determined to prevent the trees' destruction. He enlisted friends to join him in writing articles and letters to local newspapers. Carrie Stevens Walter of the San Jose Women's Club offered her organization's considerable publicizing skills. Hill persuaded the Boards of Trade in Santa Cruz and San Jose to petition Congress (unsuccessfully) for the creation of a park. In the process, he learned from Santa Cruz physician-naturalist Charles Anderson that Big Basin, rather than the grove he had visited at Felton, offered the best local redwood site. Soon Hill's group heard of the Stanford faculty members' interest in Big Basin, and David Starr Jordan agreed to preside over a public meeting to discuss a course of action.[5]

In May, thirteen people gathered in the Stanford University Library. In addition to Hill, the group included four Stanford scientists (Jordan, Dudley, John Stillman, and Rufus Green—all Sierra Club members); Stanford engineering professor Charles Wing, who had contributed to the Big Basin survey; representatives from the University of California, Santa Clara College, and San Jose Normal School; a judge, a former governor, a member of the Santa Cruz Board of Trade, and Carrie Stevens Walter. Dudley and Wing brought maps of their surveys, and convinced the group to concentrate on Big Basin. Since most of the nonscientists in the group had never explored that area, Andrew Hill and Carrie Stevens Walter organized a survey committee. Two weeks later, nine men and women (including the largest shareholder in the Big Basin Lumber Company) set out for a three-day excursion in Big Basin. Hill photographed redwoods, got lost,

found his way back to camp, and proposed that the group call itself the Sempervirens Club in honor of the redwood's botanical designation (*Sequoia sempervirens*).[6]

At a larger meeting on July 3, 1900, the participants decided to petition the state legislature to purchase the Big Basin redwoods. Dudley vigorously promoted the plan to approach the state legislature rather than Congress. By 1900 he had become one of California's most active proponents of federal control of state forests, and he would have preferred that the Big Basin be a national park. "The *Sequoia sempervirens* is only second to the Big Tree as an object of interest to the nation and the world," he wrote in his forestry column for the Sierra Club, "and it would have been a fitting ward of the United States." But earlier that year the California Club, a women's organization under the direction of Mrs. Lovell White (a future president of the Sempervirens Club), had initiated a campaign for congressional purchase of the Calaveras Big Trees in the Sierra foothills. A concurrent bill for purchasing Big Basin redwoods might jeopardize both. Furthermore, Dudley was well aware of the ill feeling that had been generated in the state by the Sierra Club's Yosemite recession campaign. A proposal for federal purchase and control of additional California parkland was likely to fuel the resentment.[7]

Dudley therefore advocated a strategy that he considered less than ideal, but politically more viable. By looking to the state legislature and building local support, he demonstrated much more political sensitivity than Muir, whose righteous denunciations and political inflexibility had created enemies even among potential allies. The difference between the two friends became even clearer when Dudley called for help from federal foresters in managing the proposed state park—a move clearly calculated to win the support of Pinchot and the American Forestry Association. At Dudley's urging, endorsements were forthcoming from the AFA, the American Association for the Advancement of Science, and two other national scientific organizations. This was both a tactical and a substantive departure from Muir, who continued to insist that placing the national parks or forests under the jurisdiction of government foresters would expose the forests to the kind of corruption and mismanagement that had resulted from forest management by political appointees in the 1880s. Dudley, by contrast, recognized that Pinchot's concept of professional forestry might accommodate a number of Dudley's and Muir's conservation

objectives. While sharing many of Muir's concerns, Dudley felt that the use of professionally trained foresters might be the most feasible way to check the abuse and destruction of the forest reserves.[8]

On January 23, 1901, the Sempervirens Club sent a delegation of four to Sacramento to testify before the Committee on Public Lands and Forests: San Francisco supervisor Charles W. Reed, the club's nominal president; Rev. Robert E. Kenna, S.J., president of Santa Clara College; Mrs. E. C. Smith, representing the San Jose Women's Club; and William Dudley, representing Stanford, the Sierra Club, and Pacific scientists. On March 16, after considerable politicking, the club convinced the governor to sign the bill appropriating funds for a state park in Big Basin. The bill created a five-member commission to oversee the purchase and maintenance of the new park. Secretary of the commission, and by far its most active member, was William Dudley.[9]

The Big Basin campaign owed its success to an activist coalition of local civic leaders, university scientists, and women's clubs. The Sempervirens Club's founding coincided with the public emergence of women's organizations as crusaders for forest preservation in California. Buoyed by the women's suffrage movement and by the proliferation of civic and progressive reform associations in the 1890s, women's organizations increased in number and expanded from local to statewide and national associations. The formation of the California Federation of Women's Clubs in 1900 was part of a nationwide trend. As this consolidation progressed, local women's organizations greatly increased their contact with each other and with the press. Previously isolated issues became part of a more formalized agenda of reform. Between 1900 and 1910, the conservation of forests became a high priority for hundreds of women's clubs and civic organizations across the country.[10] The Big Basin campaign marked California's first concerted alliance of scientists and women's organizations for environmental reform.

William Dudley played a crucial role in integrating the efforts of these groups. He regularly reported the activities of the Sempervirens Club and the forestry committees of women's organizations in his "Forestry Notes" column for the *Sierra Club Bulletin*. He also coordinated expertise and activism, corresponding regularly with local women's and civic organizations, fellow scientists, and state

politicians. At the same time, he nurtured informal support from Gifford Pinchot and national forestry organizations.[11]

The first Sempervirens campaign differed from Sierra Club activities in several notable respects. Conducted almost entirely by local residents and aimed at the state legislature rather than at Congress, the Big Basin campaign looked outside the state only for support from scientists and foresters. The Sierra Club under Muir's leadership often undertook just the opposite tactics, polarizing local opinion and exacerbating its disagreements with government foresters rather than consolidating on mutually acceptable ground. Partly due to the local divisiveness of the Hetch Hetchy campaign, the Sierra Club was also slower to integrate fully its efforts with those of local women's organizations.

Yet in the years to come it was Muir's forceful rhetoric, not Dudley's dispassionate assessments, that commanded a national audience. As the federal government played an increasingly central role in determining the status of parks and forests, California scientists found themselves looking to Washington, rather than to Sacramento, for political support. The success of the Sempervirens Club did not dismiss the lesson of the Yosemite recession fight: when thwarted by local politicians, appeal to Congress or to the secretary of the interior. Under auspicious circumstances, the Sierra Club might have overcome some of the regional animosity inspired by the recession campaign. Long before that issue was resolved, however, a series of unannounced events within a few miles of Yosemite Valley prepared the way for a dispute that would set Sierra Club members sharply at odds with many of their fellow Californians, while escalating the differences between the club's environmental activists and managerial scientists in Washington. In March 1901, San Francisco Mayor James D. Phelan played an instrumental role in securing passage of the Sempervirens Club's bill to create Big Basin State Park. At about the same time, he quietly filed a claim for a reservoir site in Hetch Hetchy, a Yosemite-like valley well within the boundaries of the national park. Not until 1905 did the Sierra Club discover the city's plan to dam the valley for its municipal water supply. Even then, they did not anticipate that the ensuing battle would prove to be the California scientists' final environmental campaign.

Showdown at Hetch Hetchy

Two conflicting interpretations have dominated the numerous accounts of the Hetch Hetchy controversy. Advocates of the preservationist position characterize Muir and the Sierra Club as champions of the right of all Americans, living and unborn, to experience the vanishing wilderness. According to this view, Pinchot and the "commodity conservationists" in Washington were misguided by the political machinations of the city of San Francisco, which sought selfish gains at the expense of a priceless national heritage. Sympathizers with the conservationist stance cast Pinchot as a utilitarian who weighed the practical resource needs of all Americans against the aesthetic proclivities of a few elitist nature lovers. Proponents of each group have described the opposing faction as obstructors of democratic formulation of national resource priorities.[12]

Neither of these arguments adequately explains the intensity of the debate or clarifies the underlying issues. The Muir and Pinchot factions are less significant in their differences than in their similarities. Both groups grounded their thinking in the expertise of earth and life scientists. Both groups were broadly conservationist, seeking rational use of the country's natural resources. Both agreed that in certain instances, the scientific or scenic value of a natural feature or region should warrant preservation in its natural state. Their disagreement seemed simple enough: did Hetch Hetchy warrant such preservation? Would sound conservation principles and the peoples' best interests be better served by retaining the valley in its undeveloped condition or by filling it with water for a major metropolitian area?

At the heart of this disagreement, however, was a fundamental conflict between two visions of the public role of science. Conservation had begun among scientists. Its rise to national prominence entailed a politicization of expertise, and a clash ensued between the two groups most qualified to judge the scientific merit of political decisions. At the outset, the difference between the Pinchot and the Muir camps had more to do with strategy than with ideology: Pinchot viewed the extractive industries as potential allies, while Muir generally saw them as adversaries. Yet the two men advocated similar land use measures.[13]

But power articulates differences. As Pinchot rose in influence,

his supporters saw firsthand the advantages of strategic shifts in rhetoric and compromises in policy. His detractors did not. What began as disagreements over tactics evolved into apparent schisms in ideology. Through this process, two varieties of scientists—California's environmental reform advocates and Washington's commodity conservation managers—learned to distinguish themselves from each other. Hetch Hetchy happened to provide the issue over which this battle of recognition was waged.

It was not a well-chosen test case for anyone. Almost nothing about the Hetch Hetchy controversy proved to be what it seemed. Special interests, in fact, congregated on both sides of the debate. Both in San Francisco and in Washington, the political background shifted constantly, ushering key participants in and out of power. Before it was done with, the Hetch Hetchy issue engaged the attention of three presidential administrations, five secretaries of the interior, two chief foresters and three San Francisco mayors—one of whom was convicted of graft involving, among other things, the city's water supply. During those years Pinchot changed careers, San Franciscans experienced a devastating earthquake, and most of the Bay Area's first generation of scientists retired or died. Since the two principal contestants were government bodies—one federal, one municipal—the crucial question of private versus public control of the nation's resources remained largely unanswered. In the course of the battle, conservation's promise of a political role for science and expertise evaporated into the application of scientific rhetoric for political purposes. In all the confusion, few of the participants were aware of the significance of the outcome: managerial scientists had appropriated the language of the California environmentalists but had attached it to a policy shaped by the needs of large corporations in the extractive industries.[14]

Like the ship in Coleridge's "Rime of the Ancient Mariner," turn-of-the-century San Francisco found itself surrounded by water, but with scarcely a drop to drink. Even during the gold rush, some enterprising San Franciscans discovered that it was often more profitable to carry water to the gold diggers than to pan the mountain waters for gold. Gradually, through a combination of foresight and chicanery, a single corporation bought out its competitors and acquired rights to the principal water sources in the area. By the 1870s, the Spring Valley Water Company enjoyed a monopoly that it retained, to the

city fathers' increasing distress, for thirty years. In its search for a solution to the water problem, the city inadvertently created an albatross for Pacific scientists.[15]

Preoccupied by the recession campaign and by threats to the Yosemite Park boundary, Sierra Club activists scarcely noticed two votes—one in Sacramento, the other in Washington—that prepared the way for the most serious challenge to the park's integrity since its formation. In 1900 the California legislature approved a new city charter for San Francisco, mandating municipal ownership of utilities. With this new power, the city could end the water monopoly either by buying the Spring Valley Water Company or by finding its own sources of water. But the company demanded an exorbitant price and had come close to exhausting its own water supplies. The city looked elsewhere.[16]

At the same time, Congress was considering a bill submitted by a Stockton, California, representative that would permit the construction of certain public works (particularly pipelines and water conduits) through federal reserves. Scholars have disagreed over San Francisco Mayor James Phelan's possible role as the silent instigator of this legislation. In any case, by the time the Right of Way Act became law in February 1901, Phelan had secretly dispatched city engineer (and Sierra Club member) Carl Grunsky to survey possible water sources for the city. By summer Phelan, Grunsky, and the city's new Board of Public Works agreed to focus on the Hetch Hetchy site, and to do so secretly, to deter speculators and political opponents.[17]

As California's scientists had observed since the 1880s, Yosemite Valley was unique. The geological, glacial, and climatic conditions required to create its U-shaped valley could be found in no other region on the continent. Within that region, however, those conditions had combined twice. Fifteen miles northwest of the Yosemite Valley, within the national park boundaries, the Hetch Hetchy Valley sported steep, perpendicular walls with slight variations on El Capitan and Cathedral Rock, dramatic Yosemite-like waterfalls, and richly landscaped meadows so reminiscent of its more famous neighbor that J. D. Whitney pronounced it "almost an exact counterpart of the Yosemite."[18]

There were, however, a few differences. Hetch Hetchy was smaller,

more enclosed, less accessible, and therefore much less well known. For the scientists, it provided the basis for comparative study of a unique valley formation. To San Francisco's engineers, Hetch Hetchy's features suggested an ideal natural site for a reservoir. Its size greatly exceeded that of other possible water sources; its walls conveniently narrowed enough to make damming the valley feasible. The water would be pure Sierra snowmelt, and the valley's isolation would insure against pollution. Even more compelling was the site's capacity to generate hydroelectric power, a feature that some critics of the city claimed to be the deciding factor. But perhaps best of all from San Francisco's viewpoint, Hetch Hetchy's location within a national park minimized the expense and legal complexities of procuring private land and water rights.[19]

In January 1903, Secretary of the Interior Ethan Allen Hitchcock denied the city permission to dam Hetch Hetchy. The 1890 legislation that created Yosemite National Park called for preservation of the park's natural features. The 1901 Right of Way Act, Hitchcock ruled, could not supersede that mandate. He denied renewed city petitions again in December 1903. Muir apparently did not learn of San Francisco's actions until February 1905, when the city's petition for reconsideration elicited a third denial from Hitchcock. Without staff or lobbyists in Washington, the Sierra Club had no systematic access to the information they required to monitor environmental policy. Nor did they see immediate cause for action. Hitchcock, after all, had rejected the reservoir proposal three times, and President Roosevelt himself had camped in Yosemite with Muir in 1903.[20]

Muir did not know, however, that Roosevelt and Pinchot had been strongly influenced by the pro-reservoir lobbying efforts of one of the Sierra Club's own members. By 1904, the principal lobbyist for San Francisco's proposal was Marsden Manson. A civil engineer by profession, Manson had much in common with the club's scientists prior to the Hetch Hetchy dispute. Arriving in California from Virginia in 1878, Manson became one of California's first generation of public engineers, working primarily for the state or for city governments. He also had scientific training: in 1893 he earned a doctorate in the physical sciences from the University of California and became a published authority on California climatology. Like Muir, Davidson and Jordan, Manson frequented the Sierra Nevada—both

in his line of work and on his own time. Like them, he explored the hinterland of the Pacific slope, including Alaska, whenever possible. And like them, he joined the Sierra Club.[21]

Manson's interest in scientific conservation predated the Hetch Hetchy debate. In the June 1899 *Sierra Club Bulletin*, he wrote an impassioned call for the protection of California's forests from destructive land use practices. His observations on the importance of preserving watershed forests for the regulation of water concurred with the views of Dudley, Muir, and Le Conte. He sounded more like Pinchot, however, when he proposed solutions: turn over all of the state's forest reserves to the University of California (with which Manson was affiliated); train professional foresters to oversee them; hire engineers to construct reservoirs to aid in water conservation. By 1900, when he was appointed to San Francisco's new Board of Public Works, Manson tended to view conservation as the public application of engineering expertise. Irascible and tenacious, he shared Muir's tendency to view anyone who opposed his proposals as "grasping interests" intent on bilking the public. He eventually came to regard the proposed Hetch Hetchy dam as the crowning achievement in his life of public service. Even when his term on the Board of Public Works expired, Manson continued his campaign for the city. He resigned from the Sierra Club in protest of its opposition to the dam. His appointment as City Engineer in 1908 caused him to redouble his efforts on behalf of the proposed reservoir.[22]

Much of Manson's energy went into public lectures and articles. Perhaps the most visible of the pro-reservoir advocates, he cast himself as a foil to Muir. Their disagreements over the best use for Hetch Hetchy were nearly obscured by their rhetorical trappings. As he had always done, Muir borrowed the declamations of the pulpit to denounce his opponents as greedy capitalists. Manson exploited the similarity between Muir's language and that of some of the women's organizations opposing the dam; by contrasting the impassioned moralizing of the "sentimentalists" with the cool precision of the engineer, Manson furthered the genderization of expertise and reform.

For Muir the controversy soon became a clear-cut moral struggle between good and evil, with conservation and extractive capitalism at opposing extremes. "In these ravaging money-mad days," he wrote in a 1908 article for the *Sierra Club Bulletin*, "San Francisco capitalists are now doing their best to destroy Yosemite Park."[23] In a book he

completed in 1912 for use in the Hetch Hetchy campaign, Muir set out to provide carefully detailed accounts of the geology and natural and legislative history of the Yosemite region. But when he reached the climactic chapter on Hetch Hetchy, the tone shifted from natural history essay to jeremiad. Denouncing the city's proposal as a "grossly destructive commercial scheme," Muir warmed up to a scathing attack on the evils of commercialism. Like anything of value, he charged, the park and national forests of the Yosemite region "have always been subject to attack by despoiling gain-seekers and mischief-makers of every degree from Satan to Senators, eagerly trying to make everything immediately and selfishly commercial." Without naming Pinchot or Manson, he made it clear that the brand of conservation espoused by the former chief forester, the city engineer, and their allies served the interests of corporate plunderers, "with schemes disguised in smug-smiling philanthropy, industriously, sham-piously crying, 'Conservation, conservation, panutilization,' that man and beast may be fed and the dear Nation made great." Those who championed San Francisco's reservoir in the name of conservation were not true conservationists, insisted Muir, but aides to the money changers in the temple.

Muir's efforts to return to a straightforward account of the political battle over Hetch Hetchy repeatedly gave way to biblical analogies. The city's arguments were "curiously like those of the devil, devised for the destruction of the first garden," while Hetch Hetchy resembled Eden, "the first forest reservation." Muir's book closed with a flourish worthy of the fiercest of fire-and-brimstone sermonists: "The temple destroyers, devotees of ravaging commercialism, seem to have a perfect contempt for Nature, and, instead of lifting their eyes to the God of the mountains, lift them to the Almighty Dollar. Dam Hetch Hetchy!" he exclaimed. "As well dam for water-tanks the people's cathedrals and churches, for no holier temple has ever been consecrated by the heart of man."[24]

Manson attacked Muir on two fronts. He inverted Muir's moral condemnations by charging that the project's opponents were unwitting agents of the corporate greed they denounced, and he sought to undermine Muir's credibility by depicting his aesthetic concerns as an effeminate, illogical obstacle to clear scientific judgment. The principal opponents of the Hetch Hetchy plan, he contended, were the Spring Valley Water Company and its "misguided allies," a

"group of sentimentalists" who failed to recognize facts that "any sane human being" could grasp. At best, these "mistaken zealots" were unwitting "catspaws" of "grasping interests." Worst of all, "these sentimentalists, backed by corporations of great power," lacked "scientific" judgment. Publicly, Manson took great pains to deride the "aesthetic," imprecise nature of the dam opponents' language. Quoting Muir at length, he belittled the "admirers of verbal lingerie and frills" for permitting Muir's talk of " 'networks,' 'veils,' 'fibers,' 'downy feathers,' 'fabrics,' 'textures,' 'patterns,' 'embroideries,' 'tissues,' 'plumes,' [and] 'irised robes' " to obscure their vision. Privately, he blasted his opponents as "short-haired women and long-haired men."[25]

Press coverage of the Hetch Hetchy debate followed a predictable geographic pattern. San Francisco newspapers adopted Manson's rhetoric wholesale; Muir's voice generally became more audible as the distance from San Francisco increased. "This is an age of commercial conquest," the Davenport, Iowa, *Democrat and Leader* opined, "and of a highly unsentimental utilitarianism which. . . . generally converts our natural beauty into market value." In the East Bay, where Hetch Hetchy's waters would not reach, newspapers emphasized the presence of local scientists among opponents to the city's proposal. In a 1907 story titled "Men of Science Oppose Hetch Hetchy Water Project," the Berkeley *Independent* reported that "famous geologists and naturalists" such as Muir and Le Conte were leading the protest. The Oakland *Tribune* noted that "the opposition is headed by John Muir, the distinguished naturalist" who was "generally considered the greatest authority on all matters pertaining to the Sierras."[26]

In San Francisco's newspapers, however, Muir and his allies were distinguished only by their "mushy opposition" to reason, as the San Francisco *Chronicle* put it, and by their ill-informed "sentimentality." In a January 1909 article titled "John Muir's Muddled Plea," the San Francisco *Call* reported that Secretary of the Interior James Garfield had "neatly and conclusively disposed of the objections [to the Hetch Hetchy grant] raised by John Muir and other sentimentalists." Two weeks later, in an article titled "Nature Lovers Delay the Hetch Hetchy Grant," the *Call* noted that a congressional committee hearing on the proposed dam had been deflected from "the real merits of

the case" by "a lot of talk about 'babbling brooks and crystal pools.' "
In October 1910 President Taft visited Yosemite Valley. The *Call's*
headlines declared that "President Taft Chafes Muir on Sentimental-
ity. Executive Listens with Good Nature to Naturalist's Frantic
Shriek of 'Sacrilege.' "[27]

Meanwhile, the *Call's* Sacramento edition claimed that the Spring
Valley Water Company was "in alliance with that strange tribe of
sentimentalists not inaptly named the 'nature fakers.' " In a Washing-
ton edition prepared for distribution in Congress, the San Francisco
Examiner characterized the dam opponents as nature lovers whose
"hyperaesthetic worship of nature" had provided a "shield of senti-
mentality" for "scheming power interests."[28]

Misguided, hysterical nature fakers versus greedy, arrogant tem-
ple destroyers: this conscious use of sexual stereotypes persisted
throughout the Hetch Hetchy debate. The extensive nationwide pub-
licity campaigns by women's and civic organizations helped to make
Hetch Hetchy a national issue (by 1910, 150 women's clubs were
involved in the preservation campaign). For Manson and other dam
advocates, however, the efforts of the women's groups made it easier
to discredit the preservationists' arguments by characterizing them
as feminine. Some of the leaders of the women's organizations, after
all, attacked the dictates of the marketplace in terms nearly identical
to Muir's. (Mrs. Robert Burdette, first president of the California
Federation of Women's Clubs, warned the organization in 1900 that
"men whose souls are gang-saws" planned to cut the Calaveras Big
Trees "into planks and fencing worth so many dollars.") But the
women's groups were equally capable of appropriating the rhetoric
of expertise. Mrs. Lovell White, president of the California Club,
cleverly campaigned for the federal purchase of all of California's Big
Trees by drafting a congressional resolution that urged the applica-
tion of scientific forestry to make the national forests profitable (with
some of the revenues set aside to purchase the Big Trees).[29]

Even when some women's organizations supported the dam pro-
posal, the sexual stereotypes remained intact. "Although woman is
commonly supposed to be on the side of sentiment," the San Fran-
cisco *Bulletin* observed of progressive reformer Elizabeth Geberding,
"in this case she sternly rejects all arguments against the dam." Per-
haps the most graphic example of the genderization of the debate

was a cartoon in the San Francisco *Call* that depicted John Muir wearing an apron, desperately trying to sweep back the rush of Hetch Hetchy water with a broom.[30]

If the park's defenders could be dismissed as muddled house-wives, the city's position was embodied in the engineer. The *Examiner's* Washington edition featured a composite of photographs depicting the Hetch Hetchy area flanked on three sides by engineers who favored the city's proposal. The headline characterized the engineers (two of whom worked for the city) as "the world's greatest experts"; the list of qualifications for one of them, consulting engineeer John R. Freeman, consumed more column inches than some of the news stories. A cartoon depicted San Francisco as a sailing ship adrift in the desert. In the *Examiner's* iconography of expertise, the Hetch Hetchy dam would provide the water on which the engineers could navigate the city to a prosperous future. (And the depicted engineers attacked the dam's opponents in terms identical to those employed by the newspapers. In the fall of 1913, Freeman wrote to San Francisco city engineer O'Shaughnessy complaining that his congressional lobbying efforts for "the great city of San Francisco and its just claims" were being hindered by "the nature fakers"—particularly by the "frantic screams of [*Century* editor] Robert Underwood Johnson and John Muir.")[31]

Expanding the expertise of the engineers to overcome all objections, the dam's advocates claimed that even the aesthetic concerns of the nature fakers would best be served by the engineered landscape of the dam. The *Examiner* observed that "when William Keith, the greatest Pacific coast landscape artist, painted Hetch Hetchy he introduced a lake on his canvas to make it scenically beautiful." The dam's engineers simply proposed to reshape the terrain to fit the artist's vision; a tastefully executed artificial lake would replace "a mosquito-breeding swamp." Clearly, the *Examiner* concluded, "the contentions of the nature lovers hardly come within the domain of the sane and the real."[32]

Pinchot gained great advantage from this war of words. As early as 1905, he supported San Francisco's position. In the years leading up to the Hetch Hetchy debate, he conducted a vigorous "conservation crusade" to link the rising public enthusiasm over conservation with his own policies. His goals were to assure the business commu-

nity that his program would increase rather than threaten profits and to discredit rival advocates of conservation. Hetch Hetchy permitted Pinchot to accomplish both. Approving the San Francisco plan would demonstrate to doubters that he placed resource development ahead of aesthetic considerations. And characterizing Muir and his colleagues as naive "butterfly-catchers" for their opposition to the dam tended to discredit the California scientists' views on conservation in general. Significantly, incoming Interior Secretary James Garfield reversed his predecessor's denial of the San Francisco application just two days before the White House hosted the Governor's Conference on Conservation, a national forum to which Muir was pointedly not invited.

As Pinchot knew, Muir and his colleagues distinguished carefully between national parks and forests. Their main objection to the dam was that it violated the sanctity of a national park. Yet the Forest Service implied that Muir's condemnation of the dam represented his position on all development anywhere in the public domain. For his own part, Pinchot wrote a series of articles that demonstrated his deftness at manipulating rhetoric. "The first great fact about conservation," he assured the nation, "is that it stands for development." Replying directly to criticism from businessmen that his policies would "lock up" the country's resources, he set out to correct "the fundamental misconception that conservation means nothing but the husbanding of resources for future generations. There could be no more serious mistake." Pinchot revised the conservation credo, "the greatest good to the greatest number," to read "the use of natural resources now existing on this continent for the benefit of the people who live here now."[33]

Like Muir, Pinchot still condemned the private misuse of public lands. Asserting that "the alliance between business and politics is the most dangerous thing in our political life," he affirmed the goal of conservation "to drive the special interests out of politics." But such abuses, he insisted, were aberrations, not systemic. Thus it was no contradiction to claim that "conservation stands for the same kind of practical common-sense management of this country by the people that every business man stands for in the handling of his own business." In fact, an "alliance between business and politics" was precisely what Pinchot sought—but on his own terms. Management,

rather than collusion, would be the new goal of government–business interaction. Both would profit, he believed, but not at public expense.[34]

Publicity, however, was only one strategy in the Hetch Hetchy battle. More important were lobbying in Washington and testimony before Congressional and Interior Department hearings. Manson began his lobbying efforts in 1905, working to solidify Roosevelt's and Pinchot's support for the city. Throughout the remainder of the campaign, San Francisco sent skilled lobbyists, often engineers, to present the city's case. With little money and no staff, the Sierra Club sent letters exhorting the government officials to see the light.[35]

Testimony at hearings demonstrated even more dramatically the different resources and strategies of the opposing camps. Belatedly realizing that engineers' assessments of the project's feasibility might sway the government more than arguments for the general land use principles involved in the case, Muir and the Sierra Club directors decided to hire an engineer lobbyist of their own. Their task proved difficult. In the highly charged political atmosphere of the Bay Area, few engineers were willing to risk alienating themselves from their peers by arguing against the city. Yet hiring an Eastern engineer would mean relying on someone who had not surveyed Hetch Hetchy himself—a clear tactical disadvantage. Finally, Colby secured the services of Philip Harroun, a private engineer in Berkeley, for the substantial sum of $1,050. Harroun's familiarity with the disputed site seemed to justify the cost.[36]

Unfortunately for the Sierra Club, Harroun did not divulge the reasons for his firsthand knowledge of Hetch Hetchy. The previous autumn, Secretary Ballinger had ordered an engineering report on the valley from the Bureau of Reclamation, which had subcontracted Harroun to survey the site. But Harroun did not tell the bureau or the Sierra Club that he was on the payroll of the Spring Valley Water Company, which hoped to discredit the technical merits of the city's reservoir plan. When Manson made the dramatic disclosure of Harroun's conflict of interest at the 1909 hearings in Washington, the Sierra Club lost its last hope of competing against the city's engineers for the political control of expertise.

Given the cohesiveness of Bay Area scientists on environmental issues a few years earlier, scientists' relative noninvolvement in the Hetch Hetchy debate indicated an important shift in their social role.

Some of the reasons for their decreased involvement were particular to the complexities and divisiveness of the Hetch Hetchy issue. The Sierra Club, largely at Manson's instigation, held a referendum in January 1910 at the request of members who disapproved of the club's opposition to the city's proposal. Although a high percentage of their members lived in San Francisco, the club's directors did reasonably well: 589 voted to continue protesting, while 161 favored the city's position on the dam. Of the latter, at least one—San Francisco meteorologist Alexander McAdie—was a scientist.

But as the final congressional decision of 1913 approached, the number of scientists involved in the campaign continued to dwindle. In part, the political geography of the campaign militated against widespread involvement. Beginning with the first congressional hearings in December 1908, Washington replaced San Francisco as the center of the Hetch Hetchy debate. Almost no Sierra Club members, scientists or nonscientists, could afford to attend the succession of hearings, debates, and votes that took place on the issue. At most of the congressional and Interior Department hearings, the only Californians present represented San Francisco; the Sierra Club had to rely on proxy representatives from Eastern civic organizations. Lacking the professional vocabulary of the engineer or the geologist, these spokespersons used the language their critics expected from them, condemning the reservoir as a product of the "business and utilitarian motives" of claimants "enslaved by Mammon." Pitted against San Francisco's staff of politically astute engineers, the opponents of the reservoir offered little competition in the battle of expertise. American Civic Association president Horace McFarland complained to Interior Secretary Ballinger that support for the park "may be damned by the term 'sentimentalism' or cursed by the epithet 'aestheticism.' " Yet he and the other civic organization representatives lacked any other frame of reference for arguing their case.[37]

For some of the scientists, reticence on Hetch Hetchy may have been connected with to job security. United States Geologist Robert Marshall, a Sierra Club member and a close friend of Muir, was an ardent opponent of the dam proposal. His survey work in the Hetch Hetchy Valley provided him with a firm basis for contradicting the testimony of the city's engineers, and he was perhaps the only Sierra Club member in Washington who could have attended the June 1913 hearings at which Pinchot carried the day. But as Marshall wrote in

an anguished letter to Muir, "I did not appear before the Committee. I have taken no action whatever, for to do so would, no doubt, cost me my position"—something that he would be willing to do were it not for his family responsibilities, Marshall added. As a government scientist, he was forbidden to espouse a position on the issue. "I regret more than I can say," he concluded, "that I can not, for financial reasons, remove the gag that my official position compels me to respect." Still, Marshall had spoken privately to Pinchot in 1907 on behalf of the Sierra Club, and he offered to help pay Muir's expenses to Washington.[38]

Marshall and his fellow government scientists were not the only scientists under pressure to remain silent. University of California president Benjamin Ide Wheeler staunchly backed San Francisco's claim, and made it clear to his faculty that criticism of the proposal would not be welcome. And anyone at Stanford or in San Francisco lived in the area to be served by the reservoir; sentiment in these communities ran overwhelmingly in favor of the dam.

With so much local fervor attached to the issue, Hetch Hetchy was unlikely to provide a desirable forum for discussing social priorities for the environment. Local newspapers hurled epithets at anyone who criticized the city's claim. And San Francisco's case looked stronger each year, especially after City Attorney Franklin Lane became secretary of the interior in 1913. But perhaps the most important reason for the scientists' silence over Hetch Hetchy was the clear evidence that Pinchot and the city engineers had successfully appropriated the vocabulary of conservation. Cloaking advocacy in the language of expertise, the Pinchot camp had reduced their opponents' argument to a pejorative caricature of feminine social traits. Harold Bradley, a young Wisconsin professor and future Sierra Club president, sardonically characterized the effect of this strategy:

> What *we sentimentalists* . . . desired and fought for was a fuller examination of conditions, a more exact collection of data and estimates. . . . What *we inexact sentimentalists* have demanded is a really adequate canvass of facts obtainable at some pain and expense and time. . . . You on the other hand—*you men of cold analytical temperament*, trained to be exact and study exact conditions, unemotional, knowing just what you are doing— you desire to turn over the Park areas on the advice of a few

prominent men, like Pinchot, and to do it as expeditiously as possible.

"It is not necessary for you to check up on the facts," Bradley continued, "these men are persuaded that it is all right; isn't that enough? Why investigate further? Why look over the facts? Why even subject the statements of these men to analysis? That," he wryly concluded, "would be sentimental."[39]

Finally, California's first generation of scientists provided dwindling support for the Sierra Club during the final Hetch Hetchy years because they were dying out. On December 6, 1913, the U.S. Senate cast a dramatic midnight vote that gave San Francisco approval for the Hetch Hetchy reservoir. By that time most of the charter scientists in the Sierra Club had retired or died. Muir himself died the following year. The scientists who replaced them had been trained to view social activism as unprofessional. California's first scientific community had tried to take its message of environmentalism to the nation's leaders on the East Coast. Instead, managerial science had come to California.

9

The End of the Trail:
Ishi, Science, and the
Panama Pacific Exposition

On February 20, 1915, a quarter of a million people attended the opening exercises of the Panama Pacific International Exposition in San Francisco. Officially a commemoration of the opening of the Panama Canal, the exposition was San Francisco's declaration of membership in the international community of modern industrial city-states. The region's merchants and manufacturers hoped that the fair would broadcast an image of a city miraculously recovered from the devastating earthquake and fire of 1906—a city poised to welcome the influx of trade that the new canal would surely create. But the fair's designers also meant to showcase the aesthetic maturity and environmental beauty of California. Previous world's fairs outlined their pavilions with electric light bulbs, but the San Francisco fair was the first to use indirect lighting. (Even the fog was illuminated by hidden colored spotlights; and when the fog failed to appear, a steam engine created a substitute.) The 1893 Columbian Exposition in Chicago relied on simulated white marble facades for its celebrated White City; the Panama Pacific Exposition featured soft pastels that were chosen to reflect the colors of the California landscape.[1]

A stroll through the exposition grounds approximated a form of time travel; from the Court of Ages to the Avenue of Progress, visitors witnessed the compressed history of California, America, the world of nations, and the evolution of life itself. One of the most popular

sculptures at the fair was James Earl Fraser's *The End of the Trail*, which depicted an American Indian on horseback—his head, horse, and spear all bent downward in defeat. Across the courtyard, Solon Borglum's *The American Pioneer* sat erect on a robust steed, his rifle tilted upward in readiness as he led "the victorious march of his civilization."[2] *The End of the Trail* was designed to evoke the pathos of the Indian's fate while reasserting the inevitable path of progress in the West. (And since the American West was depicted as the new culmination of European history, borrowing from other pasts also seemed appropriate. Oregon housed its state exhibits in a replica of the Parthenon, with the trunks of Douglas firs for columns.)

The exposition's time-travelers caught hints of the future alongside comforting renditions of the past. At one end of the grounds was Machinery Palace, flanked by the Palaces of Transportation, Manufactures, Varied Industries, and Mines and Metallurgy—all pointing to an expansive industrial future. At the opposite end was the Palace of Fine Arts, a configuration of columns, arches, and cloisters designed by local architect Bernard Maybeck to evoke "an old Roman ruin." Maybeck's creation was a favorite among fairgoers, and the only structure to escape demolition when the fair ended. Commentators interpreted its message variously as sadness over the impermanence of the fair, mourning the irretrievability of the past, or the melancholy awareness that art will always fall short of perfection.[3] Like the pioneer and the Indian, the Machinery Palace and the Palace of Fine Arts reflected two aspects of the same process. And if the machine exhibits were emblems of a certain coming of age, so were Maybeck's ruins; for a culture that could express nostalgia—even for a past that still lay in the future—was surely one of great maturity and dignity.

As the Palaces of Machinery and Fine Arts suggested, the Panama Pacific Exposition was a study in contrasts. The Underwood Company exhibited a fourteen-ton typewriter, fully functional, with keys the size of barstools. The Santa Fe Railroad displayed a scale model of the Grand Canyon; not to be outdone, the Union Pacific Railroad constructed a replica of Yellowstone National Park, featuring periodic discharges from tiny simulated geysers. The giant typewriter and the miniaturized parks were graphic demonstrations of one of the fair's pervasive themes: the frontier had been subdued and contained by the industrial transformation of the West.[4] At least in the

collective imagination of its promoters, the machine had outgrown the garden.

Like many world's fairs before it, the Panama Pacific Exposition had an unofficial carnival area at its perimeter (at the San Francisco fair it was called the Joy Zone), which played the role of village idiot, mocking the cultural pretentions of the urban middle class inside the city walls. In the Zone, lights and colors were deliberately garish, society matrons were replaced by "diving girls," and the imposing machinery of the exposition palaces was caricatured by carnival rides and gigantic mechanical toys. If the official fair had sculptures of defeated Indians and triumphant pioneers, the Joy Zone had real Indians enacting an imaginary past in Wild West shows. One of the most arresting features of the Joy Zone was the Souvenir Watch Palace, where a three-story-high papier-mâché Uncle Sam dangled a giant pocket watch above a display of one-dollar timepieces and cheap trinkets. The official exposition presented itself as a somber time-machine; but in the Joy Zone's environment of proclaimed leisure, where time stood still and the rides and exhibits lampooned work-discipline, what better souvenir than a cheap, expendable watch?

Science, too, was on display at the San Francisco fair. Early in August, scientists from all over the United States gathered at the exposition for the first West Coast meeting of the American Association for the Advancement of Science (AAAS). For California scientists, this convention represented their deliverance from regional isolation. The AAAS had begun in 1840 as an association of geologists, but it evolved into one of the country's formative attempts to create a national scientific identity. Seventy-five years later, the San Francisco meeting provided the occasion for establishing the Pacific Divison of the AAAS. If California had come of age, so had its scientists.[5]

For AAAS members, California's most important displays were located beyond the fairgrounds. Across town from the exposition was Golden Gate Park, where scientists could inspect the new site of the California Academy of Sciences. Due to reopen in 1916, the academy had made prudent use of its decade of rebuilding after the quake. The new building incorporated the latest environmental exhibition techniques and featured "the first large hall in any museum in the world to be devoted exclusively to modern habitat groups of birds and mammals." In the decades to come, such additions as an

aquarium, a planetarium, an Alice Eastwood botanical wing, and a substantial staff of professional taxonomists all contributed to the academy's prestige as an outstanding museum of natural science. After 1916, the academy's financial and organizational uncertainties were practically things of the past. So, too, was its briefly realized aspiration to provide common ground for professional scientists, amateurs, patrons, and the general public. Scientists did not discontinue their association with the academy; Jordan and several of his Stanford colleagues played key leadership roles there in the first two decades of the twentieth century. But specialization had reshaped the display value of science as well as its research aims. For the most part, the academy curtailed its hopes of extending its research beyond its own collections, while the universities limited their role as museums for the public demonstration of science.[6]

The AAAS delegates who ventured across the bay to Berkeley or down the peninsula to Stanford found changes at the universities as well. After thirty years of agitation by Pacific scientists, the University of California finally established the state's first school of forestry in 1913. But in other parts of the university, changes were occurring more rapidly. Benjamin Ide Wheeler's appointment as president of the University of California in 1899 let to an aggressive policy of hiring prominent national scientists and upgrading facilities. Having won the federal suit against its endowment and largely recovered from the damage inflicted by the 1906 earthquake, Stanford too began to plan for a faculty of national stature. The new scientists brought prestige to the universities; they also brought new interests. In the natural sciences, Wheeler's proudest achievement was the hiring of eminent German botanist Jacques Loeb, whose mechanistic theories on the primacy of heredity and instincts stood in direct contrast to the older academic generation's emphasis on environmental adaptation. Most significant, however, was the university's effort to establish stronger programs in the physical sciences. Wheeler convinced MIT physical chemist Gilbert N. Lewis to come to Berkeley in 1912 on the condition that the university provide new research facilities, equipment, and graduate fellowships. At the 1915 meeting, Lewis discussed his work in a paper titled "The Atom and the Molecule," a major contribution to the theory of covalent bonding.[7]

Lewis' arrival signaled the rising prominence of the physical sciences—an international development that was destined to change

the scientific landscape of California. In 1915, Andrew Lawson became dean of the College of Mining at the University of California. When he first arrived in Berkeley in 1891, he looked out the window of South Hall to the Berkeley hills and said, "Well, that looks fine for geology!" By the time Lawson died in 1952, those hills had begun to acquire new outcroppings: chain-link fences and armed guards protecting a federally funded cyclotron, electron synchrotrons and proton linear accelerators. After World War II the Manhattan Project's facilities at Los Alamos fell under the jurisdiction of the University of California, as did the new Lawrence Radiation Laboratory at Livermore in the 1950s.[8]

Change for California scientists was also evident beyond the campuses in 1915. Looking across the bay to Alameda, fairgoers could see the refineries that gave proof of the oil boom to the south. Particularly in the Los Angeles area, a growing forest of derricks was transforming California into the nation's leading oil producer— a fact of great import for the next generation of geologists and chemists in the West. In 1920 Standard Oil of California established its first research facility in Richmond, just north of Berkeley. And while visitors explored the San Francisco fair, construction for the Great Western Electrochemical Company was underway in nearby Pittsburg. In the years to come, these new science-based industries, along with the federal government, subsidized the universities' retooling of their science and engineering programs to meet the needs of the new corporations.[9]

Much that was new for California science, however, was not visible from San Francisco. As San Diego's concurrent Panama–California Exposition suggested, more was rising from the ground in southern California than oil. In 1868, when John Muir arrived in San Francisco, about one Californian in twelve lived south of the Tehachapi Mountains. By 1910 the state's population had quintupled, and Los Angeles had expanded from an adobe village to the largest metropolis in the state. In 1919 the University of California officially launched a second campus located in Los Angeles. Even more important for scientists were the efforts of astrophysicist George Ellery Hale to convert the modest Throop Polytechnic Institute in Pasadena into the California Institute of Technology. Hale had already played the crucial role in persuading Andrew Carnegie to fund the Mount Wilson Observatory,

southern California's spectacular answer to the Lick Observatory on Mount Hamilton. In 1921 he convinced pioneer nuclear physicist Robert Millikan to leave the University of Chicago to preside over the new Caltech. Not only had different kinds of science come to California, but different parts of California had begun to receive them.[10]

Changes in public attitudes toward natural resources were imminent in 1915, although not in the fashion California scientists had foreseen. One highlight of the fair was the first long-distance telephone call between San Francisco and Chicago. Franklin K. Lane, the San Francisco City Attorney who had become President Wilson's Secretary of the Interior, made the historic call to his assistant, Stephen Mather, in Chicago. Two years earlier, Lane had guided the city's Hetch Hetchy proposal to victory. One year after their transcontinental phone conversation, Mather became the first director of the newly established National Park Service. Thereafter the split between Pinchot and Muir was neatly bureaucratized, with Pinchot's resource management principles guiding the Forest Service (as well as most other public domain policy), while the much smaller Park Service more closely approximated the national park aspect of Muir's conservationist thinking. With the Forest Service in the Department of Agriculture and the Park Service in the Interior Department, visitors to Yosemite could still cross jurisdictional boundaries several times in the course of an outing. Clearly, a comprehensive science-based policy towards the environment remained an elusive goal.

Environmental science, however, was emerging in new forms. The year of the exposition also marked the founding of the Ecological Society of America, the first national organization devoted to the promotion of scientific ecology. Early and mid-twentieth century ecologists developed far more sophisticated techniques than those employed by the first California scientists: bionomics, Malthusian demography and population dynamics, and especially the quadrat field analysis developed by Frederick Clements' "grassland school" of ecology at the University of Nebraska. The focus of these techniques and their relation to public policy differed considerably from the aims envisioned by California's first scientists. As a new scientific profession, ecology developed its theoretical framework in relative isolation both from the rest of the scientific community and from the general public. Like forestry, the ecological sciences affected

society primarily as a managerial instrument, applying problem-solving techniques to enhance production in forestry, agriculture, and fish and range management.[11]

Environmental activism also survived Hetch Hetchy. A short stroll to the financial district would take the 1915 fairgoer to the Mills Building, where the Sierra Club had established its new headquarters. Its activities had won national prominence, but for many years the club failed to shed the narrowly preservationist image that was the legacy of the Hetch Hetchy controversy. Scientists could still be found on the membership lists, but never again would they exert so much influence in the club. (The Sierra Club won its next major battle to stop a dam project by adopting the expertise and issues of engineers. In the 1950s a hydroelectric dam was proposed at Echo Canyon, a site on the Colorado River that fell within Dinosaur National Monument. This time the club concentrated less on arguing the sanctity of a federally designated wilderness area than on providing engineers to refute the siltation and evaporation rates projected by the dam's proponents.)

Despite all of the changes, participants at the San Francisco AAAS convention did not have to venture far to encounter reminders of the region's first scientists. Some may have strolled across town to Mount Davidson for a view of the bay. Others may have walked down Le Conte Street on their way to the Berkeley campus or accompanied Alice Eastwood on one of her tours of Muir Woods, just north of the city. The more adventurous could follow the John Muir Trail through the High Sierra to view Mount Whitney, Mount Brewer, Mount Clarence King, and Mount David Starr Jordan.

The legacy behind these names was less apparent. Pacific scientists had contributed comparatively little to theoretical science. Their social aims for California remained unrealized. Even their effort to form a synthesis of scientific and social objectives had been discredited. Yet their careers collectively pointed toward both the importance and the difficulty of developing an ecologically informed vision of science and society. Four years before the AAAS met in San Francisco, Harvard philospher George Santayana delivered his lecture on "The Genteel Tradition in American Philosophy" at Berkeley. Santayana's observations on the lessons of California's natural environment echoed what the region's scientists had spent a generation trying to convey: that the view of nature most beneficial to humanity was one in which

nature was not treated as a commodity and humans were not seen as the center of creation—not because humans were less important than the rest of nature, but because the prevailing anthropocentric vision of the earth as a marketplace was a distorted and ultimately self-destructive way of interpreting the dynamics of the biosphere.[12]

Four days after Santayana's Berkeley lecture, events elsewhere in the state added new resonance to his observation that "if the philosophers had lived among your mountains, their systems would have been different from what they are." On August 29, 1911, "the last wild Indian in North America" was apprehended in Butte County. Ishi had lived among California's mountains all his life; he was the last surviving Yahi, the southernmost of the Yana Indians who had inhabited the region southwest of Mount Lassen for thousands of years. Shortly after his detainment, University of California anthropologists Alfred Kroeber and Thomas Waterman brought him to the university's museum of anthropology in San Francisco.[13]

Ishi found certain aspects of modern industrial life very appealing (streetcars, matches, pockets, running water, and electric lights) but he feared large crowds and urban bustle. He was amused by door-knobs and typewriters and he adjusted to shoes, but he remained unimpressed by skyscrapers and airplanes (mountains were higher and hawks were better fliers). He was astonished by some of the uncivilized practices of the white people, or *saltu:* they grew beards, drank whiskey, boiled their food beyond recognition, moved too quickly, spent far too much time indoors, and were appallingly oblivious to the simplest truths of nature.[14]

Some of the visiting AAAS scientists no doubt visited Ishi's quarters at the museum, but Ishi probably spent little if any time at the Panama Pacific Exposition. The crowds were too large, and his health was failing; he spent part of 1915 hospitalized for tuberculosis and died on March 25, 1916. Still, many of the fair's features would have interested him. After all, as one present-day anthropologist has noted, world's fairs functioned as a modern international ritual not unlike the potlatches of Pacific Northwest Indians. The San Francisco fair displayed its share of quaint cultural talismans (a large bell was carried all the way from Philadelphia, even though it was badly cracked). And Ishi certainly would have appreciated the ironies implicit in the Souvenir Watch Palace, where Uncle Sam and the giant

timepiece embodied the invasion of the *saltu*. Ishi had been given a pocket watch, "which he wore and kept wound but not set." He admired its craftsmanship but preferred to tell time by the sun.[15]

After four years of publicity about the "the Stone Age man," fairgoers might have considered the sculpture *The End of the Trail* a fitting likeness of Ishi himself. But Ishi felt a greater affinity for the living Native Americans in the Joy Zone's Wild West shows; for as Ishi knew, he was himself a living exhibit. Carnival hucksters, cigar manufacturers, and filmmakers had tried to recruit him for exhibition. Visitors to the University of California's Museum of Anthropology could watch him make arrowheads or build an outdoor summer shelter. The museum presented Ishi's activities as examples of indigenous folkways, but what Ishi really exhibited was the great ingenuity of his cultural adaptability—he selected what he needed and liked from white society and discarded the rest. Alfred Kroeber remarked that if the situation were reversed, he could never have adapted to Ishi's culture with comparable success. The Indian and the anthropologist had become each other's guides, and Kroeber recognized Ishi as a living refutation of many scientists' superstitious belief in the genetic inferiority of "primitive" peoples.[16]

In their protracted adjustment to a strange new industrial world, fairgoers unknowingly shared something of Ishi's predicament. The world they were about to wander into was almost as alien to them as their own world had been to Ishi. The Panama Pacific Exposition scrubbed and rearranged California's sixty-five years of statehood into a seamless pageant of progress. Had one of the Joy Zone's rides been able to provide a glimpse of the next sixty-five years, the fair's visitors would have found a transformed environment, replete with new wonders and new threats. An aerial view of this future California would have revealed great bridges spanning the San Francisco Bay and an increasingly intricate latticework of modern freeways across the state—a sign not only of a population that doubled every two decades but also of the ascendancy of the automobile in twentieth-century California. And beginning in the 1940s, a brown smudge of photochemical pollutants would crown the Los Angeles basin as the smog capital of the nation.

Flying over the Sierra Nevada of the 1980s, Panama Pacific fairgoers would be astonished to see that Yosemite Valley, too, had developed a smog problem. With the advent of the automobile,

Yosemite became part of California's emerging car culture. In 1870 Jeanne Carr complained of Yosemite's overcrowding; over seventeen hundred tourists visited the Valley that year. By the 1980s that number had risen to 2.8 million annually. And at Hetch Hetchy's O'Shaughnessy Dam, time-traveling fairgoers could watch (with considerable déjà-vu) an October 1987 debate between the mayor of San Francisco and the secretary of the interior over a proposal to restore Hetch Hetchy to its original state.[17]

Along the coastline the visitors would witness astonishing urban growth; but the post-World War II decline in annual catches and the appearance of offshore drilling rigs and periodic oil spills would provide only a slight hint of the problems created by offshore pollution and overfishing. In the 1970s windfarms and solar collectors would appear, signaling a statewide search for new energy; but during those same years, aerial observers would witness the construction of a nuclear power plant at Diablo Canyon, where the usual uncertainties over nuclear safety were compounded by discoveries that the plant was located near a major earthquake fault and that earthquake safety structures had been erected from the wrong blueprints.

Further inland, bright green geometric patterns quilting the San Joaquin and Imperial Valleys would mark the most productive agricultural regions in the world, supported by a continental irrigation network that siphoned water from throughout the trans-Rockies watershed. By the 1980s, California's need for water had created "the greatest hydraulic society ever built in history." Tracing the Colorado River from the massive Hoover Dam to the Gulf of California, observers could watch a succession of dams and waterworks diminish the river to a dry basin before it reached the sea. More difficult to discern from the air would be the enormous quantities of fertilizers consumed by California agribusiness—by the 1980s, it reached over three million tons per year, more than the amount consumed in all of the other states combined. Traces of pale discoloration might hint that overdependence on fertilizers was gradually converting thousands of acres of land into salt flats. Meanwhile, wastewater from publicly subsidized irrigation contaminated drinking water with nitrates and lethal metals. (In the 1980s, selenium deposits from Central Valley irrigation proved fatal for waterfowl at the Kesterson Wildlife Refuge near Sacramento.)[18]

Flying over the state's fields and forests, visitors from 1915 would have no way of knowing that the rich productivity beneath them was supported in part by deadly biocides. By 1980, California was annually introducing over 300 million pounds of chemical pesticides into the food and water cycle. Many of them (particularly the growing number of phosphate esters) were fatal to humans in doses as small as a few drops; others, like dioxin, were powerful enough to register dangerous toxicity at levels of a few parts per trillion. One long-term effect of this dependency was that growers and foresters were unwittingly breeding hundreds of new strains of pesticide-resistant insects; another effect was the thousands of annual human casualties. By the 1970s California's farmworkers suffered an occupational disease rate three times as high as the average for all industries in the state. Meanwhile, a group of persistent women in Humboldt County overcame bureaucratic and corporate resistance to establish that the alarming number of miscarriages and birth defects in their communities were caused by the Forest Service's resumed spraying of 2,4,5-T to control a gypsy moth infestation in nearby forests.[19]

Biocides were just one among many new sources of environmental concern in postwar America, but they seemed to encapsulate the social dynamics of the environmental crisis. In the concluding paragraph of *Silent Spring* (1962), Rachel Carson dramatically portrayed one of the social corollaries of interdependence: that the conquest of nature was an act of self-mutilation. "The 'control of nature,' " she wrote, "is a phrase conceived in arrogance, born of the Neanderthal age of biology and philosophy, when it was supposed that nature exists for the convenience of man. The concepts and practices of applied entomology for the most part date from that Stone Age of science. It is our alarming misfortune that so primitive a science has armed itself with the most modern and terrible weapons, and that in turning them against the insects it has also turned them against the earth." Neanderthal, Stone Age, primitive: the terms that a previous generation had used to characterize Ishi were invoked by Carson to describe certain of her fellow scientists.[20]

What was needed, then as now, was a new conceptual framework for approaching environmental issues. The first step, as California's first scientists recognized, was to overcome the arrogance of anthropocentrism—to reveal the dangers implicit in advanced industrial society's unexamined assumptions, and to seek alternatives. In the

1970s, a growing national environmental movement fostered new government agencies in an attempt to join scientific ecology with the advocacy of socially responsible environmental policy. Scientists found entirely new professions emerging to meet the need for measuring and counteracting air and water pollution, toxic wastes, and occupational hazards. But even in California, where standards of environmental regulation were stricter than their federal counterparts, the 1980s demonstrated how vulnerable the regulatory process was to political and economic pressures. Under the presidency of former California governor Ronald Reagan, key environmental policy agencies (particularly the Department of the Interior, the Environmental Protection Agency, the Department of Energy, and the Occupational Safety and Health Administration) fell under the leadership of appointees who slowed or reversed the environmental aims of the 1970s.

A number of scientists and environmentalists noted that even at its best, regulation failed to address the root of the problem. As Barry Commoner observed in 1970, industrial corporations met their need for constant economic growth through the depletion and despoliation of natural resources, but "the costs of environmental degradation are borne not by the producer, but by society as a whole. . . . A business enterprise that pollutes the environment," he concluded, "is therefore being subsidized by society" financially and ideologically. A more accurate economic overview would examine industry as one agent among many in a broader ecosystem.[21]

By the 1970s and 1980s a proliferation of environmental strategies, organizations, and schools of thought had joined the fray. Scientists developing Integrated Pest Management looked for methods of applying nature's own insect containment techniques (natural predators, botanical repellants, and reproduction inhibitors). Such groups as the Union of Concerned Scientists and the Natural Resources Defense Council applied the expertise of scientists in legal and political battles over environmental issues. ("The environmental movement used to be about stopping things," NRDC attorney Ralph Cavanaugh observed in 1987; "increasingly, it's about doing things.") Two California environmental thinkers, Sierra College philosopher George Sessions and Humboldt State University political theorist Bill Devall, spearheaded the "deep ecology" movement—a broad effort to move beyond the narrow reformist agendas of most government environmental agen-

cies and conservation groups. California poet-philosopher Gary Snyder called for a "bioregional ethic," emphasizing sense of place, appropriate technologies, and local rather than multinational corporate organization of production. Greenpeace and Earth First! adopted direct action tactics (*eco-tage*) to impede the slaughter of whales, clearcutting and bulldozing in wilderness areas, and other environmental practices which they saw as acts of "official vandalism."[22]

What would observers from 1915 make of such a tour of the future? Years after the Panama Pacific Exposition had closed, Bernard Maybeck was asked what he thought should be done with his crumbling Palace of Fine Arts. Plant redwoods around the rotunda, Maybeck replied; "as they grow, the columns would slowly crumble at approximately the same speed" until the redwoods became the columns, neatly joining nature and culture.[23] Maybeck's imagined redwood palace—a more tasteful variation of the Oregon Parthenon—was never realized. In the 1960s, the palace and the redwoods were both objects of preservation campaigns, but not in the same place. The Palace of Fine Arts was demolished and reconstructed; thus a hastily constructed artificial ruin was replaced by a newer, more durable and convincing simulation of a past that never was. And in Humboldt County, a fifty-year effort to create a redwood park finally succeeded. Symbols of California's only genuine antiquity, the three-thousand-year-old trees that had once blanketed the county had been reduced to isolated groves and curiosities (burlwood gargoyles, drive-through redwoods, a single felled redwood converted into a house or a souvenir shop).

Neither the palace made of redwoods nor the redwood made into a house provided an adequate expression of twentieth century Californians' complex relation to nature. Perhaps Ishi's shelter, constructed on the grounds of the anthropology museum, more nearly expressed the alliance of past and future, science and social values that California's first environmental scientists left as an imagined but still unrealized legacy. "Master the archaic and the primitive as models of basic nature-related cultures—as well as the most imaginative extensions of science," Gary Snyder wrote in 1970, "and build a community where these two vectors cross."[24] It remains to be seen whether the lasting monument to the interaction of Californians, scientists, and the environment will be a hollow tree filled with trinkets, or roots in the abiding land.

Abbreviations

AEP Alice Eastwood Papers, Library and Archives, California Academy of Sciences, San Francisco

BL Bancroft Library, University of California, Berkeley

CAS Library and Archives, California Academy of Sciences, San Francisco

CKP Clarence King Papers, Huntington Library, San Marino, California

DSJP David Starr Jordan Papers, Stanford University Archives, Leland Stanford Junior University, Stanford, California

GDP George Davidson Papers, Bancroft Library, University of California, Berkeley

GD-CAS George Davidson Papers, Library and Archives, California Academy of Sciences, San Francisco

GD-JF Fifty-four Letters from George Davidson to Jane Dale Owen Fauntleroy, Bancroft Library, University of California, Berkeley

GEP Gustav A. Eisen Papers, Library and Archives, California Academy of Sciences, San Francisco

HL Huntington Library, San Marino, California

JMP John Muir Papers, Holt-Atherton Pacific Center for Western Studies, University of the Pacific, Stockton, California

LC Library of Congress, Washington, D.C.

LSJU Stanford University Archives, Leland Stanford Junior University, Stanford, California

PCWS Holt-Atherton Pacific Center for Western Studies, University of the Pacific, Stockton, California

RUJP Robert Underwood Johnson Papers, Bancroft Library, University of California, Berkeley

SCA Sempervirens Club Archives, Sempervirens Fund, Mountain View, California

SCB *Sierra Club Bulletin*

SIO Scripps Institution of Oceanography, La Jolla, California

WDP William Dudley Papers, Stanford University Archives, Leland Stanford Junior University, Stanford, California

Notes

Introduction

1. George Santayana, "The Genteel Tradition in American Philosophy" (in Santayana, *Winds of Change*, 1913; rpt. in Alan Trachtenberg, ed., *Critics of Culture: Literature and Society in the Early Twentieth Century*, New York: Wiley, 1976), pp. 31–32.
2. Stephen Jay Gould. *Time's Arrow, Time's Cycle: Myth and Metaphor in the Discovery of Geological Time* (Cambridge: Harvard University Press, 1987), pp. 1–2.
2. Robert V. Bruce, "A Statistical Profile of American Scientists, 1846-1876," in George H. Daniels, ed., *Nineteenth Century American Science: A Reappraisal* (Evanston: Northwestern University Press, 1972), pp. 63–94; Donald DeB. Beaver, "The American Scientific Community, 1800–1860: A Statistical-Historical Study" (Ph.D. dissertation, Yale University, 1966); Clark A. Elliott, "The American Scientist, 1800–1863: His Origins, Career, and Interests" (Ph.D dissertation, Case Western Reserve University, 1970). See also Robert V. Bruce, *The Launching of Modern American Science, 1846–1876* (New York: Knopf, 1987), p. 363.
4. Margaret Rossiter, *The Emergence of Agricultural Science: Justus Liebig and the Americans, 1840, 1880* (New Haven: Yale University Press, 1975); Charles E. Rosenberg, *No Other Gods: On Science and American Social Thought* (Baltimore: Johns Hopkins University Press, 1976), pp. 135–84; Carroll Pursell, Jr., "The Technical Society of the Pacific Coast, 1884-1914," *Technology and Culture* 17 (October 1976): 702–17; Bruce Sinclair, "Investing a Genteel Tradition: MIT Crosses the River," in Sinclair, ed., *New Perspectives on Technology and American Culture* (Philadelphia: American Philosophical Society, 1986), pp. 1–18.
5. From the extensive literature on the professionalization of science, I have relied especially on A. Hunter Dupree, *Science in the Federal Government* (Cambridge, Mass.: Harvard University Press, 1957); Nathan Reingold, "Definitions and Speculations: The Professionalization of Science

in America in the Nineteenth Century," in Alexandra Oleson and Sanborn C. Brown, eds., *The Pursuit of Knowledge in the Early Republic* (Baltimore: Johns Hopkins University Press, 1976); Sally Gregory Kohlstedt, *The Formation of the American Scientific Community: The American Association for the Advancement of Science, 1848–1860* (Urbana: University of Illinois Press, 1976); Everett Mendelsohn, "The Emergence of Science as a Profession in Nineteenth-Century Eurpoe," in Karl Hill, ed., *The Management of Scientists* (Boston: Beacon, 1964), pp. 3–47; Thomas Bender, "Science and the Culture of American Communities: The Nineteenth Century," *History of Education Quarterly* 16 (1976): 63–77; Michael J. Lacey, "The Mysteries of Earth-Making Dissolve: A Study of Washington's Intellectual Community and the Origins of American Environmentalism in the Late Nineteenth Century" (Ph.D. dissertation, George Washington University, 1979); Thomas G. Manning, *Government in Science: The U.S. Geological Survey, 1867–1894* (Lexington: University of Kentucky Press, 1967); Margaret W. Rossiter, *Women Scientists in America* (Baltimore: Johns Hopkins University Press, 1982); Daniel Calhoun, *Professional Lives in America: Structure and Aspiration, 1750–1850* (Cambridge, Mass.: Harvard University Press, 1965); Daniel J. Kevles, *The Physicists* (New York: Knopf, 1978); Thomas L. Haskell, *The Emergence of Professional Social Science* (Urbana: University of Illinois Press, 1977); Burton J. Bledstein, *The Culture of Professionalism* (New York: Norton, 1976); Lawrence R. Veysey, *The Emergence of the American University* (Chicago: University Press, 1965); Max Weber, "Science as a Vocation," in H. H. Gerth and C. Wright Mills, ed. and tran., *From Max Weber: Essays in Sociology* (1946, rpt. New York: Oxford University Press, 1978).

6. Perry Miller, *The Life of the Mind in America: From the Revolution to the Civil War* (New York: Harcourt, Brace & World, 1965), p. 283.

7. Ronald C. Tobey, *Saving the Prairies: The Life Cycle of the Founding School of American Plant Ecology, 1895–1955* (Berkeley: University of California Press, 1981).

8. Christopher Lasch, *The Culture of Narcissism: American Life in an Age of Diminishing Expectations* (New York: Norton, 1978).

1: Geopolitics and Gold

1. Andrew F. Rolle, *California: A History*, 2d ed. (New York: Crowell, 1969), p. 37.

2. Rodman W. Paul, *Mining Frontiers of the Far West, 1848–1880* (1963, rpt. Albuquerque: University of New Mexico Press, 1974), p. 16; John Henry Brown, *Reminiscences and Incidents of Early Days of San Francisco (1845–50)* (1886, rpt. San Francisco: Grabhorn, 1933), p. 97.

3. John Francis Bannon, *The Spanish Borderlands Frontier, 1513–1821* (1963, rpt. Albuquerque: University of New Mexico Press, 1974), p. 157.

4. William H. Goetzmann, "Paradigm Lost," in Nathan Reingold, ed., *The Sciences in the American Context: New Perspectives* (Washington, D.C.: Smithsonian Institution Press, 1979), pp. 21–27; Nathan Reingold, ed., *Science in Nineteenth-Century America: A Documentary History* (New York: Hill and Wang, 1964), pp. 60-62; Joseph Ewan, "San Francisco as a Mecca for Nineteenth Century Naturalists," in *A Century of Progress in the Natural Sciences, 1853–1953* (San Francisco: California Academy of Sciences, 1955), pp. 1-8.

5. Ewan, "San Francisco," pp. 2–6. Throughout this section I am indebted to Carl I. Wheat, *Mapping the Trans-Mississippi West* (San Francisco: San Francisco Institute of Historical Cartography, 1957–63).

6. Alice Eastwood, "Early Botanical Explorers on the Pacific Coast and the Trees They Found There," *California Historical Society Quarterly* 18 (Winter 1939): 335–346; Roland H. Alden and John D. Ifft, "Early Naturalists in the Far West," *Occasional Papers of the California Academy of Sciences* 20 (1943): 1–53.

7. Alden, and Ifft, "Early Naturalists," pp. 40-46; Ewan, "San Francisco," pp. 3-4.

8. Goetzmann, *Exploration and Empire: The Explorer and the Scientist in the Winning of the American West* (1966, rpt. New York: Vintage, 1972), pp. 308; Donald Jackson, ed., *The Letters of the Lewis and Clark Expedition* (Urbana: University of Illinois Press, 1962), pp. 4, 10.

9. A. Hunter Dupree, *Science in the Federal Government* (Cambridge: Harvard University Press, 1957), pp. 56–61; "[Lt. Charles] Wilkes to the Secretary of the Navy," 16 July 1842, in Reingold, ed., *Science in Nineteenth-Century America*, p. 124; "Extract from Wilkes' Memorandum, 1838," publ. in Reingold, ed., *Science in Nineteenth Century America*, p. 119. Herman J. Viola, "The Story of the U.S. Exploring Expedition," in Herman J. Viola and Carolyn Margolis, eds., *Magnificent Voyagers: The U.S. Exploring Expedition, 1838–1842* (Washington, D.C.: Smithsonian Institution Press, 1985), pp. 13–14, 23.

10. Dupree, *Science in the Federal Government*, pp. 60-61, 70-76; "Wilkes to the Secretary of the Navy," p. 125.

11. John C. Frémont, *Memoirs of My Life* (Chicago: Belford Clark, 1887), p. 65; Charles Preuss, *Exploring with Frémont*, Erwin G. Gudde and Elizabeth K. Gudde, ed. and trans. (Norman: University of Oklahoma Press, 1958).

12. Goetzmann, *Army Exploration in the American West, 1803–1863* (New Haven: Yale University Press), p. 68; Cardinal L. Goodwin, *John Charles Frémont: An Exploration of his Career* (Palo Alto: Stanford University

Press, 1930). For a less critical treatment, see Allen Nevins, *Frémont: Pathmarker of the West* (New York: Appleton-Century, 1939).

13. Walton Bean and James J. Rawls, *California: An Interpretive History,* 4th ed. (New York: McGraw-Hill, 1983), pp. 95, 157; New York *Herald, California Herald-Extra,* 16 January 1849, quoted in Paul, *Mining Frontiers,* 14; Bayard Taylor, *Eldorado; or Adventures in the Path of Empire* (1850, rpt. New York: Knopf, 1949), p. 226.

14. Gustavus A. Weber, *The Coast and Geodetic Survey: Its History, Activities and Organization* (Baltimore: Institute for Government Research, 1923).

15. George Davidson to Ed Hall, 26 June 1850, GDP, BL.

16. James Lawson, "Autobiography," MS, 1879, BL, p. 2.

17. Lawson, "Autobiography," p. 4; Davidson to Ed Hall, 26 June 1850, GDP; Davidson to Jane Dale Owen Fauntleroy, 28 July 1851, GD-JF; Davidson to Jane Fauntleroy, 18 January 1851, GD-JF; Davidson to Jane Fauntleroy, 14 May 1852, GD-JF. James Lawson served as Davidson's assistant.

18. William F. King, "George Davidson: Pacific Coast Scientist for the U.S." (Ph.D., Claremont Graduate School, 1973); Oscar Lewis, *George Davidson: Pioneer West Coast Scientist* (Berkeley: University of California Press, 1954).

19. For Davidson's views on the shortcomings of his education, see Davidson to Jane Fauntleroy, 15 January 1857, GD-JF.

20. Dupree, *Science in the Federal Government,* p. 117.

21. Davidson to Jane Fauntleroy, 18 January 1851, GD-JF; Davidson to Robert Fauntleroy, 27 October 1848, GDP; Davidson to Ed Hall, 20 January 1851, GDP.

22. Lewis, *George Davidson,* p. 9; Davidson to Robert Fauntleroy, 27 October 1848, GDP.

23. Quoted in Mark Holloway, *Heavens on Earth: Utopian Communities in America, 1680–1880,* 2d ed. (New York: Dover, 1966), p. 104.

24. Samuel G. Morton, *A Memoir of William Maclure* (Philadelphia: Collins, 1841), p. 20; George P. Merrill, *The First One Hundred Years of American Geology* (New Haven: Yale University Press, 1924), pp. 32-37.

25. Gary Lane, "New Harmony and Pioneer Geology," *Geotimes* 11 (September 1966): 19; "Richard Owen, M.D., LL.D.," *Indiana Student* (April 1886): 158-62; Nora C. Fretageot, "The Robert Dale Owen Home," *The New Harmony Times,* n.d., GDP; Lewis, *George Davidson,* p. 21. For David Dale Owen's influence on American geologists, see Merrill, *First One Hundred Years,* pp. 194-99, 217-18, 271-75, 321-23, 365-67; "Sketch of the Life of David Dale Owen, M.D.," *The American Geologist*

4 (August 1889): 67-70; "New Harmony Ready for Fête," *The Christian Science Monitor*, 4 June 1914.

26. Oweniana, Box 64, GDP; Davidson to Jane Fauntleroy, 19 December 1859, GD-JF.

27. Davidson to Robert Fauntleroy, 27 October 1848, GDP; Davidson to Ed Hall, 12 (?) June 1851, GDP.

28. Davidson to Ed Hall, 20 January 1851, GDP; Davidson to Jane Fauntleroy, 28 July 1851, GD-JF; Lawson, "Autobiography," "My first astonishment," Lawson wrote of their arrival, "was seeing a man digging a trench among hot ashes and burning embers to lay the sills of a new structure. By noon the next day the house—a skeleton frame with cotton cloth roof and sides—was finished, stocked with goods, and stood conspicuously as a first class store."

29. Lawson, "Autobiography," p. 19; Erwin G. Gudde, "A Century of Astronomy and Geodesy in California," in *A Century of Progress*, p. 66; Davidson to Ed Hall, 26 June 1850, GDP; Davidson to Kate Romney, 25 June 1850, GDP.

30. Davidson to Kate Romney, 25 June 1850, GDP; Davidson to Ed Hall, 26 June 1850, GDP.

31. Lewis, P. 23; Davidson to Kate Romney, 23 September 1850, GDP; Davidson to Jane Fauntleroy, 11 February 1858, GDP.

32. Richard Henry Dana, *Two Years before the Mast* (1840, rpt. New York: Dutton, 1969), p. 313.

33. Davidson to Jane Fauntleroy, 7 September 1851, GD-JF; Davidson to Jane Fauntleroy, 4 March 1856, GD-JF.

34. Davidson to Jane Fauntleroy, 4 March 1856.

35. Davidson to Jane Fauntleroy, 25 September 1854, GD-JF.

36. Davidson to Jane Fauntleroy, 26 July 1858, GD-JF.

37. Taylor, *Eldorado*, p. 226.

2: So Fine an Experiment

1. Davidson sailed from San Francisco for Panama on November 1; Whitney's party left Panama at midnight, October 31, arriving in San Francisco the morning of November 15.

2. William H. Goetzmann, *Exploration and Empire* (1972), pp. 314, 317–31; A. Hunter Dupree, *Science in the Federal Government* (1957), pp. 94–95. See also Goetzmann, *Army Exploration in the American West, 1803–1863.* (1959).

3. Robert C. Miller, "The California Academy of Sciences and the Early History of Science in the West," *California Historical Society Quarterly* 21 (December 1942): 364; Gerald D. Nash, "The Conflict Between Pure

and Applied Science in Nineteenth-Century Public Policy: The California State Geological Survey, 1860–1874," *Isis 54* (June 1963): 219–20.

4. Alan E. Leviton and Michele L. Aldrich, "John Boardman Trask: Physician-Geologist in California, 1850–1879," in Alan Leviton, Peter Rodda, Ellis Yochelson, and Michel Aldrich, eds., *Frontiers of Geological Exploration of Western North America* (San Francisco: American Association for the Advancement of Science, 1982), pp. 37, 59; George P. Merrill, ed., *Contributions to a History of American State Geological and Natural History Surveys* (Washington, D.C.: Government Printing Office, 1920), pp. 27–29.

5. Rodman W. Paul, *Mining Frontiers of the Far West, 1848–1880* (1974), pp. 28–36; Edwin T. Brewster, *Life and Letters of Josiah Dwight Whitney* (Boston: Houghton Mifflin, 1909), pp. 184–85.

6. Russell H. Chittendon, "Biographical Memoir of William Henry Brewer, 1828–1910," *National Academy of Sciences Biographical Memoirs 12* (1929): 289–96; Francis P. Farquhar, ed., "Introduction" to William H. Brewer, *Up and Down California in 1860–1864*, 3d ed. (1966, rpt. Berkeley: University of California Press, 1974), pp. ix–xxiii; Brewer, "Data and Letters . . . in Regard to the California State Geological Survey" TS, Francis P. Farquhar Papers, BL.

7. Brewer, *Up and Down California*, pp. 9–10.

8. Brewster, *Josiah Dwight Whitney*, p. 196.

9. "Report on the Termination of the Geological Survey," California Academy of Sciences, 16 March 1868, pamphlet, n.p., Farquhar Papers, BL; Gerald Nash, "Conflict," pp. 222–25; Leviton and Aldrich, "John Boardman Trask"; Clarence King, *Mountaineering in the Sierra Nevada* (1872, rpt. Lincoln: University of Nebraska Press, 1970), p. 179.

10. Josiah Dwight Whitney, "Lecture on Geology, Delivered before the Legislature of California, at San Francisco, Thursday Evening, February 27, 1862," California Legislature, *Appendices to the Journals of the Senate and the Assembly*, 13th sess. (San Francisco: Benjamin P. Avery, 1862), p. 17; Nash, "Conflict," p. 223; "Professor Whitney," *Pacific Mining Journal*, 2 May 1863.

11. Josiah Dwight Whitney to William Dwight Whitney, 14 November 1863 and 26 February 1868, publ. in Brewster, *Josiah Dwight Whitney*, pp. 232, 264. Gordon B. Oakeshott, "Contributions of the State Geological Surveys: California as a Case History," in Ellen T. Drake and William M. Jordan, eds., *Geologists and Ideas: A History of North American Geology* (Geological Society of America, 1985), p. 328.

12. Verne A. Stadtman: *The University of California, 1868–1968* (New York: McGraw-Hill, 1970), pp. 71, 26–27, 64, 68, 101.

13. "Legislative Ignorance," *Daily Chronicle* (San Francisco), 30 March

1868; "Letter from the Capitol," *Daily Examiner* [San Francisco], 28 March 1868.

14. "Professor Whitney," *Pacific Mining Journal,* 2 May 1863.
15. *Daily Chronicle* [San Francisco], 30 March 1868.
16. For this account I am indebted to William Frederic Badè, *The Life and Letters of John Muir* 2 vols. (Boston: Houghton Mifflin, 1928); Linnie Marsh Wolfe, *Son of the Wilderness: The Life of John Muir* (1945, rpt. Madison: University of Wisconsin Press, 1978); Stephen Fox, *John Muir and His Legacy: The American Conservation Movement* (Boston: Little, Brown, 1981); Frederick Turner, *Rediscovering America: John Muir in His Time and Ours* (New York: Penguin, 1985); and to the John Muir Papers, PCWS.
17. Wolfe, *Son of the Wilderness,* p. 28.
18. John Muir, *The Story of My Boyhood and Youth* (Boston: Houghton Mifflin, 1913), p. 109; Turner, *Rediscovering America,* p. 51.
19. Wolfe, *Son of the Wilderness,* p. 53. See also Muir, *Story,* chap. 7.
20. Wolfe, *Son of the Wilderness,* pp. 60, 59, 67, 65. A college roommate initially mistook Muir's room for "part of the college museum": the walls were covered by shelves "filled with retorts, glass tubes, glass jars, botanical and geological specimens, and small mechanical contrivances," while the floor was littered with "machines of larger size whose purposes were not apparent at a glance" (Badè, *John Muir,* 1: 89–90).
21. Turner, *Rediscovering America,* pp. 368–69.
22. Muir, *John of the Mountains: The Unpublished Journals of John Muir,* ed. Linnie Marsh Wolfe (1938, rpt. Madison: University of Wisconsin Press, 1979), p. x; Muir to Jeanne Carr, 13 September 1866, publ. in John Muir, *Letters to a Friend* (Boston: Houghton Mifflin, 1915), p. 10.
23. Muir to Jeanne Carr, 13 September 1866, publ. in Muir, *Letters to a Friend,* p. 10; John Muir, *A Thousand-Mile Walk to the Gulf* (Boston: Houghton Mifflin, 1917), p. 313; Badè, *John Muir,* 1:93. Linnie Marsh Wolfe vigorously denies that Muir undertook his prolonged sojourn in Canada to avoid the draft ("he had no intention of running"); instead, she casts his emigration in Biblical terms: "and now a powerful compulsion was upon him to go out into the untouched wilderness" (pp. 88–89). But as more recent biographers have noted, the evidence suggests otherwise. See Fox, *John Muir and His Legacy,* pp. 42–43; Turner, *Rediscovering America,* pp. 109–11.
24. Muir to Jeanne Carr, 21 January 1866, publ. in Muir, *Letters to a Friend,* pp. 3–4.
25. Wolfe, *Son of the Wilderness,* pp. 99, 101–02.
26. Muir to Jeanne Carr, 26 July 1868, publ. in Muir, *Letters to a Friend,* p. 37.

27. Muir, *The Yosemite* (1912; rpt. New York: Doubleday, 1962), pp. 1–2. For the original account, see Muir, "Autobiography" notes, TS, Box 70, Muir Papers, PCWS.

28. Daniel Muir to John Muir, 9 March 1874, publ. in Badè, *John Muir*, 1:21. "And the best and soonest way of getting quit of the writing and publishing [of] your book [on glaciers in Yosemite] is to burn it, and then it will do no more harm either to you or to others."

29. Muir, *John of the Mountains*, pp. 43–44.

30. Badè, *John Muir*, 1:18; Muir to Jeanne Carr, 8 September 1871, publ. in Muir, *Letters to a Friend*, p. 106.

31. Muir, *John of the Mountains*, p. 16; Wolfe, *Son of the Wilderness*, p. 133.

32. Muir, *John of the Mountains*, p. 436.

33. Badè, *John Muir*, 1:204.

34. Muir, *John of the Mountains*, p. 89; Wolfe, *Son of the Wilderness*, p. 144.

35. Muir to Jeanne Carr, 15 May 1873, publ. in Muir, *Letters to a Friend*, p. 152.

36. Badè. *John Muir*, 2:292; Ralph Rusk, *The Letters of Ralph Waldo Emerson*, 6 vols. (New York: Columbia University Press, 1939), 6:157.

37. Joseph Le Conte, *The Autobiography of Joseph Le Conte*, ed. William Dallam Armes (New York: Appleton, 1903), p. 247; Joseph Le Conte, *A Journal of Ramblings through the High Sierra of California by the University Excursion Party* (1875, rpt. San Francisco: Sierra Club, 1930), pp. 56, 67–68; John Muir, "Reminiscences of Joseph Le Conte," *University of California Magazine* 7 (September 1909): 210.

38. Le Conte, *Autobiography*, pp. 8, 17–18; Lester D. Stephens, *Joseph Le Conte: Gentle Prophet of Evolution* (Baton Rouge: Louisiana State University Press, 1982), pp. 1–7.

39. Le Conte, *Autobiography*, pp. 128, 146; Eugene W. Hilgard, "Biographical Memoir of Joseph Le Conte," *National Academy of Sciences Biographical Memoirs* 6 (1909): 157.

40. Le Conte, *Autobiography*, pp. 123–26.

41. Ibid., p. 131; John Campbell Merriam, "The Geological Work of Professor Joseph Le Conte," *The University of California Magazine* 7 (September 1901): 214; Stephen, *Joseph Le Conte*, pp. 33–36.

42. Le Conte, *Autobiography*, pp. 143, 128.

43. Ibid., pp. 179, 231, 163; Caroline Le Conte, "Introduction" to Joseph Le Conte, *'Ware Sherman: A Journal of Three Months' Personal Experience in the Last Days of the Confederacy* (Berkeley: University of California Press, 1937), pp. xvii–xxi.

44. The nation's population growth rate between 1860 and 1870 was 22.6 percent; that of California, 47.4 percent; San Francisco's was 163 percent. In 1870 nearly 40 percent of the state's 560,000 people lived in the

San Francisco Bay Area; in that year, 15,000 Californians lived in Los Angeles County. Not until 1900 did Los Angeles County's population reach half that of San Francisco County. In science as in nearly every other endeavor, the San Francisco Bay Area dominated the state throughout the late nineteenth century.

45. Le Conte, *Autobiography*, pp. 252, 243; Stadtman, *University of California*, pp. 52, 59.

46. Le Conte, *Autobiography*, pp. 243, 257. On Le Conte's popularity as a lecturer, see Josiah Royce, "Joseph Le Conte," *The International Monthly* 4 (1901: 327–28; on the impact of his *Elements of Geology*, see Andrew Cowper Lawson, "Joseph Le Conte," *Science*, 23 (August 1901): 276.

3: This Daily Spectacle

1. Stephen Jay Gould, "Agassiz's Marginalia in Lyell's *Principles*, or the Perils of Uniformity and the Ambiguity of Heroes," *Studies in the History of Biology* 3 (1979): 119–38; Edward Lurie, *Louis Agassiz: A Life in Science* (Chicago: University of Chicago Press, 1960); François Matthes, *The Incomparable Valley: A Geological Interpretation of the Yosemite*, ed. Fritiof Fryxell (Berkeley: University of California Press, 1950); Mott T. Greene, *Geology in the Nineteenth Century: Changing Views of a Changing World* (Ithaca: Cornell University Press, 1982); Cynthia Russett, *Darwin in America: The Intellectual Response, 1865–1912* (San Francisco: Freeman, 1976), pp. 1–22; Edward J. Pfeifer, "The Genesis of American Neo-Lamarckism," *Isis* 56 (Summer 1965): 156–67;; Frank J. Sulloway, "Geographic Isolation in Darwin's Thinking: The Vicissitudes of a Crucial Idea," *Studies in the History of Biology* 3 (1979): 23–48.

2. Edwin Brewster, *Josiah Dwight Whitney* (1909), pp. 197–98.

3. James J. Parsons, "The Uniqueness of California," *American Quarterly* 7 (Spring 1955): 45; Elna S. Bakker, *An Island Called California: An Ecological Introduction to Its Natural Communities*, rev. ed. (Berkeley: University of California Press, 1984), pp. 72–73.

4. David Starr Jordan, "California and the Californians," *Atlantic Monthly* (December 1898): 794; Robert W. Durrenberger, *Patterns on the Land: Geographical, Historical and Political Maps of California* (Woodland Hills, Calif.: Aegeus, 1965), p. 16.

5. John Muir, "Autob." notes, Box 70, JMP, PCWS; Alan Leviton and Michele Aldrich, "John Boardman Trask," p. 48; Bakker, *Island Called California*, p. 72.

6. Clarence King, *Mountaineering in the Sierra Nevada* (1970), p. 1; Bakker, *Island Called California*, pp. 198–200.

7. King, *Mountaineering*, p. 21.
8. Donald Worster, *Nature's Economy: The Roots of Ecology* (1977, rpt. New York: Anchor, 1979), pp. 196–98; Bakker, *Island Called California*, pp. 184, 197.
9. Bakker, *Island Called California*, pp. 78, 206.
10. Lester Stephens, *Joseph Le Conte* (1982), p. 162.
11. Peter Vorzimmer, "Darwin's Ecology and Its Influence Upon His Theory," *Isis* 56 (Summer 1965): 153–55.
12. Bakker, *Island Called California*, pp. 89–91.
13. Worster, *Natures Economy*, p. 296; Chalres Darwin, "Struggle for Existence," chap. 3 of *On the Origin of Species* (1859, rpt. in Philip Appleman, ed., *Darwin: A Norton Critical Edition*, New York: Norton, 1970, pp. 114–19).
14. Bakker, *Island Called California*, pp. 38–40.
15. Vorzimmer, "Darwin's Ecology," p. 150; Joseph Grinnell, "The Niche-Relationships of the California Thrasher," *Auk* 34 (1917): 427–33.
16. Edward J. Pfeifer, "The Genesis of American Neo-Lamarckism," 156–67.
17. Douglas Botting, *Humboldt and the Cosmos* (New York: Harper and Row, 1973), p. 65. For Humboldt's role in the history of ecology, see Worster, *Nature's Economy*, pp. 133–38; for his influence on scientific exploration, see William Goetzmann, *Exploration and Empire* (1972).
18. Alexander von Humboldt, *Aspects of Nature*, 2 vols., (London: Longmans, Brown, Green and Longmans, 1849), 1:26, 2:31, 241.
19. Ibid., 2:13; Alexander von Humboldt, *Cosmos: A Sketch of a Physical Description for the Universe*, 4 vols., (New York: Harper & Bros., 1860) 1:23, 42.
20. Humboldt, *Cosmos*, 1:42.
21. William Brewer, "Data and Letters . . . in Regard to the California State Geological Survey," FFP, BL, pp. 6–11.
22. Goetzmann, *Exploration and Empire*, p. 363.
23. Brewer, "Data and Letters," pp. 7, 11–12. Hoffmann trained Clarence King and James Gardner who modified and developed this technique for use in King's Fortieth Parallel Survey. When King became director of the U.S. Geological Survey, the triangulation method that Whitney, Hoffmann, Gardner, and King had developed became the basis for all USGS fieldwork. Henry Gannett, who was trained by King, detailed the method in Gannett, *Manual of Topographic Method* (Washington, D.C.: Government Printing Office, 1906).
24. Lawson, "Autobiography," MS, 1879, BL, p. 22; George Davidson, *Directory for the Pacific Coast of the United States* (Washington, D.C.: Government Printing Office, 1858), pp. 1–3; Davidson to Ed Hall, 27 (?) August 1850, GDP, BL.

25. Davidson to Jane Fauntleroy, 28 July 1851, 7 December 1851, GD-JF; Davidson to Ed Hall, 3 October 1852, GDP.
26. Davidson to Jane Fauntleroy, 6 April 1853, GD-JF. For Davidson's vacillating attitude toward California and the West, see William F. King, "George Davidson and the Marine Survey in the Pacific Northwest," *Western Historical Quarterly* 10 (July 1979): 291–301.
27. Michele Aldrich, Bruce A. Bolt, Alan E. Leviton, and Peter U. Rodda, "The 'Report' of the 1968 Haywards Earthquake," *Bulletin of the Seismological Society of America* 76 (February 1986): 71–76; Davidson to Jane Fauntleroy, 15 August 1855, GDP.
28. Ruliff S. Holway, *George Davidson* (Berkeley, n.d.), p. 7.
29. Davidson to Jane Fauntleroy, 26 July 1858, GD-JF; Oscar Lewis, *George Davidson*, p. 90; Davidson, "The Origin and Meanings of the Name California," *Transactions and Proceedings of the Geographical Society of the Pacific*, 1910, pp. 1–50; Davidson, "The Discovery of San Francisco Bay," ibid., 1907, pp. 1–53; Davidson, "The Discovery of San Diego Bay," ibid., 1892, pp. 37–47; Davidson, "Francis Drake on the Northwest Coast of America in the Year 1579: The Golden Hinde Did Not Anchor in the Bay of San Francisco," ibid., 1908, pp. 1–114; Davidson, "Early Spanish Voyages of Discovery on the Coast of California," *Bulletin of the California Academy of Sciences*, November 1886, pp. 325–35.
30. Josiah Dwight Whitney to George Brush, 19 July 1863, publ. in Brewster, *Josiah Dwight Whitney*, pp. 230–31.
31. Whitney, *The Yosemite Guide-Book* (Cambridge, Mass.: Welch, Bigelow, 1870), p. 18.
32. Whitney, "Lecture on Geology, Delivered before the Legislature of California" (1862), p. 25.
33. Hans Huth, "Yosemite: The Story of an Idea," *SCB* 33 (March 1948): 66; Carl P. Russell, *Yosemite: Saga of a Century, 1864–1964* (Oakhurst, Calif. Sierra Star, 1964), pp. 5–6.
34. Laura Wood Roper, introduction to Frederick Law Olmsted, "The Yosemite and the Mariposa Big Trees: A Preliminary Report (1865)," *Landscape Architecture* 43 (October 1952): 12–13; Hans Huth, *Nature and the American, Three Centuries of Changing Attitudes* (1957, rpt. Lincoln: University of Nebraska Press, 1972), p. 149.
35. William Brewer, *Up and Down California* (1974), pp. 429, 547–49; Olmsted, "The Yosemite Valley and the Mariposa Big Trees," 12, 16, 22, 25. "Fearing Olmsted could not reach" the summit of Mount Dana, Brewer chose a smaller adjacent peak, which Olmsted named after Wolcott Gibbs, newly appointed dean of Harvard's Lawrence Scientific School. Olmsted subsequently invited Brewer and James Gardner to tour the Mariposa Estate (Brewer, *Up and Down California*, p. 547).

36. Holway R. Jones, *John Muir and the Sierra Club: The Battle for Yosemite* (San Francisco: Sierra Club, 1965), pp. 29–33; Olmsted, "The Yosemite Valley and the Mariposa Big Trees," 16, 22. Hans Huth claims, "Whitney, though not his assistants, disliked this [Yosemite preservation] activity and tried to obstruct it," but he provides no evidence for this assertion. On the contrary: in the "decisive letter" Huth quotes from Israel Ward Raymond to Senator John Conness outlining the particulars of the Yosemite bill (20 February 1864), the proposed list of Yosemite Commissioners not only names Whitney but lists him before Olmsted (Huth, "Yosemite: The Story of an Idea," 66).

37. Whitney, *Yosemite Guide-Book*, p. 89; Whitney, "Report of the Commissioners to Manage the Yosemite Valley and the Mariposa Big Tree Grove," *Appendix to Journals of Senate and Assembly of the Seventeenth Session of the Legislature of the State of California*, vol. 2 (Sacramento: Gelwicks, 1868), pp. 3–5.

38. Whitney, *Yosemite Guide-Book*, pp. 22–23. Whitney wrote this defense in response to landownership claims by two Yosemite residents, James Hutchings and John Lamon. The legislature passed a bill granting the claims, but Governor Haight vetoed it in language strongly reminiscent of Whitney's. The claimants pursued the case in the courts until the U.S. Supreme Court ruled against them in December 1872. See Whitney, "Report of the Commissioners" (1868), pp. 7–8 ("Veto Message of the Governor in Relation to Assembly Bill No. 238" precedes the report, pp. 3–4); William Ashburner, "Biennial Report of the Commissioners to Manage the Yosemite Valley and Mariposa Grove of Big Trees," *Appendix to Journals of the Twentieth Session of the Legislature of the State of California*, vol. 6 (Sacramento: G. B. Springer, State Printer, 1874), p. 3.

39. Whitney, *Yosemite Guide-Book*, p. 57; see also Whitney, *Geology* (vol. 1 of *Geological Survey of California*, Philadelphia: Sherman, 1865), p. 410.

40. For Whitney's comparison of "Swiss and Californian Alpine scenery," see *Yosemite Guide-Book*, pp. 89–90. "I have seen some of the first scenery of Switzerland, the Tyrol, and the Bavarian Alps," Brewer wrote from the crest of Yosemite Falls, "but I never saw any grander than this" (*Up and Down California*, p. 406).

41. Whitney, *The Yosemite Guide-Book*, pp. 9, 57; Whitney, *Geology*, p. 410. Holway R. Jones argues that Whitney, Ashburner, and Raymond hindered the maintenance of the new park by suppressing a report by Olmsted, with its accompanying request for $37,000 in appropriations, in order to help the state survey's battle for funds. There is no reason to suppose, however, that such a large appropriation would have been approved; nor is it likely that Raymond would have agreed to a plan that

would undercut the park he fought to create in order to assist the state survey, with which he had no connection. In light of the legislature's chronic reluctance to provide adequate financial support for the survey, a more likely interpretation might be that Whitney and several members of his staff played an active role in creating, surveying, and supervising the park in spite of the danger of creating finanical competition between the park and the survey. See Jones, *John Muir and the Sierra Club*, p. 32; and Roper, introduction to Olmsted, "The Yosemite Valley and the Mariposa Big Trees," 12.

4: An Elevated Lookout

1. Clarence King, *Mountaineering in the Sierra Nevada* (1970), p. 178; William Brewer, *Up and Down California* (1966), p. 261.
2. King, "Private notes July 1867," Notebook D-12, CKP, HL; King, *Mountaineering*, pp. 178–80.
3. Clarence King, "Active Glaciers Within the U.S.," *Atlantic Monthly* 27 (March 1871): 371–77; John Muir, "Yosemite Glaciers," *Tribune* [New York], 5 December 1871.
4. Henry Adams, "King," in James D. Hague, ed., *Clarence King Memoirs*, (New York: G. P. Putnam's Sons, 1904), p. 160; Adams, *The Education of Henry Adams* (1918, rpt. Boston: Houghton Mifflin, 1973) pp. 311–13, 416; Muir to Emily Pelton, in William F. Badè, *The Life and Letters of John Muir* (Boston, 1924), 1:321.
5. Evelyn Fox Keller, *Reflections on Gender and Science* (New Haven: Yale University Press, 1985), pp. 3–8.
6. Marjorie Nicolson, *Mountain Gloom and Mountain Glory* (Ithaca: Cornell University Press, 1959); George P. Landow, *The Aesthetic and Critical Theories of John Ruskin* (Princeton: Princeton University Press, 1971), pp. 183–95; Barbara Novak, *Nature and Culture: American Landscape Painting, 1825–1875* (New York: Oxford University Press, 1980), p. 34.
7. Ronald Rees, "The Taste for Mountain Scenery," *History Today* 25 (May 1975): 307, 310–13; Raymond Williams, *The City and the Country* (London: Chatto & Windus, 1973); Landow, *Ruskin*, p. 196.
8. John Ruskin to Henry Acland, 1851, cited in Landow, *Ruskin*, p. 266.
9. John Tyndall, *The Glaciers of the Alps* (London: John Murray, 1860); A. J. Mackintosh, *Mountaineering Clubs, 1857–1900* (London: Spottiswoode, 1907); Allen H. Bent, "The Mountaineering Clubs of America," *Appalachia* 14 (December 1916): 5–18.
10. Peter J. Schmitt, *Back to Nature: The Arcadian Myth in Urban America* (New York: Oxford University Press, 1969), pp. 45–55; Barbara Novak, *Nature and Culture*, pp. 47–77; Perry Miller, *The Life of the Mind in*

America from the Revolution to the Civil War (New York: Harcourt, Brace & World, 1965), pp. 276, 316–26.

11. Michel Foucault, "Questions on Geography," in *Power/Knowledge: Selected Interviews and Other Writings, 1972–1977* (New York: Pantheon, 1980), pp. 63–77; Carl O. Sauer, "On the Background of Geography in the United States," in *Selected Essays, 1963–1975* (Berkeley: Turtle Island Foundation, 1981), pp. 241–59.

12. William Goetzmann, *Exploration and Empire* (1972), p. 243. Compare Charles Wilkes' anger upon learning that two officers of his Exploring Expedition had climbed Sugar Loaf mountain without scientific instruments. Wilkes "shamed them into scaling the peak again, this time lugging the proper apparatus, lest their effort result 'only in the idle & boastful saying that its summit has been reached, instead of an excursion which might have been useful to the expedition' " (Herman J. Viola, "The Story of the U.S. Exploring Expedition," 1985, pp. 14–15).

13. Keller, *Gender and Science*, p. 76; Ruth Bleier, *Science and Gender: A Critique of Biology and Its Theories on Women* (New York: Permagon, 1984), pp. 199–206; William Leiss, *The Domination of Nature* (New York: Braziller, 1972, pp. 101–65. See Donald Worster's distinction between "imperial" and "arcadian" traditions in natural science (Worster, *Nature's Economy*, 1979).

14. Karen Halttunen, *Confidence Men and Painted Women: A Study of Middle-class Culture in America, 1830–1870* (New Haven: Yale University Press, 1982), pp. 1–32; Katherine K. Sklar, *Catherine Beecher: A Study in American Domesticity* (New Haven: Yale University Press, 1973); Carolyn Merchant, *The Death of Nature: Women, Ecology, and the Scientific Revolution* (San Francisco: Harper & Row, 1980), pp. 1–41, 164–91.

15. Keller, *Gender and Science*, pp. 77, 162–76.

16. Ann Douglas, *The Feminization of American Culture* (1977, rpt. New York: Avon, 1978), pp. 5–13.

17. King, *Mountaineering*, pp. 81, 149; Wolfe, *Son of the Wilderness*, pp. 128–29.

18. Thurman Wilkins, *Clarence King: A Biography* (New York: Macmillan, 1958), p. 96; James M. Sebl, *King, of the Mountains* (Stockton: University of the Pacific, 1974), p. 57.

19. Samuel F. Emmons, "Biographical Memoir of Clarence King," *National Academy of Sciences Biographical Memoirs*, vol. 6 (Washington: N.A.S., 1909), p. 29; Rossiter W. Raymond, "Biographical Notice," in Hague, ed., *Clarence King Memoirs*, p. 307.

20. Wilkins, *Clarence King*, pp. 38–39; Brewer, quoted in Raymond, "Biographical Notice," p. 313.
21. Raymond, "Biographical Notice," p. 315; David H. Dickason, "Clarence King's First Western Journey," *Huntington Library Quarterly* 7 (November 1943): 72.
22. Brewer to George Brush, 1 October 1862, publ. in Francis P. Farquhar, "The Whitney Survey on Mount Shasta, 1862: A Letter from William H. Brewer to Professor Brush," *California Historical Society Quarterly* 7 (June 1928): 124, 127, 129. They negotiated their descent through thick fog "so cold that our beards were white as snow, mustaches frozen, and faces blue." Sliding "on our 'bases,' down the soft snow," sped their progress but "was soon rendered uncomfortable to me by the giving way of the main seam of my pants, and the consequent introduction of large quantities of snow" (Brewer, *Up and Down California*, pp. 316–17). See also Brewer, "Private journal 1860–1861," MS, and pocket diaries 1862–1864, MS, BL.
23. Clarence King, *Mountaineering*, p. 81; Robert Berkelman, "Clarence King: Scientific Pioneer," *American Quarterly* 5 (Winter 1953): 301, 303.
24. James D. Hague, "Memorabilia," in Hague, ed., *Clarence King Memoirs*, pp. 378–81; James Gardner to his mother, 10 March 1864, quoted in Brewer, *Up and Down California*, p. 469; Raymond, "Biographical Notice," p. 312.
25. Raymond, "Biographical Notice," p. 345. On the theatricality of geologists' clothing, see Martin J. S. Rudwick, *The Great Devonian Controversy: The Shaping of Scientific Knowledge among Gentlemanly Specialists* (Chicago: University of Chicago Press, 1985), pp. 38–39.
26. Wilkins, *Clarence King*, p. 65. Compare Brewer's description of the grove (*Up and Down California*, pp. 514–15).
27. Keller, *Gender and Science*, pp. 76–79.
28. Raymond, "Biographical Notice," pp. 317, 319; Brewer, *Up and Down California*, p. 465.
29. Tyndall, *The Glaciers of the Alps*, p. v. King, too, found it difficult to combine the two voices. Eventually, he regulated the two aspects of mountaineering to separate volumes: "narrative" in *Mountaineering in the Sierra Nevada* (1872), and "science" in his *Systematic Geology* (Washington, D.C.: Government Printing Office, 1878).
30. John Ruskin, *Modern Painters* (New York: John Wiley, 1853), 1:266–68.
31. David H. Dickason, "The American Pre-Raphaelites," *Art in America* 30 (January 1942): 159; John Hay, "Clarence King," in Hague, ed., *Clarence King Memoirs*, pp. 129–30. For King's satire of landscape painters see *Mountaineering*, pp. 207–12.

32. King, *Mountaineering*, pp. 21–22; see also Whitney's distinction between sublimity and beauty in *Yosemite Guide-Book*, pp. 88, 90.

33. Clarence King, Notebook D-12, CKP, HL; Wilkins, *Clarence King*, p. 37.

34. Goetzmann, *Exploration*, p. 439; James T. Gardner, "Appendix" to Clarence King, *Systematic Geology*, p. 765; Henry Gannett, *Manual of Topographic Methods* (1906), pp. 12–37; King, "Calif. Geol. Survey, Summer of 1866," Notebook D-3, CKP, HL. King referred to Merced Peak as Black Mountain.

35. King, "Scientific notes—private," Notebook A-2, CKP, HL.

36. King, Notebook D-12, CKP, HL (punctuation added).

37. King, "Misc. notes—1869," Notebook D-17, CKP, HL (cf. King, *Mountaineering*, p. 126); King, "Catastrophism and Evolution," *American Naturalist* 11 (August 1877): 449–50. Cf. King's battlefield rhetoric with his attack on Social Darwinism later in the address.

38. King, *Mountaineering*, pp. 51, 126, 182–84.

39. King, "Calif. Geol. Survey—Mt. Whitney climb 1864," Notebook D-4, CKP, HL; King, *Mountaineering*, pp. 62–63, 66–67, 74–75. Francis P. Farquhar argues that King was "obsessed with the notion of inaccessibility" and that he exaggerated the difficulty of his High Sierra ascents (Farquhar, *History of the Sierra Nevada*, 1965, pp. 142–54).

40. King, *Mountaineering*, pp. 77–79; see also King's descriptions of Yosemite in June and in October, pp. 133–34.

41. Ibid., p. 79.

42. King, "Active Glaciers Within the U.S.," 371–77.

43. King, *Mountaineering*, pp. 236–37. Cf. the desert from Mount Tyndall, p. 77.

44. Ibid., pp. 34, 238.

45. Ibid., pp. 244–45.

46. Linnie Marsh Wolfe, *Son of the Wilderness* (1978), pp. 123–24.

47. Muir, *My First Summer in the Sierra* (1911, rpt. Boston: Houghton Mifflin, 1979), pp. 240–41; King, *Mountaineering* (1970), pp. 203–05; Muir, *John of the Mountains* (1979), pp. 79–81. King referred to the peak of Mount Clark as the Obelisk.

48. Muir, *The Mountains of California* (1917, rpt. Berkeley: Ten Speed Press, 1977), pp. 69–70.

49. Muir, *Studies in the Sierra*, ed. William E. Colby (San Francisco: Sierra Club, 1960), p. 21.

50. Muir, *My First Summer*, p. 102; Muir, *John of the Mountains*, p. 88; Muir, *Studies in the Sierra*, p. 21.

51. Muir to Jeanne Carr, 27 July 1872, publ. in Muir, *Letters to a Friend* (1915), p. 157.

52. Muir, *John of the Mountains*, pp. 79, 95.

53. Ralph Rusk, ed., *The Letters of Ralph Waldo Emerson* (1939), 6:203–04; Turner, *Rediscovering America*, pp. 188–89.

54. Muir to J. B. McChesney, 10 January 1873, quoted in Stephen Fox, *John Muir and His Legacy* (1981), p. 85; Muir to Jeanne Carr, 31 May 1872, publ. in Muir, *Letters to a Friend*, p. 122; Muir to J. B. McChesney, 9 January 1873, quoted in Frederick Turner, *Rediscovering America* (1985), p. 222.

55. Muir, *John of the Mountains*, p. 94; Muir, *Mountains of California*, p. 60.

56. Muir, *Mountains of California*, p. 3–4, 79.

57. Muir, *My First Summer*, p. 241; Robert Underwood Johnson, *Remembered Yesterdays* (Boston: Little, Brown, 1923), pp. 273–79; Muir, *John of the Mountains*, p. 191.

58. Muir, *John of the Mountains*, p. 94; Muir, *Mountains of California*, pp. 68–69; Daniel B. Weber, "John Muir: The Function of Wilderness in an Industrial Society" (Ph.D. diss., University of Wisconsin, 1965), pp. 192–93.

59. Muir, *My First Summer in the Sierra*, pp. 228–29.

60. Muir, *Our National Parks* (Boston: Houghton Mifflin, 1901), p. 289; Muir to Jeanne Carr, n.d. (1873), publ. in Muir, *Letters to a Friend*, p. 160.

61. Muir, *Mountains of California*, pp. 249–54.

62. Wolfe, *Son of the Wilderness*, p. 177.

63. Muir, *Mountains of California*, pp. 53, 64–65. Cf. King, *Mountaineering*, p. 58.

64. King, *Mountaineering*, p. 32; Muir, *Studies in the Sierra*, p. 18; Holway Jones, *John Muir and the Sierra Club* (1965), pp. 29–33.

65. Josiah Dwight Whitney, *Geology* (1865), pp. 421–22.

66. King, "Field Notes & Observations on the Yosemite Valley and Surrounding Country, Oct. and Nov. 1864," Notebook B-2, CKP, HL.

67. Whitney, *Geology*, pp. 421–22.

68. Muir to Jeanne Carr, 8 October 1872, publ. in Muir, *Letters to a Friend*, pp. 136–37.

69. Whitney, *The Yosemite Guide-Book*, p. 84; King, *Systematic Geology*; Farquhar, *History of the Sierra Nevada*, p. 163.

70. King, "Catastrophism and Evolution," pp. 453, 457, 469; Muir, *Mountains of California*, p. 16.

71. Muir, *Studies in the Sierra*, p. 18; King, *Mountaineering*, p. 184.

72. François Matthes, *The Imcomparable Valley: A Geologic Interpretation of the Valley* (1950, rpt. Berkeley: University of California Press, 1964), p. 59.

73. King, "Catastrophism and Evolution."

5: A Field of Richer Promise

1. "Regular Meeting, September 2d, 1872," *Proceedings of the California Academy of Sciences*, ser. 1, vol. 4, p. 257.

2. Edward Lurie, *Louis Agassiz: A Life in Science* (Chicago: University of Chicago Press, 1960), p. 125.

3. Agassiz did, in fact, envision the expedition as an opportunity to reconsider evolution. While aboard the *Hassler* he wrote to a colleague in Germany, "I had a special purpose in this journey. I wanted to study the whole Darwinian theory free from all external influences and former prejudices. It was on a similar voyage that Darwin himself came to formulate his theories!" But his plan to examine deep-sea creatures for evidence of environmental adaptation of species was thwarted when the expedition's sophisticated dredging equipment repeatedly malfunctioned (ibid; pp. 373–74.)

4. "Regular Meeting, September 2d, 1872," pp. 254–55.

5. Ibid.

6. Ralph S. Bates, *Scientific Societies of the United States*, 3d ed. (Cambridge: MIT Press, 1965), pp. 5–10; Augustus A. Gould, "Notice on the Origin, Progress, and Present Condition of the Boston Society of Natural History," *American Quarterly Register* 14 (February 1842): 236–41; Samuel G. Morton, "History of the Academy of Natural Sciences of Philadelphia," *American Quarterly Register* 13 (May 1841): 433–38. Agassiz and Bache were two of the earliest honorary members elected to the California Academy of Sciences.

7. Nathan Reingold, ed., *Science in Nineteenth-Century America* (1964), p. 200. Some California scientists spoke of their detachment from the world of capital in terms reminiscent of religious vows of poverty and purity. Hans Behr, botanist at the California Academy of Sciences and the University of California school of pharmacy, "boasted that he had never included gold ore among the animate and inanimate specimens subjected to his scrutiny" (Robert T. Legge, "Hans Herman Behr," *California Historical Society Quarterly* 32, September 1953, 243).

8. George Davidson to Jane Fauntleroy, 4 March 1856, GD-JF.

9. Davidson to "Gibson" (draft), 13 January (?) 1876, GDP.

10. Clarence King, *Mountaineering* (1970), pp. 291–92.

11. Davidson to Jane Fauntleroy, 7 September 1851, GD-JF; Davidson to Jane Fauntleroy, 18 January 1851, GD-JF.

12. Davidson to Jane Fauntleroy, 27 February 1853, GDP.

13. Edwin Brewster, *Josiah Dwight Whitney,* (1909), p. 238. California scientists tended to judge their field companions by their familiarity with the terrain rather than by professional prestige. Compare, for example, King's depiction of survey handyman Dick Cotter with his imagined

reception by the "spectacled wise men of some scientific society" (King, *Mountaineering*, pp. 25, 26, 51, 180).

14. Davidson to Gibson, 13 January (?) 1876, GDP.

15. Brewster, *Josiah Dwight Whitney*, p. 238.

16. J. D. Whitney, "Lecture on Geology" (1862), p. 133; Whitney to William Dwight Whitney, 17 February 1866, publ. in Brewster, *Josiah Dwight Whitney*, pp. 250–51.

17. Alan E. Leviton and Michele L. Aldrich, "John Boardman Trask: Physician-Geologist in California, 1850–1879," in Alan Leviton, Peter Rodda, Ellis Yochelson, and Michele Aldrich, eds., *Frontiers of Geological Exploration of Western North America* (San Francisco: American Association for the Advancement of Science, 1982). Three of the academy's founders—Albert Kellogg, Henry Gibbons, and Charles Ferris—were M.D.s; John B. Trask had earned a license in medicine from Yale. Andrew Randall may have practiced medicine, but it is unlikely that he held a medical degree. (I am grateful to Alan Leviton for sharing this information with me.)

18. Robert C. Miller, "California Academy," p. 364; Theodore H. Hittell, "Historic Account of the California Academy of Sciences, 1853–1908," TS, CAS, pp. I-12, V-14, VI-4, XI-11.

19. Theodore H. Hittell, "Historic Sketch of the California Academy of Sciences" (TS of paper delivered before the California Academy of Sciences, May 18, 1903), CAS, p. 11; *Proceedings of the California Academy of Sciences*, San Francisco 1, 1:3.

20. Hittell, "Sketch," pp. 12, 17–18; Miller, "California Academy," pp. 365–66.

21. William Brewer, *Up and Down California* (1974), p. 120; Hittel, "Account," pp. IV-8, V-2, VI-10, VII-1; Hittel, "Sketch," p. 19.

22. "It might be supposed that the Academy of Sciences was also an important element in my own career here," Joseph Le Conte wrote in his *Autobiography*, "but not so. It had little effect in determining my scientific activity. I read many papers there, to be sure, and several of them were published in their Proceedings, but I always reserved the right to publish them elsewhere also." Le Conte complained of delays in the academy's publications and of the "internal dissensions" that developed in the decades after Whitney's departure (p. 264).

23. Oscar Lewis, *George Davidson* (1954), p. 66; Hittell, "Account," p. XVIII-1.

24. Susanna Bryant Dakin, *The Perennial Adventure: A Tribute to Alice Eastwood, 1859–1953* (San Francisco,: California Academy of Sciences, 1954), p. 15; Robert Miller, "California Academy," p. 368; see also Margaret Rossiter, *Women Scientists in America, 1982*; and Sally Gregory

Kohlstadt, "In from the Periphery: American Women in Science, 1830–1880," *Signs* 4 (Autumn 1978): 81–96.

25. Alice Eastwood, "Autobiography," MS, AEP, CAS; Carol Green Wilson, *Alice Eastwood's Wonderland: The Adventures of a Botanist,* (San Francisco: California Academy of Sciences, 1955); Robert C. Miller, "Alice Eastwood, Perpetual Pioneer," n.p. (copy, AEP, CAS); Dorothy Sutliffe, "Alice Eastwood," AEP, CAS; Gloria Ricci Lothrop, "Women Pioneers and the California Landscape," *The Californians* 4 (May-June 1986): 22–23.

26. Robert Miller, "California Academy," p. 369; George Davidson, "President's Address," 1873 (rpt. from *Proceedings of the California Academy of Sciences*), p. 3; Davidson, "President's Annual Address," 1874 (rpt. ibid.; this copy, with Davidson's marginalia, GD-CAS), p. 10.

27. Howard S. Miller, *Dollars for Research: Science and Its Patrons in Nineteenth-Century America* Seattle: University of Washington Press, 1970), pp. 100–01. For the influence of other scientists on Lick, see Rosemary Lick, *The Generous Miser: The Story of James Lick of California* (Los Angeles: Ward Ritchie Press, 1967), pp. 61–62.

28. William H. Worrilow, *James Lick (1796–1876), Pioneer and Adventurer: His Role in California History* New York: Newcomen Society, 1949), p. 11.

29. Edward C. Lahey, "California's Miser Philanthropist: A Biography of James Lick," M.A. thesis, University of California, Berkeley, 1949, pp. 76, 80–81; Worrilow, *James Lick* p.16. When asked by an advisor why he bequeathed so little to his son, Lick described his son's neglect of a parrot which Lick had left in his custody. When the advisor replied that "you should make your son join the Society for the Prevention of Cruelty to Animals," Lick responded, not by increasing his son's $3,000 inheritance, but by allotting $10,000 to the SPCA (Lahey, "Miser Philanthropist," 80–81).

30. S. B. Dickson, "James Lick: The Man Who Made Lick Observatory Possible," *Sunset* 63 (November 1929): 21; Howard Miller, *Dollars for Research,* p. 99.

31. Davidson, "A Few Incidents in My Conferences with Mr. James Lick in the Matter of the Great Telescope," *University of California Magazine* (April 1899): 131–37; Miller, *Dollars for Research,* p. 102; Lick, *Generous Miser,* p. 90. Davidson advocated a High Sierra observatory site, but astronomers persuaded Lick that an intermediate altitude would be more practical.

32. Charles Frederick Holder, "The California Academy of Sciences," *California Illustrated Magazine* (January 1893): 233, 236, 232.

33. Lewis, *George Davidson,* pp. 64–65, 72. For an example of the acrimony

between Davidson and Harkness, see Harkness's inaugural address, in which he remarks that "such epithets as 'Fossil' and 'Dodo' " had become "familiar sounds to the late administration." ("President's Address," 17 January 1887, rpt. from *Proceedings of the California Academy of Sciences*, p. 4).

34. Lewis, *George Davidson*, pp. 98–100, 106. "I saw a great deal of him," Le Conte recalled of Davidson's years at the university, "used to attend his lectures frequently, and sometimes operated the electric stereopticon for him" (Le Conte, *Autobiography*, p. 106).

6: The Struggle for Existence

1. Kevin Starr, *Americans and the California Dream* (1973), pp. 152–53.
2. Stanley M. Guralnick, "The American Scientist in Higher Education, 1820–1910," in Nathan Reingold, *The Sciences in the American Context* (1979), pp. 99–141; Robert Bruce, *The Launching of Modern American Science* (1987), pp. 29–63, 326–38; Howard S. Miller, *Dollars for Science* (1970); Lawrence Veysey, *The Emergence of the American University* (1965), pp. 1–18; Frederick Rudolph, *The American College and University* (1965), pp. 264–86.
3. Guralnick, "The American Scientist in Higher Education," p. 103; Arthur L. Norberg, "Chemistry in California: How It Started and How It Grew," *Chemical and Engineering News* (30 August 1976): 26–36. Ironically, some of the schools that most vigorously resisted granting full academic citizenship to scientists were the quickest to criticize those who did not conform to the new professional standards. John Tyndall's lecture tour of America in 1871 provided a case in point. In California, he received lavish praise for traveling so far in the interests of science; but at Harvard, President Eliot complained that a scholar of Tyndall's stature should not be "wasting his time giving 'exhibitions' " (Guralnick, "The American Scientist in Higher Education," p. 116).
4. 2. Walton Bean and James J. Rawls, *California: An Interpretive History* (1983), pp. 154–55, 239–42.
5. Rudolph, *The American College and University*, pp. 247–52.
6. Stadtman, *University of California*, (1970) p. 61. For Berkeley's early history see the *University of California Register* and the University Archives, BL. I am also indebted to the Academic Personnel Office, University of California, Berkeley, for making available unpublished biographical material from their storage vaults.
7. Stadtman, *University of California*, pp. 67, 71–76, 79–80; William W. Ferrier, *Origin and Development of the University of California* (Berkeley: Sather Gate Books, 1930), pp. 355–64. For the role of Ezra Carr,

formerly John Muir's teacher at Wisconsin, in the California Grange's attack on the university, see pp. 76–78.

8. Legge, "Hans Herman Behr," p. 250.

9. Charles Palache, "Autobiography," TS, BL, pp. 1–4; Palache, "Six Weeks in the Saddle," MS, BL; Francis E. Vaughan, *Andrew C. Lawson: Scientist, Teacher, Philosopher* (Glendale, Calif.: Clark, 1970), p. 60.

10. John H. Thomas, "Botanical Explorations in Washington, Oregon, California and Adjacent Regions," *Huntia* 3 (1969): 29–32; Lincoln Constance, "Willis Linn Jepson, 1867–1946," *Science* 105 (13 June 1947): 614; Emanuel Fritz, "Willis Linn Jepson, 1867–1946," *Journal of the California Horticultural Society* 9 (January 1948): 23–26. See also Jepson's entry on Greene in *Dictionary of American Biography* (New York: Scribner's, 1931), 7:564–65.

11. Chester Stock, "John Campbell Merriam, 1869–1945," *National Academy of Science Biographical Memoirs* 35 (1946): 209–13; Hilda W. Grinnell, *Annie Montague Alexander* (Berkeley: University of California, 1958), pp. 4–8. See also the more detailed "Biographical Sketch of Annie Montague Alexander," copy of MS, BL; and correspondence with Alexander in Merriam Papers, BL.

12. William Ritter to Joseph Grinnell, 14 August 1907, Ritter Papers, BL; Francis B. Sumner, "William Emerson Ritter: Naturalist and Philosopher," *Science* 102 (28 April 1944): 335–38. See also Ritter Papers, BL; Ritter Papers, SIO; E. W. Scripps Papers, SIO; Ritter, "Philosophy of E. W. Scripps," TS, SIO.

13. E. W. Scripps, *Damned Old Crank: A Self-Portrait of E. W. Scripps Drawn from His Unpublished Writings*, ed. Charles R. McCabe (New York: Harper & Bros., 1951), p. 231; Negley Cochran, *E. W. Scripps* (New York: Harcourt, Brace, 1933), pp. 113ff.

14. Ritter to Gov. Hiram Johnson. 14 November 1912, Ritter Papers, BL.

15. Andrew Rolle, *California*, pp. 338–40.

16. Orrin Elliott, *Stanford University: The First Twenty-five Years* (Palo Alto: Stanford University Press, 1937), pp. 14–15. For the university's early history see the University Archives, LSJU.

17. Elliott, *Stanford University*, p. 42; David Starr Jordan, *Days of a Man: Being Memories of a Naturalist, Teacher and Minor Prophet of Democracy*, 2 vols. (Yonkers-on-Hudson, N.Y.: World, 1922), 1:1, 100.

18. Jordan, *Days of Man*, 1:85; Edward McNall Burns, *David Starr Jordan: Prophet of Freedom* (Palo Alto: Stanford University Press, 1953), p. 3. Jordan "dug potatoes, husked corn, swept out the Chemistry Building, and later earned subsistence by waiting on tables in a student dormitory" (p. 3).

19. Jordan, *Days of Man*, 1:105, 106, 114.
20. Elliott, *Stanford University*, p. 45; Jordan, *Days of Man*, 1:186.
21. Jordan, *Days of Man*, 1:202, 217.
22. Ibid., pp. 354–55; Elliott, *Stanford University*, p. 43.
23. Jordan to John C. Branner, 1 May 1891, and 22 July 1891, Branner Papers, University Archives, LSJU.
24. Kevin Starr, *Americans and the California Dream, 1850–1915* (New York: Oxford University Press, 1973), p. 315; Elliott, *Stanford University*, pp. 259, 256.
25. Starr, *Americans*, pp. 329, 330, 332; Jane Stanford to Jordan, 16 December 1899, and 26 April 1901, Jane Stanford Papers, LSJU.
26. R. A. F. Penrose, Jr., "Memorial to John Caspar Branner," *Bulletin of the Geological Society of America* 36 (1925): 18–19; C. F. Tolman, "James Perrin Smith, Ph.D., LL.D.," *Stanford Spectator*, March 1923, p. 57.
27. Jordan, *Days of Man*, 1:52.
28. David Starr Jordan, "William Russell Dudley," *Science* 34 (4 August 1911): 142; Branner, "Memorial Address," *Dudley Memorial Volume* (Palo Alto: Stanford University Press, 1913), p. 7; Douglas Houghton Campbell, "Memorial Address," ibid., p. 12. "As might be expected," Campbell noted, "his sympathies were entirely with those who would protect our magnificent western forests from the reckless exploitation of ignorant or unscrupulous men who have so devastated the forests of the eastern states, and are now threatening the great forests of the Pacific Coast" (pp. 13–14).
29. Campbell, "Memorial Address," p. 13; LeRoy Abrams, "Professor Dudley's Work for Stanford," *Dudley Memorial Volume*, p. 20. See also Abrams's entry on Dudley in the *Dictionary of American Biography*.
30. William Russell Dudley, "The Vitality of *Sequoia Gigantea*," rpt. in *Dudley Memorial Volume*, pp. 40–41.
31. David Starr Jordan, "California and the Californians," *Atlantic Monthly* (December 1898): 793–97.
32. Daniel J. Kevles, *In the Name of Eugenics: Genetics and the Uses of Human Heredity* (New York: Knopf, 1985), p. 64.
33. William Frederic Badè. *The Life and Letters of John Muir*, 2. vols. (Boston: Houghton Mifflin, 1928), 2:6; Muir, "Autob. notebook," quoted in Linnie Marsh Wolfe, *Son of the Wilderness: The Life of John Muir* (1945, rpt. Madison: University of Wisconsin Press, 1978), p. 153.
34. Badè, *John Muir*, 1:166–68.
35. Edwin Way Teale, ed., *The Wilderness World of John Muir* (Boston: Houghton Mifflin, 1954), p. 319; Muir, *John of the Mountains*, p. 85; Muir, *My First Summer in the Sierra* (1911, rpt. Boston: Houghton Mifflin, 1979), pp. 22–23; John Muir, *Steep Trails*, ed. William Frederic

Badè (Boston: Houghton Mifflin, 1918), pp. 3, 11. When he learned that the landlord of a Yosemite hotel had received money from the park commissioners for " 'Fixing' Nevada Falls," Muir called it "American enterprise with a vengeance. Perhaps we may yet hear," he mused, "of an appropriation to whitewash the face of El Capitan or correct the curves of the Domes" (*John of the Mountains*, p. 283).

36. *Record-Union* [Sacramento], 5 February 1877.

7: The Greatest Good

1. Sierra Club, "Agreement of Association," rpt. in Holway R. Jones, *John Muir and the Sierra Club* (1965), p. 170; Allen H. Bent, "The Mountaineering Clubs of America," *Appalachia* 14 (December 1916): 5–18.

2. For purposes of this analysis, I have defined scientists as those whose principal paid occupation involved scientific training, teaching, or research. (Thus Dr. H. W. Harkness, president of the California Academy of Sciences and a charter member of the Sierra Club, is excluded from table 7.1 because his major professional role was as a physician.) But in addition to customary considerations of professional esteem (institutional affiliation, published articles, membership in professional or honorary societies), I have taken into account the individuals' social role in California. John Muir held no professional scientific position, and by the 1890s he no longer conducted research. Yet his early work on Yosemite glaciology and his subsequent fame as a writer had won him a reputation, among scientists as well as the general public, as one of California's most famous scientists. He is therefore included.

3. In addition to the Sierra Club's published list of charter members, two membership updates appeared in the *Sierra Club Bulletin:* one in January 1894 (107–08), with 48 names, and another in May 1897 (124–27), adding 122 names. In June 1896, a club circular listed 253 members and 8 honorary members. No further membership information was published (apparently due to the growing size of the club). Still extant, however, is a typed list of 905 names, entitled "Membership List of Sierra Club," updated but probably compiled just after the earthquake. (I am indebted to Holway R. Jones for making copies of this and many other Sierra Club documents available to me).

4. Chemists and physicists were particularly hampered by insufficient equipment. Those who joined the Sierra Club were often de facto members of the larger community of earth and life scientists. John M. Stillman, one of Le Conte's first students at Berkeley, completed graduate work in Germany and returned to teach at Berkeley. Finding opportunities in chemistry there to be rudimentary, he moved to Boston in order to pursue a career in industrial chemistry. In 1891 he accepted Jordan's

offer to join Stanford's first faculty, but he soon found that Stanford in the 1890s resembled Berkeley in the 1870s in its dearth of chemical research facilities. For several years Stillman concentrated on teaching, published articles on the history of chemistry, and looked to his colleagues in geology and biology for professional camaraderie.

5. Membership cardfile, CAS; *Call* [San Francisco], 20 November 1892. For letters from Sierra Club honorary members, see *SCB* 1 (June 1893): 25–29.

6. Le Conte became second vice president in place of Branner, who decided that the difficulty of traveling between Palo Alto and San Francisco precluded his regular attendance at board meetings, but Branner pledged his continuing support and "complete sympathy with all the aims of the club" (Branner to Muir, 5 October 1892, Branner Papers, LSJU).

7. Grove Karl Gilbert, "Domes and Dome Structure of the High Sierra," *SCB* 5 (January 1905): 211–20; Gilbert, "Systematic Asymmetry of Crest-Lines in the High Sierra of California," *SCB* 5 (June 1905): 279–86; François Matthes, "The Extinct Eagle Peak Falls, " *SCB* 7 (June 1910): 222–24; Matthes, "The Striped Rock Floor of the Little Yosemite Valley," *SCB* 8 (January 1911): 3–9; Matthes, "The Winds of the Yosemite Valley," *SCB* 8 (June 1911): 89–95; John Lemmon, "Conifers of the Pacific Slope," *SCB* 2 (May 1897): 61–78, and 2 (January 1898): 156–73; Willis Linn Jepson, "Mt Whitney, Whitney Creek and the Poison Meadow Trail," *SCB* 4 (February 1903): 207–15; Jepson, "The Steer's Head Flower of the Sierra Nevada," *SCB* 8 (June 1912): 266–69; William Setchell, "The Sierran Puffball," *SCB* 6 (January 1906): 39–42; Joseph Grinnell, "Early Summer Birds in the Yosemite Valley," *SCB* 8 (June 1911): 118–24; Vernon Kellogg, "The Great Spruce Forest and the Hermit Thrush," *SCB* 4 (January 1902): 35–39; Kellogg, "Butterflies of the Mountain Summits," *SCB* 9 (June 1913): 85–94.

8. Muir, "Lake Tahoe in Winter," *SCB* 3 (May 1900): 119–26; Muir, "Studies in the Sierra," *SCB*, 5 parts: 9 (January 1915): 225–39; 10 (January 1916): 62–77; 10 (January 1917): 184–201; 10 (January 1918): 304–18; and 10 (January 1919): 414–28; Joseph Le Conte, "Ramblings through the High Sierra," *SCB* 3 (January 1900): 1–108; Le Conte, "My Trip to King's River Cañon," *SCB* 4 (June 1902): 88–99; Mark Kerr, "Crater Lake, Oregon," *SCB* 1 (June 1893): 31–39; Alice Eastwood, "From Redding to the Snow-Clad Peaks of Trinity County," *SCB* 4 (January 1902): 39–58.

9. "Proceedings of the Meeting of the Sierra Club Held November 23, 1895," *SCB* 1 (January 1896): 268–84.

10. William Dudley, "Forest Reservations; With a Report on the Sierra Reservation, California," *SCB* 1 (January 1896): 254–67; Dudley, "Zonal Dis-

tribution of Trees and Shrubs in the Southern Sierra," *SCB* 3 (June 1901): 298–312.

11. "Proceedings of the Sierra Club," *SCB* (January 1893): 23.

12. Wallace Stegner, *Beyond the Hundredth Meridian: John Wesley Powell and the Second Opening of the West* (1954, rpt. Lincoln: University of Nebraska Press, 1982), pp. 337 ff.

13. Samuel P. Hays, *Conservation and the Gospel of Efficiency: The Progressive Conservation Movement, 1890–1920* (1959, rpt. New York: Atheneum, 1975), pp. 122–46.

14. "Proceedings of the Sierra Club," *SCB* 1 (January 1893): 24.

15. Holway Jones, *John Muir and the Sierra Club* (1965), p. 29; *John of the Mountains* (1979), pp. 283–85.

16. Johnson, *Remembered Yesterdays*, pp. 79ff; Muir to Johnson, 13 May 1891, Johnson Papers, BL.

17. John Muir, "Treasures of the Yosemite," *Century* (September 1890): 656–67; "As It Appears to John Muir," *Tribune* [Oakland], 6 September, 1890; John P. Irish, letter to editor, *Tribune*, 8 September, 1890; Muir's reply, *Tribune*, 16 September 1890.

18. *Call* [San Francisco], 11 November 1895.

19. Jones, *Muir and the Sierra Club*, p. 13.

20. *Call* [San Francisco], 25 November 1894.

21. "Statement Concerning the Proposed Recession of Yosemite Valley and Mariposa Big Tree Grove by the State of California to the United States," *SCB* 5 (January 1905): 242–50.

22. Muir to Warren Olney, Sr., publ. in Badè, *John Muir*, (1924) 2:303; Elmo R. Richardson, *The Politics of Conservation: Crusades and Controversies, 1897–1913* (Berkeley: University of California Press, 1962), pp. 13ff. As Richardson notes, Gifford Pinchot inspected the valley in 1899 and decided to write a *Century* article defending the commissioners; apparently a trip to the Calaveras Grove with Muir dissuaded him, however, for the article never appeared.

23. Jones, *Muir and the Sierra Club*, pp. 70–72, 78.

24. See, for example, Hays, *Conservation*, pp. 192ff; Roderick Nash, *Wilderness and the American Mind* (New Haven: Yale University Press, 1973), pp. 130ff.; Kendrick A. Clements, "Politics and the Park: San Francisco's Fight for Hetch Hetchy, 1890–1913," *Pacific Historical Review* 48 (May 1979): 184–215.

25. Hays, *Conservation*, pp. 22, 27–28; Lawrence Rakestraw, "Sheep Grazing in the Cascade Range: John Minto vs. John Muir," *Pacific Historical Review* 27 (November 1958): 371–82. Note Minto's challenge to Muir's position on vegetation and water regulation, p. 376.

26. John Ise, *The United States Forest Policy* (New Haven: Yale University Press, 1920), pp. 117–18.
27. Dudley, "Forest Reservations," p. 259.
28. Sierra Club, "Circular of November 14th, 1895" (copy, WDP, LSJU); "Proceedings of the Meeting of the Sierra Club Held November 23, 1895," 284, 276.
29. Sierra Club, "Circular," 269–70.
30. Ibid., 265–67.
31. Ibid. See also "Proceedings of the Meetings of the Sierra Club Held November 23, 1895," 285–86.
32. Gifford Pinchot, *Breaking New Ground* (New York: Harcourt, Brace, 1947), pp. 90–92; Ise, *Forest Policy*, pp. 128–29.
33. Fox, *John Muir and His Legacy*, p. 111; Hays, *Conservation*, pp. 28–29. See also M. Nelson McGeary, *Gifford Pinchot: Forester-Politician* (Princeton: Princeton University Press, 1960).
34. Pinchot, *Breaking*, pp. 100, 101, 103. "In the early morning," Pinchot recalled, "we sneaked back like guilty schoolboys, well knowing that we must reckon with the other members of the Commission, who probably imagined we had fallen over a cliff." For Muir's account of this excursion, see Muir, *John of the Mountains* (1979), p. 363.
35. Pinchot, *Breaking*, p. 101.
36. Ibid., p. 97.
37. Sargent to Muir, 8 July 1898, JMP, PCWS; Pinchot, *Breaking*, pp. 95–96. "We must combat whenever there is opportunity the idea that pasturage does no harm to forests," Sargent wrote in reference to Pinchot, "and we must fight to the death the scheme of political bummers for forest protectors." During the Forest Commission's deliberations, Pinchot wrote in his diary: "Sargent opposed to all real forest work, and utterly without a plan, or capacity to decide on plans submitted" (p. 96).
38. Ise, *Forest Policy*, pp. 135, 140–41; Pinchot, *Breaking*, p. 115.
39. Muir, "The National Parks and Forest Reservations," *Harper's Weekly*, 5 June 1897, pp. 563, 566–67.
40. Wolfe, *Son of the Wilderness* (1978) pp. 275–76. Muir stepped up his opposition to sheep grazing in the public reserves after this incident. That winter he published an article condemning grazing and plundering in the name of "practical" forestry ("The Wild Parks and Forest Reservations of the West," *Atlantic Monthly* 81, January 1898, 15–28). In May 1899, en route to Alaska with the Harriman expedition, Muir stopped over in Portland and answered Pinchot's 1897 speech with one of his own, attacking the region's sheep owners and urging local conservationists to oppose grazing in the reserves (see Rakestraw, "Sheep Grazing,"

p. 380). In his memoirs fifty years later, Pinchot portrayed himself as a fellow opponent to sheep grazing: "John Muir called them hoofed locusts, and he was right" (*Breaking*, p. 179).

41. Muir to Sargent, 28 October 1897, draft, JMP, PCWS.
42. Pinchot to Muir, 15 December 1897, cited in Jones, *Muir and the Sierra Club*, p. 18; Muir to Sargent, 3 January 1898, copy, JMP, PCWS. Pinchot wrote to Muir in December 1896, expressing his hope "to be able to accompany you on some longer trip than was my fortune last summer [with the Forest Commission]. You know that my appetite for being in the woods with you has grown vastly by what it fed on" (Pinchot to Muir, 9 December 1896, JMP, PCWS).
43. Johnson to Muir, 17 March 1898, JMP, PCWS (draft of Muir's reply follows text of Johnson's letter); Muir to Johnson, 3 September 1910, Johnson Papers, BL.
44. Sargent to Muir, 27 June 1898, JMP, PCWS.

8: *Temple Destroyers and Nature Fakers*

1. Carol Green Wilson, *Alice Eastwood's Wonderland* (1955), pp. 130–31; Robert C. Miller, "Alice Eastwood," p. 15; Alice Eastwood, "Autobiography," MS, AEP, CAS; Gustav A. Eisen, "Sierra Nevada-Sequoia National Park: Early Explorations by G. A. Eisen," MS, GEP, CAS; Douglas Strong, "The Significance of Gustavus Eisen and the California Academy of Sciences in the Establishment of Sequoia National Park," MS, GEP, CAS; Theodore Roosevelt to David Starr Jordan, 6 November 1907, DSJP, LSJU; Newton B. Drury, *Saving the Redwoods* (San Francisco: Save the Redwoods League, 1945). See also Robert Underwood Johnson's letter to Jordan, congratulating him on his May 1, 1893, Sierra Club talk "in favor of the rescue of the Yosemite Valley and other public reservations in California" (6 June 1893, DSJP, LSJU), and Sierra Club secretary Elliott McAllister's letter to Jordan regarding his committee work to help establish a "Pacific (Mt. Rainier) Forest Reserve" (21 December 1893, DSJP, LSJU).
2. Redwoods and Big Trees were originally classified under the same genus: *Sequoia sempervirens* and *Sequoia gigantea*, respectively. Big Trees are now considered a separate genus, *Sequoiadendron*. By the mid-twentieth century, 85 percent of the original redwood groves were gone. Additional state and national parks increased the protected areas to 68,000 acres, or about 0.3 percent of the original stands.
3. "Proceedings of the Meeting of the Sierra Club Held November 23, 1895," *SCB* 1 (January 1896): 285–86. For redwood park proposals be-

fore Dudley's, see Carolyn de Vries, *Grand and Ancient Forest: The Story of Andrew P. Hill and Big Basin Redwoods State Park* (Fresno: Valley Publishers, 1978), pp. 13–16.

4. William Dudley, "The Big Basin," *The Stanford Sequoia* 10 (April 16, 1901): 362–66; David Starr Jordan, *Days of a Man* (1922), 1: 519, 742; Carolyn de Vries, *Grand and Ancient Forest*, p. xv.

5. De Vries, *Grand and Ancient Forest*, pp. 18–23; Victoria Thomas Olson, "Pioneer Conservationist A. P. Hill: 'He Saved the Redwoods,' " unidentified journal: 32–40 (copy, SFA); J. F. Coope to David Starr Jordan, 10 November 1900, DSJP, Papers, LSJU.

6. William Dudley, "Forestry Notes, *SCB* 3 (May 1900): 187; Frank E. Hill and Florence W. Hill, *The Acquisition of California Redwood Park* (San Jose: Florence W. Hill, 1927), pp. 14–15; Victoria Olson, "Pioneer Conservationist," p. 37.

7. William Dudley, "Forestry Notes," *SCB* 3 (February 1901): 266–67; Carolyn Merchant, "Women of the Progressive Conservation Movement," *Environmental Review* 8 (Spring 1984): 59–60.

8. One indication of Dudley's political and professional abilities is the high esteem he enjoyed not only from Muir but from both Pinchot and Sargent as well. Pinchot sought Dudley's advice often, and called him "a tower of strength in all forest matters on the Coast" (Gifford Pinchot, *Breaking Ground*, p. 171). Sargent considered Dudley's article "Forest Reservations" (*SCB* 1, January 1896) to be "the first authentic account of the condition of the California reservations which I have read." He then paid Dudley his highest compliment by claiming an idea of Dudley's as his own. "Dudley's plan for a Redwood Reservation I have, I think, already advocated," he wrote to Muir; "at any rate I have had it in mind for years" (Sargent to Muir, 25 March 1896, JMP, PCWS.)

9. De Vries, *Grand and Ancient Forest*, pp. 30–37; Dudley to Gov. Henry T. Gage, 6 December 1902, copy in WDP, LSJU; Dudley, "The California Redwood Park: Present Plans of the Commission," TS, WDP, LSJU.

10. Karen Blair, *The Clubwoman as Feminist: True Womanhood Redefined, 1868–1914* (New York: Holmes and Meier, 1980); Merchant, "Women of the Progressive Conservation Movement," pp. 57–59; Stephen Fox, *John Muir* (1981), pp. 173, 341.

11. Carrie Stevens Walter to Dudley, 17 January and 14 May 1902; Dudley to David Starr Jordan, 20 January 1902; Rev. Robert Kenna to Dudley, 24 January 1902; J. F. Coope to Dudley, 25 April 1902; Dudley to Gifford Pinchot, 16 September 1903; and Pinchot to Dudley, 5 October 1903. All in WDP, LSJU.

12. For a preservationist interpretation of Hetch Hetchy, see Jones, *Muir and the Sierra Club*, (1965), 119–69; Wolfe, *Son of the Wilderness*, (1945),

pp. 310–345; Roderick Nash, *Wilderness* (1973), pp. 161–81. For a utilitarian reading, see Kendrick A. Clements, "Engineers and Conservationists in the Progressive Era," *California History* 58 (Winter 1979–80): 282–303; Clements, "Politics and the Park"; Elmo R. Richardson, "The Struggle for the Valley: California's Hetch Hetchy Controversy, 1905–1913," *California Historical Society Quarterly* 38 (September 1959): 249–58; Ray W. Taylor, *Hetch Hetchy: The Story of San Francisco's Struggle to Provide a Water Supply for Her Future Needs* (San Francisco: Ricardo Orozco, 1926).

13. Not until Pinchot's exclusion of Muir from the 1908 Governors' Conference on Conservation was the rift between the two men complete (see Johnson, *Remembered Yesterdays*, pp. 301–07).

14. Nash, *Wilderness*, p. 139.

15. Marsden Manson, "Outline of the History of the Water Supply of the City of San Francisco," *Journal of the Association of Engineering Societies* (March 1907): 109–15.

16. Clements, "Politics and the Park," p. 187.

17. John Ise, *Our National Park Policy: A Critical History* (Baltimore: Johns Hopkins University Press, 1961), pp. 68–69; Clements, "Politics and the Park," p. 188; Jones, *Muir and the Sierra Club* (1965), pp. 88–89.

18. Josiah Dwight Whitney, *Yosemite Guide-Book* (1870), p. 98.

19. Manson, "Outline," 115–16.

20. *Reports on the Water Supply of San Francisco, California, 1900 to 1908, Inclusive* (San Francisco: Board of Supervisors, 1908), pp. 112ff: Holway Jones, *Muir and the Sierra Club*, p. 91.

21. Manson Papers, BL; Clements, "Engineers and Conservationists."

22. Manson, "Observations on the Denudation of Vegetation: A Suggested Remedy for California," *SCB* 2 (June 1899): 295–309; Clements, "Engineers," p. 285. See also Manson, "The Effects of Partial Suppression of Annual Forest Fires in the Sierra Nevada Mountains," *SCB* 6 (January 1906): 22–24.

23. John Muir, "The Hetch-Hetchy Valley," *SCB* 6 (January 1908):211–22.

24. Muir, *Yosemite* (1912), pp. 197–202.

25. Manson, "Hetch-Hetchy: The Law and the Facts," *The California Weekly* [San Francisco], 18 June 1909; Manson to G. W. Woodruff, 6 April 1910, Manson Papers, BL.

26. "Let All the People Speak," *Democrat and Leader* [Davenport, Iowa], 21 October 1907 (see also "Beauty vs. Utility in California Fight," *Post* [Chicago], 10 February 1909); "Men of Science Oppose Hetch Hetchy Water Project," *Independent* [Berkeley], 16 November 1907; "Sierra Club, Headed by John Muir, Comes Out in Strong Opposition to Hetch Hetchy Reservoir Scheme," *Tribune* [Oakland], 17 November 1907 (see also "Muir Opposes Yosemite Scheme," *Enquirer* [Oakland], 18 November 1907).

27. *Chronicle* [San Francisco], 20 January 1909; "John Muir's Muddled Plea", *Call* [San Francisco], 27 January 1909; "Nature Lovers Delay the Hetch Hetchy Grant," *Call* [San Francisco], 11 February 1909; "President Taft Chafes Muir on Sentimentality," *Call* [San Francisco], 10 October 1909.

28. "Raise the Money for Hetch Hetchy," *Call* [Sacramento], 1 February 1909; "Scheming Power Interests Hide Behind 'Nature Lovers,' " *Examiner* [San Francisco; special edition, Washington, D.C.], 2 December 1913.

29. Merchant, "Women of the Progressive Conservation Movement," pp. 59, 78; California Club, "Resolutions Urging upon the Federal Government the Necessity of Placing Her Forest Reservations on an Income Producing Basis," circular, San Francisco, November 1900.

30. "Woman's Finger in San Francisco Pie," *Bulletin* [San Francisco], 28 February 1910 (see also "Women Will Boost Hetch Hetchy Plan," *Examiner* [San Francisco], 13 March 1910); "Sweeping Back the Flood," *Call* [San Francisco], rpt. in Jones, *Muir and the Sierra Club.*

31. "Engineering Problem Worked out and Endorsed by the World's Greatest Experts," *Examiner* [San Francisco, Washington edition], 2 December 1913; John R. Freeman to M. M. O'Shaughnessy, 8 September 1913, John R. Freeman Papers, HHL.

32. "San Francisco's Plea to the United States," *Examiner* [San Francisco; Washington edition], 2 December 1913.

33. Pinchot, *The Fight for Conservation* (New York: Doubleday, Page, 1910), pp. 42, 43.

34. Ibid., pp. 133, 144, 79–80.

35. Clements, "Engineers," p. 287; "The Hetch Hetchy Water Project," *SCB* 6 (January 1908): 264–65.

36. Jones, *Muir and the Sierra Club*, pp. 124–25. The Sierra Club conferred with University of California engineering professor Charles Gilman Hyde, but university president Benjamin Ide Wheeler's firm support for the city's case helped convince Hyde that representing the Sierra Club would be impolitic.

37. *Proceedings before the Secretary of the Interior in re Use of Hetch Hetchy Reservoir by the City of San Francisco* (Washington, D. C.: GPO, 1910), pp. 17–22; *Hetch Hetchy Reservoir Site*, U.S. Senate, Committee on Public Lands, Hearings on S.R. 123, 60th Cong., 2d Sess., 1909, p. 14.

38. Robert B. Marshall to Muir, 19 July 1913 and 28 September 1907, JMP, PCWS.

39 Harold Bradley to Norman Hapgood, 7 December 1913, quoted in Jones, *Muir and the Sierra Club*, pp. 167–68. See also Horace McFarland's testimony in *Proceedings Before the Secretary of the Interior*, p. 18.

9: *The End of the Trail*

1. Gray Brechin, "Sailing to Byzantium: The Architecture of the Fair," in Burton Benedict et al., *The Anthropology of World's Fairs: San Francisco's Panama Pacific International Exposition of 1915* (Berkeley: Scolar Press), pp. 98–100.

2. Elizabeth N. Armstrong, "Hercules and the Muses: Public Art at the Fair," in Benedict, *Anthropology of World's Fairs*, pp. 120–22; Eugen Neuhaus, *The Art of the Exposition* (San Francisco: Paul Elder, 1915), pp. 32–33.

3. Kevin Starr, *Americans and the California Dream* (1973), p. 297; George Starr, "Truth Unveiled: The Panama Pacific International Exposition and Its Interpretors," in Benedict, *Anthropology of World's Fairs*, pp. 149–50.

4. Burton Benedict, "The Anthropology of World's Fairs," in *The Anthropology of World's Fairs*.

5. Carroll Pursell, Jr., "The Technical Society of the Pacific Coast" (1976), 715; Sally Kohlstedt, *Formation of the American Scientific Community* (1976), pp. x ff.

6. Robert Miller, "California Academy" (1942), p. 370.

7. C. Raymond Clar, *California Government and Forestry from Spanish Days* (1959), pp. 191, 362–63; Verne Stadtman, *University of California* (1970), pp. 191–92; Orrin Elliott, *Stanford University* (1937), pp. 561–62; Daniel Kevles, *The Physicists* (1978), p. 90; Aurthur L. Norberg, "Chemistry in California: How It Started and How It Grew," *Chemical and Engineering News*, 30 August 1976, p. 27.

8. Charles Palache, "Autobiography," "College" section, p. 3; Stadtman, *University of California*, p. 370.

9. Andrew Rolle, *California* (1987), pp. 366–73; Norberg, "Chemistry," pp. 34–35. See also David F. Noble, *America by Design* (1977); and Kendall Birr, "Industrial Research Laboratories," in Nathan Reingold, ed., *Sciences in the American Context* (1979), pp. 193–207.

10. Stadtman, *University of California*, p. 226; Kevles, *The Physicists*, pp. 110, 155–56.

11. Dorothy Nelkin, "Scientists and Professional Responsibility: The Experience of American Ecologists," *Social Studies of Science*, 1977, pp. 75–95; Ronald Tobey, *Saving the Prairies* (1981).

12. George Santayana, "The Genteel Tradition" (1976), pp. 31–32 (see chap. 1, n. 1).

13. Theodora Kroeber, *Ishi in Two Worlds: A Biography of the Last Wild Indian in North America* (1961, rpt. Berkeley: University of California Press, 1976), pp. 3–10. Ishi, the Yahi word for man, was the name chosen by Alfred Kroeber; Ishi never revealed his real name (pp. 128–29).

14. Ibid., pp. 136, 141, 153, 165, 168–69. 180–81.
15. Burton Benedict, "The Anthropology of World's Fairs," in Benedict, *Anthropology of World's Fairs*, pp. 8–12; Kroeber, *Ishi*, p. 169.
16. For Ishi's interaction with a Sioux Indian traveling with the Buffalo Bill Wild West Show, see Kroeber, *Ishi*, p. 239.
17. William E. Colby, "Yosemite's Fatal Beauty," *SCB* 33 (March 1948): 79. Interior Secretary Donald Hodel's proposal to dismantle the dam prompted Mayor Dianne Feinstein to visit Yosemite Park, where she pronounced the dam "beautiful" and (like Mayor Phelan before her) vowed to "fight in every hallway and courtroom" on the city's behalf. This time, however, dam supporters were the preservationists. The Sierra Club supported Hodel's proposal; but other environmental groups noted his lack of prior interest in park preservation and worrked that he was really trying to rekindle interest in Auburn Dam, a project that environmentalists had helped to arrest. When Hodel and Feinstein toured the dam, a member of Earth First!, dressed as a tree, told the secretary, "We're not sure if you're wholly trustworthy" (Marshall Kilduff, "Feinstein, Hodel Clash at the Dam," *Chronicle* [San Francisco], 14 October 1987).
18. Donald Worster, *Rivers of Empire: Water, Aridity, and the Growth of the American West* (New York: Pantheon, 1985, pp. 272–76); Tom Harris and Jim Morris, "Selenium: Conspiracy of Silence," *Bee* [Sacramento], 8, 9 and 10 September, 1985.
19. Walton Bean and James Rawls, *California* (1983), p. 504; Robert C. Fellmeth et al., *Politics of Land* (New York: Grossman, 1973), pp. 104–10; John D. Rabinovitch, "The Politics of Poison," in Ralph Nader et al., *Who's Poisoning America* (San Francisco: Sierra Club, 1981), pp. 240–68.
20. Rachel Carson, *Silent Spring* (Cambridge, Mass.: Houghton Mifflin, 1962), p. 297.
21. Barry Commoner, *The Closing Circle: Nature, Man and Technology* (New York: Bantam, 1970), p. 267.
22. Seth Zuckerman, "A Grassroots Rebellion Revamps Environmentalism," *The Nation*, 18 October 1986, rpt. in *Utne Reader*, May/June 1987: 77; Bill Devall and George Sessions, *Deep Ecology: Living as if Nature Mattered* (Salt Lake City: Peregrine, 1985); Gary Synder, *The Real Work: Interviews and Talks 1964–1979* (New York: New Directions, 1980), pp. 138–58; Fred Setterberg, "The Wild Bunch: Earth First! Shakes Up the Environmental Movement," *Image* (San Francisco *Examiner*, November 9, 1986, rpt. in *Utne Reader*, May/June 1987: 68–76.
23. Brechin, "Sailing to Byzantium," pp. 106–07.
24. Gary Snyder, *Turtle Island* (New York: New Directions, 1974).

Index